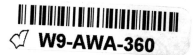

AFRICAN

SCULPTURE

The exhibition and catalogue are supported by grants from the

National Endowment for the Arts

The Pew Memorial Trust

Rohm and Haas Company and

The Phoebe W. Haas Charitable Trust "B."

Additional support was provided by

Bell of Pennsylvania.

AFRICAN

SCULPTURE

FROM THE UNIVERSITY MUSEUM

UNIVERSITY OF PENNSYLVANIA

ALLEN WARDWELL

PHOTOGRAPHY BY BOBBY HANSSON

PHILADELPHIA MUSEUM OF ART

Philadelphia Museum of Art, November 23, 1986—February 8, 1987
Cover: Mask (*Kifwebe*), Songye, Zaire (no. 58)
Frontispiece: Dance Crest (detail), Ejagham, Nigeria (no. 22)

EDITED BY Sherry Babbitt
DESIGNED BY Joseph B. Del Valle
MAPS BY David Lindroth
COMPOSITION BY Circle Graphics, Harmans, Md.
PRINTED BY Eastern Press, Inc., New Haven

Library of Congress Cataloging-in-Publication Data

University of Pennsylvania. University Museum.
 African sculpture from The University Museum,
University of Pennsylvania.

 Bibliography: p.
 Includes index.
 1. Sculpture, Black—Africa, Sub-Saharan—Exhibitions.
2. Sculpture, Primitive—Africa, Sub-Saharan—Exhibitions.
3. University of Pennsylvania. University Museum—
Exhibitions. I. Wardwell, Allen. II. Title.
NB1091.65.U54 1986 730'.0967'074014811 86-22489
ISBN 0-87633-067-7 (Phila. Museum of Art : pbk.)
ISBN 0-8122-7956-5 (Univ. of Pa. Press)

Contents

Foreword

One of the world's leading museums devoted to anthropology and archaeology, The University Museum of the University of Pennsylvania marks its one-hundredth anniversary in 1986–87. The University Museum possesses a long and distinguished record of research, expeditions, exhibitions, and publications, and its collections add immeasurably to the cultural resources of Philadelphia. Among its treasures is one of the earliest important collections of African art in the United States, and the Philadelphia Museum of Art is delighted to join the Centennial Celebration of The University Museum by presenting an exhibition of African sculpture which constitutes a broad survey of those holdings.

This project continues a fruitful tradition of cooperation between two Philadelphia institutions which extends back over many decades and which was most recently evident in the exhibition of Nigerian objects from The University Museum organized to complement the touring exhibition "Treasures of Ancient Nigeria" when it was shown at the Philadelphia Museum of Art in 1982. By mutual agreement, the two museums do not actively collect in overlapping fields. The small number of African objects belonging to the Philadelphia Museum of Art entered the Museum with collections of modern painting and sculpture such as those formed by Louise and Walter Arensberg and Vera and Samuel S. White, 3rd. This exhibition and catalogue afford a most welcome opportunity for this Museum both to broaden our program and audience by presenting fine works of art beyond the scope of our own collection and to salute a sister institution as it embarks on its second century.

The success of such a cooperative venture depends upon the coordinated effort and hard work of all involved. We are most grateful to Robert H. Dyson, Jr., Director of The University Museum, for his warm and unfailing support of this project. As guest curator for the exhibition, Allen Wardwell selected the objects, wrote the catalogue, and worked with the staffs of both museums with exemplary efficiency and contagious enthusiasm. His admiration for the works of art in the exhibition, his lucid explanations of their purpose, and his ready and gracious response to demands on his time made the project a particular pleasure. This exhibition also owes much to the many dedicated staff members of both museums who worked so devotedly to bring it into being. Donald J. LaRocca capably served as curatorial liaison for this Museum, and Kathryn Grabowski and her colleagues at The University Museum made collaboration a smooth and gracious process. Sherry Babbitt was responsible for the meticulous editing of the catalogue, which was handsomely designed by Joseph B. Del Valle. Tara G. Robinson conceived and carried out the installation of the exhibition with her customary skill. The staff of the Division of Education and the Library, as well as the departments of Exhibitions and Installations, Publications, and the Registrar's Office, and the Museum's ingenious Packing Department, likewise deserve special acknowledgment for their contributions to this project. Cheryl McClenney-Brooker, Assistant Director for Program, and Sandra Horrocks, Manager of Public Relations, explored a variety of means of bringing the exhibition to new audiences.

Generous grants from the National Endowment for the Arts, The Pew Memorial Trust, Rohm and

Haas Company, and The Phoebe W. Haas Charitable Trust "B" have supported the exhibition and its accompanying catalogue. Their contributions, together with additional funding from Bell of Pennsylvania and an educational newspaper supplement published by the *Philadelphia Daily News,* have made it possible for the Philadelphia Museum of Art to salute the anniversary of The University Museum in an appropriate fashion and for both institutions to share a handsome and important group of African sculpture with a wide public.

Anne d'Harnoncourt
The George D. Widener Director
Philadelphia Museum of Art

Preface

It is with great pleasure that I have this opportunity to address the subject of The University Museum's African collections, which were among the first to enter an American museum. When Westerners initially became intimately involved in African cultures in the nineteenth century, the discipline of anthropology was in its infancy. In fact, it was not until 1886 that the University of Pennsylvania appointed its first professor of anthropology, Daniel G. Brinton; the following year the university authorized the formation of a museum to house its anthropological and archaeological collections. This institution, which came to be known as The University Museum, quickly recognized the need to include examples of the material cultures of Africa to complement its growing body of artifacts from other societies. A small proportion of The University Museum's African collections form the present exhibition, so generously organized by the Philadelphia Museum of Art in honor of our Centennial Celebration.

To build its African collections, The University Museum, like all museums interested in the field, first turned to the existing networks, namely the missionaries and the few colonial government officials who were active among African peoples. The objects that were purchased and donated from these sources in the late nineteenth and early twentieth centuries were frequently accompanied by only the most meager documentation because they had been collected primarily as curios according to individual tastes and values. The notion of systematically developing a collection had not yet taken hold.

Due to its increasing international reputation as a scholarly institution, The University Museum in time was able to procure from professional dealers and collectors a wider range of African objects of a higher quality and with somewhat more detailed documentation. However, it was not until Henry Usher Hall's expedition to Sierra Leone in 1936–37 that the museum engaged in the kind of in-depth study of an African culture that it strove to achieve through its other archaeological and ethnological expeditions. Objects collected during Hall's stay in Africa were meticulously documented as to their origin, function, and cultural significance.

In recent decades The University Museum has acquired few African objects. In keeping with its commitment to the principle that an object removed from its cultural context can only reveal part of its story and its orientation toward scholarly research, the museum places paramount importance upon adequate evidence of the source and purpose of its accessions. Equally significant to this institution is a strict adherence to current standards that apply to the movement of cultural materials between countries.

The objects in this exhibition represent some of the finest examples of African sculpture. Despite the lack of detailed information on many of the early acquisitions, this selection nevertheless contains works that were made and used by African peoples for a way of life that has long since been affected by both colonialism and modernization. The overall importance of a collection such as that of The University Museum is immense. To the anthropologist these works may be seen as artifacts of now greatly altered African cultures. To the art historian they may appear as manifestations of the changing aesthetic sensibilities of their makers. In many ways these two approaches are but different aspects of the same study, for both hinge upon an understanding of the cultural context that gave rise

to the creation of the objects.

I should like to thank our colleagues at the Philadelphia Museum of Art for their warm and generous cooperation in preparing this exhibition to give recognition to The University Museum's contributions to the understanding of the cultures of Africa. All of us, I am sure, look forward to the rewards of the future collaboration between our two institutions. Special thanks go to Allen Wardwell, who selected and researched the objects, which are brought together for the first time in this very fine catalogue. To those members of The University Museum's staff, both past and present, who have made this exhibition possible through their efforts in conserving and documenting the African collections, I wish to express my deep appreciation as Director. Finally, I extend our collective appreciation to the many people throughout the world who have supported The University Museum through their gifts and other contributions.

<div style="text-align: right;">

Robert H. Dyson, Jr.
Director
The University Museum
University of Pennsylvania

</div>

Acknowledgments

Putting together an exhibition such as this is a rare opportunity. It was afforded me by my friend and former colleague Anne d'Harnoncourt, Director of the Philadelphia Museum of Art. I thank her for making the staff and resources of her great museum available. Donald J. LaRocca worked closely with me on many details. He was especially helpful in providing information and photographs from The University Museum Archives that were incorporated into the history of the African collections. The catalogue benefited from the guidance of George H. Marcus and the meticulous, understanding editing of Sherry Babbitt. I also received assistance from Suzanne F. Wells, Cheryl McClenney-Brooker, and Tara G. Robinson.

It has been a privilege for me to work once again with The University Museum, from which I have always received warm and generous cooperation. Its Director, Robert H. Dyson, Jr., was enthusiastic from the start, and I was given immediate and complete access to the collections, files, and archives throughout my research. Kathryn Grabowski, assisted by Lisa Stigelman, was my day-to-day contact at the museum and facilitated my work in every way possible. Archival records were efficiently provided by Georgianna Grentzenberg, Douglas M. Haller, Mary Anne Kenworthy, Caroline Dosker, and Eleanor M. King; Mary Virginia Harris helped with the preliminary work in the archives. I thank David Crownover, formerly Executive Secretary at The University Museum, for his valuable suggestions on the history of the collections.

This catalogue represents a continuing collaboration between me and Bobby Hansson, whose excellent photographs have now appeared in three of my publications. Joseph B. Del Valle was often our choice as a designer for catalogues produced by the Asia Society Gallery in New York during my directorship, and it has been a pleasure to work with him again.

A.W.

African Sculpture: Criteria and Methods of Selection

There are over eleven thousand objects in the sub-Saharan African collections of The University Museum of the University of Pennsylvania. Many are examples of material culture and ethnography—weapons, tools, textiles, utensils, implements, and undecorated items of daily use—that have been acquired by purchase and gift since the end of the nineteenth century. However, also included among the collections are numerous art objects made for ceremonial, magical, and decorative purposes, and a selection of the best of them forms the subject of this exhibition.

Some of these objects are well known, having been included in major exhibitions of African sculpture as early as 1935, when the Museum of Modern Art in New York mounted the great display "African Negro Art," which brought the works to the attention of visitors to American art museums for the first time (see Sweeney, 1935). Quite a few were published by The University Museum in its *Journal* and *Bulletin* between 1917 and 1945 in a series of articles written by Henry Usher Hall and Heinrich A. Wieschhoff, two Curators of the African collections. Many others remained in the storerooms from the day of their acquisition, never to be photographed or studied, let alone exhibited.

The present selection emphasizes both familiar and unfamiliar African art treasures that are a part of this great museum's holdings. It was decided not to include examples of the court art from the Nigerian kingdom of Benin, which are also among the highlights of the museum's collections, both because the Philadelphia Museum of Art had shown the "Treasures of Ancient Nigeria" together with an exhibition of Nigerian art from The University Museum in 1982 and because the ivories and bronzes of this society form an expression of a very

different nature than the wood carvings from the more indigenous cultures. Furthermore, The University Museum's Benin collections are comparatively well known, whereas much of what is presented here is in need of new exposure and updated research.

The objects in this exhibition have been chosen primarily for their aesthetic merits. This was not, however, the criterion that brought them to The University Museum, for they were initially collected for anthropological and ethnographical research and display. Despite this difference in purpose, a number of the works that were chosen for study and illustration in the museum publications by anthropologists Hall, Wieschhoff, and Emil Torday appear here. It seems that when both anthropologists and art historians set out to select the finest objects for display or publication, the choices are made through the qualitative comparison of similar works and the application of such universal aesthetic standards as form, balance, design, and skillful workmanship.

The African artists who made these objects did not consciously seek to infuse them with these aesthetic qualities. Instead they had been carefully schooled from the time they were adolescents in the traditions and beliefs of their culture and then trained in their craft, often through long apprenticeships to master carvers. They therefore knew exactly and almost instinctively how to make their creations understandable and acceptable to those who would see and use them.

Over the past twenty years, a number of provocative studies of the aesthetics of African art have been completed. The most significant are summarized by Susan Mullin Vogel in her essay "African Aesthetics" (in Vogel, 1986, pp. XI–XVII),

in which she defines the elements that Africans themselves seek within a work of art. Good craftsmanship, balance, attention to finish, fine detail, and the treatment of the human form as an idealized image, in the prime of life and radiating strength and health, are among the common denominators she discovers in much African sculpture. In the works that portray rulers and members of their families, the ability to convey a sense of composure and dignity is also sought. Most importantly, Vogel identifies the principle of moderation that is the basis of all African art. Individual objects may deviate from an established style in small details or in the conception of the entire sculpture. It is therefore sometimes possible to recognize the hand of a specific master carver among a body of works made for the same purpose. Nonetheless, even these objects are variations on very specific themes, for each creation must always be a recognizable and true representative of the traditions that produced it.

Personal taste obviously played a role in the formation of this exhibition, and given the same challenge another individual would not have chosen exactly the same objects. In addition to trying to follow Vogel's aesthetic criteria and to bear in mind the aforementioned acknowledged universal artistic values, selection was made with an eye toward indications of the actual use of each object. In discussing African wood sculpture, age is a relative factor, due largely to the extensive damage caused by termites, and it is thus unlikely that any works in the exhibition are more than one hundred years old. However, evidence that an object had been used time and time again suggests that it had been effective and successful in fulfilling its function. Such evidence, which may include a patina from the repeated application of palm oil, signs that a mask had been frequently worn, a renewal of magic materials, or marks caused by handling and rubbing, provides insight into how an object was regarded in its own culture and thus served as an important point of reference in the selection process. Even though these works could never carry the same meaning for us as they had for their creators, owners, and users, it was necessary to learn as much as possible about the purposes they served within their societies, and this information has been included in the catalogue entries.

Although this exhibition cannot be regarded as a survey of the major style areas of Africa, the objects represent three principal factors that underlie the creation of African art. First, art is used to transmit the laws, moral codes, and history of each group to its young. Among most African peoples, boys—and in some cases girls—are sent away from their villages to attend bush schools for varying periods. There they are taught about the ethics, values, religion, and traditions of their culture that will enable them to become responsible adult members of their community. The art form most often used for this instruction is the mask, which may represent any number of significant figures within the traditions of the group, including ancestors, powerful spirits, cultural heroes, and important past or present members of the society. Figure sculptures are occasionally used for this purpose as well.

Second, African art serves to facilitate communication between people and supernatural forces and beings. Objects made to fulfill this function are chiefly in the form of human or animal figures. They are given their powers by religious practitioners who are able to make contact with the spirit world and to work with magic. Sculptures of this nature serve such essential purposes as warding off disease, natural calamities, and other evil; bringing fertility to people, animals, or crops; and rendering difficult judgments. They are frequently rubbed with palm oil and coated with other potent materials both to imbue them with their magical powers and to maintain their effectiveness. Certain large sculptures in this category are invoked to assure the general well-being of the entire community. Smaller examples are used by individuals to bring similar benefits to themselves and their families.

Art is also made in Africa to indicate the wealth and status of its owner. Objects of daily use such as neck rests, stools, cups, boxes, staffs, and pipes are carefully carved to proclaim the taste and social position of those who use them. Much of this art is purely decorative, made to be seen and casually admired by all members of the community. Other examples serve to signify that their owners have undergone the process of investiture to become rulers and are therefore entitled to the prerogatives of leadership.

Art plays an essential role in the lives of the African peoples and their communities. It serves a much more vital purpose than merely to beautify the human environment, as art is usually employed

in contemporary Western societies. The beauty of African art is simply an element of its function, for these objects would not be effective if they were not aesthetically pleasing. Its beauty and its content thus combine to make art the vehicle that ensures the survival of traditions, protects the community and the individual, and tells much of the person or persons who use it.

In this catalogue, the use of past or present tense in the entries is intended to indicate whether the philosophies that produced the objects remain alive. Most of the entries are accordingly written in the present tense, for although the majority of the works were collected over fifty years ago and many changes have been occurring in Africa, the traditional values, systems, and motivations for creating art often still hold force.

In addition, the recently adopted practice of dropping the prefixes "Ba-" and "Ma-" from the names of the Bantu-speaking peoples has been followed. In the Bantu language, "Ba-" or "Ma-" means "people," and the use of these prefixes with the name of a group, such as Kongo or Luba, is therefore redundant. It should also be noted that geographical terms referred to in a historical context are those that were in use at the time being discussed. Furthermore, in accordance with standard practices, the placement of the various groups on the maps in this catalogue is intended to indicate their approximate locations and not to define their exact boundaries.

A major source for information on the location and populations of various groups was George Peter Murdock's *Africa: Its Peoples and Their Culture History* (1959). Material has also been drawn from published studies of particular African styles. Much of the general history of the early years of the formation of The University Museum's African collections was drawn from Percy C. Madeira, Jr.'s *Men in Search of Man* (1964), which was published to commemorate the seventy-fifth anniversary of the museum. Documentation from correspondence and other primary sources was found in The University Museum Archives and in accession files in the Registrar's Office; citations for quotations from specific records have been abbreviated in the text and appear in full in the Bibliographic Abbreviations at the back of the catalogue.

History of the African Collections of

The University Museum, University of Pennsylvania

Africa was not foremost in the minds of the prominent Philadelphians who met in 1887 and contributed funds to establish the institution that would one day become The University Museum of the University of Pennsylvania. An interest in archaeology had instead provided the impetus, and the money raised was used for an expedition to Nippur, the ancient Babylonian city. The finds from that expedition were to become the property of the university, provided that it could "'furnish suitable accommodation for [them] . . . in a fire-proof building'" (quoted in Madeira, 1964, p. 16). Two years later, the Department of Archaeology and Palaeontology was formed with the intent to offer instruction in archaeology, ethnology, and palaeontology and to establish a museum and a library; the department was financially dependent on the University Archaeological Association, the citizens' group that had been founded to fund and promote interest in expeditions and other work in the study of man. By 1890, forty thousand dollars had been raised, and there were twelve thousand objects on view in the museum that had been established in the new university library building. During these first years, numbers of works came into the collections from Asia, the Near East, the Mediterranean, and pre-Columbian America. The few African works that were acquired at the time were not important, and they were overshadowed by the more spectacular archaeological discoveries and the stories that went with them.

In fact, no African objects of any significance entered the collections of the University of Pennsylvania until 1891, when a group of 117 examples of art and ethnography from Gabon was presented by the Reverend Robert Hamill Nassau. Nassau, a member of the Presbyterian Board of Foreign Missions, had served in Africa from 1861 to 1891. After 1874 he lived in Lambaréné, Gabon, and became an authority on the Fang people with whom he worked. On his return to Philadelphia, he gave most of the Fang objects that he had assembled to the university's museum. (Several others were given later by the prominent Philadelphia surgeon Dr. Thomas G. Morton [see no. 29].) Nassau also wrote the African section in the catalogue of the Department of Archaeology and Palaeontology's exhibition *Objects Used in Religious Ceremonies,* which was organized in 1892 by Stewart Culin, the first Director of the museum (see Culin, 1892, pp. 164–68). Works from different parts of the world that had been collected by missionaries were shown, many of them lent by the Presbyterian Board. Three of the African objects, which are described in the catalogue as idols, were gifts from Nassau to the museum (ibid., pp. 166–67, nos. 714–16).

In the same year that Culin organized his exhibition, the missionary Matthew Henry Kerr, an architect from the Germantown section of Philadelphia, was sent by the Presbyterian Board to build mission stations in Africa. There Kerr worked with the Bulu in the southern Cameroons until 1899. During the seven years of his service, he, along with his fellow missionary Dr. Adolphus C. Good, translated a hymnal and the Four Gospels into the Bulu language. Although Kerr did not bring back much material from the Cameroons, one sculpture (no. 28) from his small collection was given to the museum many years later by his daughter-in-law.

During the next few years African objects came into The University Museum sporadically until, in 1899, the flamboyant big-game hunter Arthur

Donaldson Smith lent 145 ethnological items he had collected in Somaliland and "the Galla country." The minutes of the museum's Board of Managers of that year, however, record that there was no provision for their adequate exhibition. Perhaps because of this, Smith removed almost all of the loans in 1901, and the museum purchased the twelve he left behind. A happy ending was nevertheless achieved in 1914, when the museum purchased, for a nominal figure, some four hundred objects that Smith had collected in the 1890s in Abyssinia and the northeastern Congo Free State (which became the Belgian Congo in 1908 and today is known as Zaire).

The year 1899 was also when Henry Ling Roth, an English adventurer and dealer from Halifax, gave the museum nineteen objects from Benin City that had been collected on the Punitive Expedition led by the British against the Nigerian kingdom in 1897. These works were all bronze bracelets of more ethnographic than artistic interest, and Roth published them in 1899 with comparable examples from other collections (see Roth, 1899). His gift proved to be portentious, for it provided the nucleus for the great Benin collections that were later sold to The University Museum by the London dealer William O. Oldman, most of which had also been part of the 1897 booty.

Another missionary who played a role in the formation of the museum's African holdings was the Reverend W. H. Leslie. In 1905 Leslie, who had worked in the lower Congo River area among the Kongo at the beginning of the twentieth century, presented about one hundred objects to the museum, including a Yombe dance staff (no. 42). He had apparently allowed the museum to pay part of his expenses in Africa, and in return agreed to give some of the material he had collected.

It can thus be seen that almost all of The University Museum's early African collections came from missionaries or adventurers who had gone to the continent for their own purposes. None of the objects had been gathered systematically, nor did any have much documentation concerning their use and provenance. This situation was unfortunately to be the case with the bulk of the museum's African holdings.

In 1907 W. O. Oldman wrote the first of his many letters to the museum. From that time, practically until his retirement in 1927, this renowned dealer in "Ethnographical Specimens,

Eastern Arms, &" maintained a steady flow of lists of available objects, descriptive letters, catalogues, invoices, and objects themselves between his office and Philadelphia. He became the single most important source for the museum's African collections, and he also supplied it with Melanesian, Polynesian, and Indonesian works as well as Tibetan objects, Far Eastern weapons, and American Indian and Eskimo artifacts.

Oldman was well known to collectors and museum curators in Europe and parts of the United States from his series of mailings showing objects in his stock with brief descriptions and prices. Over a period of eleven years, he sent one of these mailings a month, and through this channel he became a chief supplier of ethnographica and what would become known as "primitive" art. Today he is memorialized by his great private collection of Polynesian art and artifacts, many of which are documented as having been collected in the late eighteenth and early nineteenth centuries. Oldman had quietly gathered these objects during his active years as a dealer, and in a letter to The University Museum's Curator Henry Usher Hall dated December 3, 1930, and marked "Private & Confidential," called it his "life secret" (Oldman Correspondence, 1930–39). He finally sold the collection to the New Zealand government in 1948, the year before his death, reputedly for fifty thousand pounds. It is now among that country's national treasures, spread equally among the museums of Auckland, Christchurch, Dunedin, and Wellington. Interestingly, in his letter to Hall of December 3, 1930, Oldman had shown his loyalty to The University Museum by offering it his Polynesian collection for fifty-five thousand pounds. Unfortunately for Philadelphia, the sum was far beyond the museum's modest budget for acquisitions.

The first Oldman shipment to The University Museum was, in fact, of Oceanian specimens. It was sent in 1908 but not actually purchased until three years later. Over the years Oldman would become used to these protracted negotiations, and most of the time he showed remarkable patience awaiting payment. In 1911 the first African objects arrived from Oldman: three Epa festival headdresses from the Yoruba of Nigeria (see nos. 15, 16), which were purchased a year later for forty-one pounds and were among the first masks of this type to come into an American collection.

The interest the museum displayed in Oldman and other European and American dealers of the time was largely brought about by George Byron Gordon, who was appointed Director in 1910. Gordon was a Canadian with a proper British manner who had joined the staff of the museum in 1903 as Assistant Curator of the Section of General Ethnology and American Archaeology. As curator he distinguished himself through the publication of scholarly articles on such topics as the western Eskimo (among whom he had also done fieldwork), an analysis of an engraved bone from the Ohio Mound Builder culture, and a study of the serpent figure in pre-Columbian art. He also made a trip to the Yucatan in 1910, just after taking up the directorship, a post he held until his death in 1927. This seventeen-year span was the most important period for the formation of both the African and Oceanian collections of The University Museum; of the eighty-eight objects in this exhibition, for example, sixty-five were acquired either during his tenure or as a result of it. However, what Gordon did for the African holdings comprises only a small part of his legacy to the museum.

The year 1912 proved to be very important in the history of the African collections at the museum. First Oldman sent a group of sixty Benin objects that were part of the famous collection of the British General Augustus Pitt-Rivers, which had been brought out during the Punitive Expedition of 1897. When these works were combined with the group given by Roth in 1899, the museum suddenly had a specific concentration of African objects of similar provenance. The Pitt-Rivers material was purchased from Oldman for 335 pounds.

The dealer also wrote to Gordon on February 19, 1912, about his work over the years "in gathering a very complete Ethnographical Collection to represent Africa." In the price notice enclosed with his letter Oldman said the collection had been

> carefully selected avoiding any *actual duplicates* & every specimen is as perfect & old as possible. . . . Comprises about *2,000* objects in all . . . forming an important & very complete Collection not likely to be Ever got together again, as a great number of these pieces were gathered some years ago when specimens came on the market frequently. Now it is very seldom anything good is to be secured at all. (Oldman Correspondence, 1908–16)

Oldman himself would prove the latter statement untrue many times over, but he was, after all, a

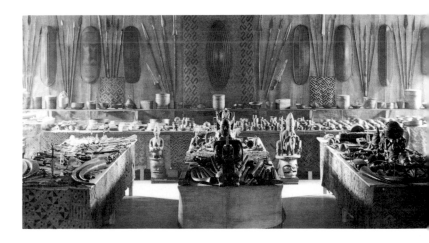

The African collections as installed at The University Museum in 1913. Two of the Epa festival headdresses purchased from W. O. Oldman the previous year (see nos. 15, 16) are on the floor in the center (negative 22446, UMA).

George Byron Gordon, whose tenure as Director from 1910 to 1927 was the most important period in the formation of the African collections at The University Museum (negative 19137, UMA)

dealer. His asking price for the lot was 865 pounds, although the museum finally paid 770 pounds. The items were mostly from West Africa (see nos. 20, 24a, 25, 41, 52), but some from the east and south were also included.

Also featuring prominently in the early history of The University Museum's acquisition of African art

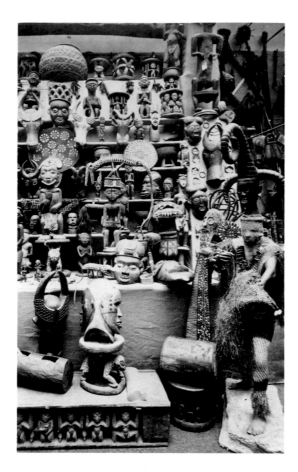

The J.F.G. Umlauff shop in Hamburg filled with objects from Africa, including a skin-covered headdress (at right) similar to one in The University Museum (no. 22). Several of these objects are now in the Field Museum of Natural History in Chicago. From J.F.G. Umlauff, *Völkerkundliches Institut und Museum, Hamburg, Kamerun Sammlung, Bali, Bamum* (Hamburg, c. 1913) (negative 137245, UMA)

A collecting expedition in Africa sponsored by the Hamburg firm of J.F.G. Umlauff. From J.F.G. Umlauff, *Völkerkundliches Institut und Museum, Kurze Erklärung zu den Katalogen no. 222 und 223 der Kamerun-Sammlung* (Hamburg, May 1914), cat. 223, pl. 141 (negative 137052, UMA)

was the German firm J.F.G. Umlauff, which had a shop in Hamburg that was actually called a museum. Like Oldman, the firm promoted its stock by sending museums its catalogues and photographs, which often showed its rooms absolutely crammed with extraordinary examples of African and Oceanian art. In 1912, while on a visit to Hamburg, Gordon purchased from Umlauff a group of 1,827 objects that had been collected between 1904 and 1906 by the great German Africanist and ethnographer Leo Frobenius. (Frobenius would later complete important studies on the Kuba and their art and form significant collections of African ethnography for the Museum für Völkerkunde in Berlin and other German museums.) The material that Gordon bought had been gathered on Frobenius's first expedition to Africa, which took him to the Kasai and Congo river basins in the Congo Free State. His trip had been supported by two Berlin foundations as well as the Museum für Völkerkunde in Hamburg, for which he was collecting. The objects that The University Museum acquired had been deemed surplus by the Hamburg museum and turned over to the Umlauff shop for sale. The Philadelphia museum purchased the collection, thus suddenly gaining another comprehensive group of African works from one area with an excellent provenance and an early collection date (see nos. 44, 45, 47, 53b, 54–56, 59a,b, 64). The price, described in the firm's letter to Gordon of July 1, 1912, as "very cheap," was twelve thousand marks. The dealer told Gordon that he had received such a bargain because when he was at the shop in Hamburg "in the room there was really placed two collections and the seller asked you by a blunder the price for one, so you get two collections paying only for one" (Umlauff Correspondence, 1912–14).

Emil Torday is another great name from the early years of African ethnography and collecting. Working with the Kuba in the Congo Free State between 1900 and 1907, he conducted the first chronological studies of Kuba sculpture and formed a large Congo collection for the British Museum in London. In 1913 he served briefly on the staff of The University Museum as Assistant for Africa in the Section of General Ethnology. During his stay he researched and wrote on the Frobenius material (see Torday, 1913). Before he left, he sold the museum his own small Congo collection, including a Pende cup (no. 51).

The name "The University Museum" was also officially adopted in 1913. Until then the museum had been known by a number of names: The original Department of Archaeology and Palaeontology and the University Archaeological Association merged into the Department of Archaeology; the new museum building, which opened at the turn of the century, was called the Free Museum of Science and Art. Gradually, by the first decade of the twentieth century, it had become popularly known as The University Museum, which the 1913 decision of the Board of Managers finally formalized.

The following year Henry Usher Hall joined the museum staff. Hall's interests first took him on an ethnographical expedition to Siberia. He was subsequently appointed Assistant Curator in the Section of General Ethnology in 1916, but then spent the next two years with the American forces in Europe during World War I. On his return in 1919, his duties at the museum covered the full range of the ethnographical collections (he served as Curator from 1924 to 1935), and he was also able to conduct fieldwork in prehistoric archaeology in the Dordogne Valley in France in 1926. Nonetheless, his major interests remained focused on Africa.

The combination of Hall's expertise and scholarship and Gordon's contacts and enthusiasm resulted in the acquisition of the major part of The University Museum's African collections during the years the two men were at the institution together. Hall wrote extensively about the collections in museum publications (see Hall, 1917; 1919; 1920; 1922; 1923, "Notes on Woodcarvings"; 1923, "Woodcarvings"; 1924, "Cups"; 1924, "Fetish"; 1926; 1927; 1931; 1932), and although some of his conclusions have been superseded by more recent research, he was one of the pioneer American scholars in African art. The articles he wrote between 1917 and 1932 provide excellent evidence of the state of knowledge of African ethnology and anthropology at the time.

By 1917 the museum had begun to seek examples of African sculpture from somewhat more selective sources than Oldman and Umlauff. Objects from little known and "exotic" cultures were becoming accepted as art rather than as curios or ethnographica that belonged only in museums of natural history or anthropology. African works began to appear in European and American art

Henry Usher Hall, who served in The University Museum's Section of General Ethnology as Assistant Curator from 1916 to 1923 and as Curator from 1924 to 1935, and conducted the museum's expedition to Sierra Leone in 1936–37 (negative 19139, UMA)

galleries. Usually, however, they were not major components of exhibitions, but instead served as juxtapositions or sidelights to the theme of a show. At the time few American and European dealers displayed African art exclusively, and it was most often found in galleries that specialized in ancient Near Eastern and Oriental art, undoubtedly because they were already known for showing "unusual" objects. Dikran Kelekian was the proprietor of one such establishment in New York, and he had already sold a number of Egyptian and Assyrian objects to The University Museum when, in 1917, he sent a group of African sculptures as well. A few of these were purchased, including a small Kongo male figure (no. 37).

In 1919 Gordon, on a trip to Paris, visited Arts d'Asie, the gallery run by H. Vignier. It was known to specialize in Chinese art, but objects from Oceania and Africa were featured as well. Gordon had nineteen examples of African sculpture from the gallery sent to Philadelphia for purchase. However, over two years passed before the sale was completed, and during the interim Vignier tried to double his original price of 91,500 francs, but Gordon remained firm and the deal was finally

closed. Object for object, it was the best single purchase of African art outside of Benin the museum made.

Vignier was well known among the early collectors of so-called primitive art and, judging from the works in The University Museum shipment, assembled objects of very high quality, including the great Luba stool (no. 62), the Luba bowl bearer (no. 63), and possibly the female figure from Brass (no. 26). There seems also to have been some connection between Vignier's gallery and Carl Einstein, who in 1915 published the first significant book on African art, which illustrates a sculpture (no. 36) that Vignier sold to The University Museum (see Einstein, 1915, pl. 46) and another (no. 26) that may have come from this dealer (see ibid., pl. 51).

Throughout these years Oldman had maintained his contact with The University Museum, and in 1920 he sent yet another group of objects brought out of Benin City in 1897, this time by Colonel Maximilian John DeBathe. The shipment also included Benin carved elephant tusks from the collection of Henry Lyne of London, which were part of the spoils of the Punitive Expedition as well. The entire lot was acquired in 1921 for 765 pounds.

In 1920 the museum also began two long-term negotiations that would eventually greatly strengthen its African holdings. The first of these transactions again involved Oldman, who had bought a collection of eighty-four objects that the Belgian Captain C. Blank, who lived in Uccle, a suburb of Brussels, had gathered during a tour of duty in the Belgian Congo just prior to 1920. Included were a number of small magic figures from the lower Congo River region (see no. 38); on March 20, 1922, Oldman wrote to Gordon that "these fetishes are getting exceedingly difficult to find now & the prices they realize are out of all proportion to those of a year or so ago" (Oldman Correspondence, 1921–22). Oldman's asking price for the Blank collection was 345 pounds, and Gordon had the group sent on. However, the museum had an unusually hard time raising the money for the purchase. Oldman was willing to be patient for a while, but in frustration wrote to Gordon on July 27, 1922,

> . . . If you are quite unable to keep them after this long spell there is no alternative but to let me have them back.—As a matter of fact, I should not mind having them as they are a particularly fine old lot and I find it is next to impossible to get such pieces

> now & there is a considerable amount of interest now being taken in African Art. (Oldman Lists, 1921–28)

Fortunately the collection, with the exception of eighteen objects that were returned to Oldman, was purchased in 1924 (see nos. 38, 46, 49, 50, 53a, 57, 60a–c, 65a,b, 66). Although Oldman continued to maintain his contacts with the museum, these were the last African objects to come from him.

Henry C. Mercer was at the center of the second set of protracted negotiations involving African art that began in 1920. Mercer was one of the early benefactors of The University Museum, having served on the Board of Managers from 1891 to 1899 and receiving the appointment as Curator for the Section of American and Prehistoric Archaeology in 1894. He carried out some archaeological work for the museum in the Yucatan in 1895, but nevertheless was restless and wanted to start his own museum. He was particularly interested in American tools and machines that had been made in the era before steam power, and in 1914 began construction of the Mercer Museum in Doylestown, Pennsylvania, to display the thirty thousand objects that he had amassed, including American boat models, mining and nautical equipment, farm implements, spinning wheels, and cradles.

Although Mercer's major focus was Americana, he actively collected objects from other cultures as well, including China. In 1920 he became involved in the formation of The University Museum's African collections when he began to consider funding Amandus Johnson's proposed expedition to Angola to collect tools and implements from the Ambundu and neighboring peoples. Because of his long association with The University Museum, Mercer intended to share part of what Johnson collected with that institution. In his quite specific instructions outlined in a letter of September 4, 1922, addressed "To Whom It May Concern," Mercer asked Johnson to add to his museum's exhibitions "of the history of Human Industries" by bringing back from Africa objects

> illustrating in general the following Native Industries, namely—Tools, implements, etc., pertaining to Agriculture, Net Making, Salt making, Food preparation, cookery, etc., Mining, Reduction of Metals, Particularly of Iron, Smelting, Smithing, Casting, etc., Steel making, etc., Skin

dressing, Textile making, Cloth making, etc., Carpentry, Wood working, Stone quarrying and working, House building, etc., Transport, Boat making, Pottery, Domestication of Animals, Harness making, etc. (Johnson Correspondence, 1908–23)

Johnson was a Minnesotan of Swedish heritage who had received a Ph.D. from the University of Pennsylvania in 1908. He was appointed an instructor at the university in 1910, and shortly afterward was awarded the chair in Scandinavian languages, a post he held until 1922. In 1920, however, he suffered the loss of his papers and library in two fires that left him unable to teach. He therefore looked upon the possibility of an expedition to Africa as an opportunity to get away from his problems at home.

Mercer finally agreed to fund the expedition, which Johnson described on his letterhead as "The Educational West-African Expedition, 1922–1924, Directed by Amandus Johnson, Ph. D., Lit. D." Johnson had also agreed with Gordon to collect ethnographical and archaeological material for The University Museum, although the museum made no commitment to purchase any object until it had been examined. The Staatliches Museum für Völkerkunde in Munich also had Johnson under contract at the same time.

Johnson set out on his expedition in 1922 and remained in Angola for two years. Although on February 1, 1924, he wrote to a Professor Crawford in Malange, Angola, that his "stay in Africa has been pleasant and profitable in some ways" (Johnson Correspondence, 1924–61), he in fact had encountered considerable problems. In addition to hunting and collecting, Johnson wanted to shoot ethnographic and hunting motion pictures. For this purpose he had enlisted a character named J. Allen Ewertz. During the course of their travels in 1923, Ewertz absconded with all the films, leaving behind sixteen containers that he had filled with stones so that the theft was not discovered until some time after he had disappeared. Ewertz apparently used several aliases, which Johnson listed in a letter to the Reverend Robert Shields on September 6, 1923, in which he also called Ewertz an "arch liar and master thief," a "contemptible mouth-piece," and a "miserable worm," among other things (Johnson Correspondence, 1908–23).

For his part, Ewertz wrote to Gordon on

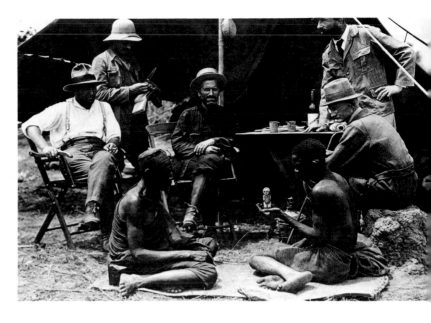

Postcard produced by Amandus Johnson (in helmet, second from left) showing his camp in Angola, c. 1923 (negative 136729, UMA)

December 27, 1923, accusing Johnson of taking the trip under false pretenses and

not due to any enthusiasm relating to Entnographic [sic] discoveries or collections, Dr. Johnson simply intended in company with a German Mr. Freyberg and myself to lift a cache of Diamonds which the above mentioned German buried in Africa years ago. The collections and taking movie film was [sic] to cover up the real game. The plans failed when Dr. Johnson started to fight with the German accusing him of stealing cartridges. (Hall Correspondence, 1917–23)

Ewertz suggested Gordon contact others who would corroborate his account, and included their names and addresses. However, no response to this letter appears in The University Museum's files, and Gordon evidently accepted Johnson's version of the incident.

On February 28, 1924, Johnson also wrote to Horace Mann, Secretary and Assistant Curator of the Mercer Museum, of other difficulties he was facing in Angola. He said that he had brought seven loads of objects from the Kisama country to a storehouse where they were kept while he was off on another excursion. Upon his return, Johnson found that "the white ants had eaten them all except some pots!!!!" (Johnson Correspondence, 1924–61).

When it came time for Johnson to pack and ship his materials to Mercer, Mann wrote to Johnson on

December 12, 1923, that he and Mercer felt that the price of the items "should be based first on the original cost to the natives," to which should be added the expenses of shipping as well as "a reasonable or even generous margin or commission" for Johnson. However, Mann warned, "such prices as dealers obtain by manipulating the market among collectors and faddists would not apply" to the objects Johnson had gathered, "nor would there be any reason to place an exorbitant price on them because of their rarity in United States" (Johnson Correspondence, 1908–23). Quickly taking offense (with justification), in his February 28 letter to Mann Johnson described his interests in collecting as being "entirely scientific" and not monetary. " . . . [W]hat you evidently for get," he wrote, "is that you have to do with a scholar . . . " (Johnson Correspondence, 1924–61). The various problems Johnson had faced during his two years in Angola caused him to write from Loanda on February 25, 1924, to his friend Colonel Henry D. Paxson (also a board member of the Mercer Museum) that "I now long to be back in dear old Philadelphia. If all the grumblers and growlers over there could be sent to Africa for fifteen months or more, they would return good citizens, and be satisfied and content for the rest of their lives" (ibid.).

Johnson finally sent a large number of objects to Mercer in twenty-five cases. He also recorded stories and gathered information for his *Mbundu English-Portuguese Dictionary with Grammar and Syntax* (Philadelphia, 1930) and a book of his experiences entitled *I Marimbans Land* [In the Land of the Marimba] (Stockholm, 1929). Johnson spent the years following his return lecturing and showing his films of Angola (which he finally recovered from Ewertz) in the United States and Sweden. In one of the flyers announcing his lectures on Africa, he is described as having "the rare ability of 'combining scholarship with popular presentation,' and he never fails to hold his audience. Press notices of his lectures have always been most flattering" (Johnson Correspondence, 1924–61).

For the next several years Mercer maintained a correspondence with Gordon over the disposition of the material Johnson had collected. The two men had a difficult time agreeing about which parts of the collection would remain in Doylestown and which would go to Philadelphia, and it was not until 1927, after Gordon's death, that Hall was

finally able to purchase part of it for The University Museum. Mercer retained such objects as tools, weapons, musical instruments, and items of daily use, while The University Museum acquired, for four hundred dollars, sculptures, prestige objects, and masks (see nos. 43, 67, 68, 70a–c).

Jack L. Buck, the renowned animal collector, also had dealings with the museum in the 1920s. While he was in the field in Africa trapping and securing live animals for shipment to zoos and circuses in America, he also kept an eye out for art and ethnographic specimens. At various times in 1923–25 he was in Sierra Leone among the Mende people. In a letter to Hall dated March 20, 1925, he said, "I stand very well with these fellows (I can take my teeth out & put them back in) and I shall secure any thing that I think you can use . . . " (Hall Correspondence, 1924–26). Buck sold a number of small Mende stone images to the museum, and collected native textiles in Sierra Leone as well. He was also the source for the fine Temne female figure (no. 5) that is one of the museum's best known African works.

In 1926 The University Museum paid twenty-five hundred dollars for eighteen African objects from the estate of John Quinn, a New York attorney who had been one of the founders of the Armory Show of 1913. He had collected early twentieth-century European paintings, but had also become interested in African art, largely through the influence of Alfred Stieglitz, from whom he bought some of his paintings. Quinn had been a regular visitor to Stieglitz's gallery 291 on Fifth Avenue in New York. Beginning in 1914, Stieglitz organized a series of exhibitions of African sculpture in which the objects were shown as art and not ethnography for the first time in America. Most of Quinn's African works, including a Senufo *kpelie* mask (no. 9) and an Igbo maiden mask (no. 24b), are said to have been purchased from these shows.

In January 1927 The University Museum suffered a profound loss when George Byron Gordon died suddenly from injuries sustained in a fall following a dinner at the Philadelphia Racquet Club. This brought a sudden end to the fruitful collaboration between him and Henry Hall that had so benefited the museum's African collections. The next Director, Horace H. F. Jayne, a specialist in Chinese art, would not be appointed until 1929, but by the time of Gordon's death Hall was well suited to the task

of acquiring additional objects on his own.

Hall began negotiations in 1928 to purchase a collection of eighty-two objects, most of which were African, owned by Lena H. White of Chicago. White had acquired the group from a French tobacconist named Tessier, who had assembled it as a hobby during the early part of the twentieth century. She originally wanted to sell the entire collection to The University Museum for nearly seven thousand dollars, a figure arrived at through an appraisal made by Alain LeRoy Locke of Howard University in Washington, D.C. Locke, a black connoisseur of and pioneer writer on African art, based his valuations on prices realized in the sale of part of the Blondiau Theatre Arts Collection of Primitive African Art in New York in 1927. In his appraisal, dated November 7, 1928, Locke noted that a number of the White objects were "primarily of artistic interest and value, and others primarily of ethnographic interest," and suggested that the collection was therefore particularly suitable for an institution like The University Museum, which showed works of both sorts (Hall Correspondence, 1927–28).

Hall also wrote to Fay Cooper-Cole of the Department of Sociology and Anthropology at the University of Chicago, asking her opinion of the White collection. She replied on October 25, 1928, that "it is what we would call a *collector's* rather than a Museum exhibit. With a few exceptions the individual pieces are fine, old, and rare. It would fit into an African collection, or it would serve to illustrate African art, but in itself it tells no story" (ibid.). Hall decided not to purchase the entire group, but was able to persuade White to send a selection of twenty-eight masks to the museum, for which she asked twenty-five hundred dollars.

White was impressed with The University Museum's African collections and pleased with the idea that some of her objects might be part of them. On September 23, 1929, she wrote to Hall, "I believe you have the choicest and most interesting collection of African sculptures I have as yet seen, and I may add, strengthened by my masks—(I agree with you) that you would have the most eminent collection of all, easily surpassing the British Museum in important pieces" (ibid.). The sale was completed that year, and those masks purchased from the White collection include two excellent Guro examples (nos. 11, 12) and an unusual Gabonese mask of undetermined origin (no. 34).

In 1928 Hall was also contacted by J. Noble White about the purchase of African objects for the museum. White had been a missionary in the Belgian Congo during the 1920s, and while there had put together a collection of some 750 objects, including figure sculptures, instruments, items of ceremonial and daily use, and animal and snake skins. When he returned to the United States he formed a traveling exhibition of his collection, which was shown at educational institutions in the South. The accompanying brochure described its acquisition "at a cost of—Not Money—but, a purchase price; perils, hardships, time, some money, and finally Black Water Fever, all to gratify a personal satisfaction of realizing a life's dream" (ibid.). In Africa White had worked with the Tetela, who live north of the Songye. He planned to prepare a dictionary of their language and to write a book, "The Mind of the Atetela," but neither was ever realized. During the course of his correspondence with Hall between 1928 and 1930, he suggested more than once that he might like to work at the museum.

The price J. Noble White was asking for his entire collection was ten thousand dollars, and he had the major objects photographed for Hall's consideration. In the end Hall wanted only one of the works, the squatting female figure (no. 61) that White had called the "Otetela idol" in a letter to Hall of March 11, 1928 (ibid.). During the negotiations, White wrote to Hall on October 24, 1930, that "a Southern manufacturing concern has had communication with me in the hope that I will sell the idol to them to be used as a 'Trade-Mark' for one of their products having the name of 'Black Beauty.' I have refused to consider any offer made by them." In the same letter he referred to the sculpture as "probably the most valuable object in the entire collection," but indicated his willingness to sell it for five hundred dollars (ibid.). Hall offered three hundred dollars, and it was purchased that year for four hundred dollars.

The University Museum was approached about the purchase of another large collection of African sculpture when the French dealer J. Laporte of Bordeaux wrote to Horace Jayne in 1929. Jayne asked René Verneau, who had been a curator at the Musée d'Ethnographie du Trocadéro in Paris (now the Musée de l'Homme), to travel to Bordeaux and evaluate the collection. Verneau agreed, and wrote back to recommend the purchase.

The museum bought a total of 265 objects from Laporte for 190,000 francs (then the equivalent of $7,434). Fifty-eight Kota reliquary guardian figures were among them (including nos. 30a–c), as well as a group of masks from Gabon (see nos. 32, 33a,b [for other Laporte objects see nos. 1, 7]). Also included were a large number of masks and figure sculptures in the Baule and Senufo styles from the Ivory Coast. Objects of these expressions were especially popular in Paris at this time, and quite an industry developed in the Ivory Coast and even in the French capital itself to supply the burgeoning market. Unfortunately, all of the Laporte Ivory Coast objects fall into this category. Margaret Plass illustrates some of them in her 1957 handbook of The University Museum's African collections (see Plass, 1957, pp. 11, 12, 16), at one point remarking that "the cult for uncritical evaluation of Negro sculpture, christened 'nègrèrie' by William Fagg of the British Museum, has often been fed by false enthusiasm for these most easily liked figures and masks . . . " (p. 17). Despite these weaknesses in the Laporte collection, however, the quality of the Gabonese material the museum purchased was sufficient to justify the sale; in fact, even the Ivory Coast objects are interesting today as documents of the tastes in African sculpture that prevailed at the time.

The Laporte sale represented the last major group of African objects that the museum purchased. The days of buying entire collections or even selections from them had mostly ended. Prices were rising, and whereas earlier Philadelphia had largely had the field to itself in America, competition from other museums was increasing. The University Museum did maintain its contact with New York dealers, and a few significant single acquisitions were made in the 1930s. They include the rare Kota half-figure (no. 31), which was bought from Jan Kleycamp, a dealer in Chinese art, in 1930 for about 150 dollars, and the fine Senufo door (no. 8) and great Chiloango River region nail figure (no. 39), which were purchased from the antiquarian Sumner Healy in the same year, the door for 800 dollars.

The history of the African collections at The University Museum from the late 1880s to the early 1930s reveals one surprising fact: This museum, which had established its reputation by sending expeditions to such places as Iraq, the Yucatan, Egypt, Peru, Siberia, China, Japan, and Palestine as well as throughout North America, had not organized one expedition to investigate any part of sub-Saharan Africa despite all the effort that had been put toward purchasing objects from the continent.

Henry Hall was eager to go to Africa, but funding was always a problem. Several of his quite ambitious expedition plans had to be abandoned, and the possibilities must have seemed hopeless in 1935, when Hall retired and his position as Curator of the Section of General Ethnology was abolished because of "unavoidable economic conditions," as Jayne later described the situation in a letter of introduction he drafted for Hall on September 29, 1936 (Hall Correspondence, 1936–40). It is ironic that the museum chose to suspend the operation of African department just then, for with the organization and display of James Johnson Sweeney's precedent-setting exhibition "African Negro Art" at the Museum of Modern Art in New York that very year (see Sweeney, 1935), 1935 is now seen as the moment when the appreciation of African art had finally become fully sanctioned by the American art museum establishment. The University Museum had in fact lent three objects to Sweeney's exhibition (see nos. 8, 36, 39).

Just before he retired in 1935, Hall had contacted the American Philosophical Society in Philadelphia about underwriting the costs of an African expedition, and in 1936 he approached the society with the idea of funding a trip specifically to the Sherbro of Sierra Leone. In explaining the purpose of his proposed expedition in a letter to Jayne of June 12, 1936, Hall wrote that the Sherbro

> are said to have preserved their older customs and way of life in general better than most other Sierra Leone peoples, who, in the northern part of the country . . . have been considerably Mahomedanized. . . . [T]hey belong to the older stratum of populations in this part of Africa, to a type which has resisted, or otherwise escaped, subjection to powerful West African kingdoms, . . . and a study of their institutions may be expected to add to our knowledge of the more primitive types of cultures on which monarchism was imposed. (Hall Correspondence, 1936–40)

The Philosophical Society awarded Hall two thousand dollars for his Sierra Leone expedition, and an anonymous donor added another five hundred dollars. The University Museum offered to help by auctioning objects from its African

collections that had been judged surplus. On April 16, 1936, a sale of ninety-seven African works was held at the Barclay Hotel in Philadelphia to benefit Hall's expedition. Most of the objects sold, and the museum was able to add almost three thousand dollars to the expedition fund. It is evident from the illustrated brochure of the sale (see University Museum, 1936) that the museum did not dispose of much that was of prime importance. One mistake was made, however. A bronze head, which was thought to be late Benin, has since been found to be a seventeenth-century work from the Nigerian town of Udo, where a significant bronze-casting style had developed. Nonetheless, the benefits the museum received from Hall's expedition far outweighed the loss of this and other objects in the sale.

Accompanied by his wife, Hall sailed for Freetown, Sierra Leone, arriving in November 1936, and from there went to the town of Bonthe on Sherbro Island. He worked at various places on the island with the assistance of missionaries, colonial commissioners, and most importantly, the chief at Yoni, who was the most powerful ruler on the island. Through him Hall found a good interpreter and was able to contact elders, who could tell him what they remembered of earlier times and customs. Following his stay on the island, Hall spent time on the mainland, principally in the towns of Bendu and Shenge. Among the aspects of the culture he recorded were lineage and family systems, medicines and antidotes, and beliefs, especially investigating the all-important men's secret Poro Society.

Hall collected about three hundred objects from Sierra Leone, including costumes, objects of daily use, figure sculpture, and a large number of women's Sande Society helmet masks (see nos. 6a,b). Although he remarked in a letter to Jayne of January 3, 1937, that it was "a poor country and the people are not rich in material goods" (Hall, 1937, p. 13), he seems to have been presented at least once with more objects than he could handle, as Mrs. Hall reported in an undated entry in her Household Book, a diary she kept during their stay:

> Before leaving Yoni, word went out that Harry was purchasing native things, we were nearly swamped by the no [number] of people, flocking, from all over the island. So many arrived in the morning that they had to display their things out side, H. would walk slowly by, make a selection, then these were

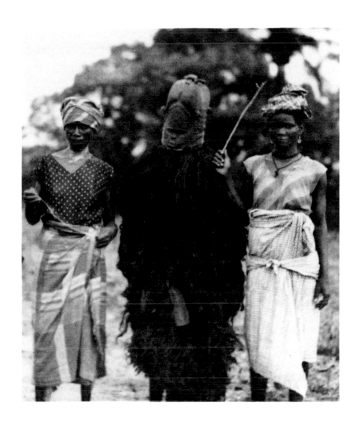

Women of Sherbro Island, Sierra Leone, photographed during Henry Usher Hall's expedition in 1936–37. The woman in the center wears a Sande Society mask, with full raffia costume, similar to several in The University Museum (see nos. 6a, b) (negative 24936, UMA).

> brought into the house, where a final choice was made—He bought some very interesting things. (evidently written shortly before February 6, 1937; see Hall Household Book, 1936–37)

Hall returned to Philadelphia in July 1937, and The University Museum published his preliminary report, *The Sherbro of Sierra Leone,* the following year (see Hall, 1938). His field notes and photographs are now in the museum archives. This was to be the last of Hall's many contributions to the museum, and he died in retirement at the age of sixty-eight in 1944.

The conclusion of the Sierra Leone expedition marked the end of the active period in the formation of the African collections at The University Museum. Furthermore, there does not seem to have been any research done on the collections between 1937 and 1942, and few if any acquisitions were made.

Interest revived, however, in 1942, when Heinrich A. Wieschhoff was appointed Curator of the African Section, a position he held until 1947. Since 1936 Wieschhoff had taught African

anthropology at the University of Pennsylvania. With the onset of World War II, he was recruited by the Office of Strategic Services and spent part of his time in Washington, D.C. When he was at the museum, Wieschhoff devoted most of his efforts to the African Studies Program, which began as a linguistics project to compile dictionaries and phrase books of African languages. The publications that resulted from this program were followed by a series of African handbooks, which gave up-to-date information on economic, cultural, and political developments in various countries. Eight such handbooks were published, with part of the funding coming from the federal government, which used them to prepare personnel headed for service in Africa. After Wieschhoff left the museum in 1947, he served at the United Nations in a number of positions relating to Africa. He died tragically in a plane crash with Secretary General Dag Hammarskjöld while on a peace mission to Zaire in 1961.

Installation in The University Museum's loan exhibition "African Tribal Sculpture," organized by Margaret Plass in 1956 (negative 71427, UMA)

With Wieschhoff's departure, The University Museum's African collections were once again without a curator, and in 1948 both the African and Oceanian sections were placed under the direction of Carleton S. Coon, who had been appointed Curator of General Ethnology. Coon was a palaeontologist whose field of research was early man, and in 1965 and 1966 he took part in an expedition to Nigeria and Sierra Leone, where he discovered remains of early Neolithic man. Although he had a wide range of knowledge of art and artifacts from around the world, the African collections did not claim much of his interest, and his involvement in the area was mostly administrative.

It was not until 1956 that The University Museum refocused its energies on Africa to any great extent. In that year Margaret Plass organized a major loan exhibition of African art at the museum, "African Tribal Sculpture" (see Plass, 1956), which coincided with the meeting of the Fifth International Congress of Anthropological and Ethnological Sciences in Philadelphia, attended by seven hundred delegates from sixty-three countries. Included in the exhibition were more than two hundred objects from eleven museums and twenty-four private collections in Europe, America, and Africa itself that displayed a broad range of art styles from Mali to Zimbabwe. The exhibition was held at a time of quickening interest in so-called primitive art in general, and was a landmark for the scope and quality of its loans and the content of its catalogue.

Mrs. Plass was in an excellent position to undertake this project, and her long association with Philadelphia made it especially appropriate that it be held at The University Museum. She was the widow of Webster Plass, a Philadelphia-born consulting engineer. The Plasses traveled all over the world and collected a variety of objects in addition to African art, including Khmer bronzes, Melanesian sculpture, Tang and Wei dynasty sculpture, and Peruvian pottery. Mr. Plass was an early benefactor of The University Museum, where he had first been exposed to the "exotic" arts that came to interest him so intensely.

Beginning in 1945, just after the end of World War II, and continuing until Mr. Plass's untimely death in 1952 at the age of fifty-seven, the couple concentrated their collecting activities on African art. This seven-year period was one of the last moments when fine examples could be found at

relatively low prices. The Plasses, who knew collections, collectors, and publications of African art in Europe and America and had lived in Africa themselves, formed their collection using a broad and deep base of knowledge and two pairs of discerning eyes.

As they started to acquire African art, the Plasses became associated with the Department of Ethnography at the British Museum, which received the bulk of their collection some years after Mr. Plass's death (see Fagg, 1953). The Plasses worked closely with William Fagg, then Assistant Keeper in the department, who would become the leading scholar of African sculpture during the next two decades. Over the years he and Mrs. Plass have maintained a close friendship and have also collaborated on a number of projects, including publications and exhibitions (see, for example, Fagg and Plass, 1964). In his many trips to Philadelphia, Fagg also became familiar with The University Museum's collections, borrowing and publishing a number of its objects during the 1960s and 1970s and lending works from the British Museum to the inaugural exhibition of the new wing of the Philadelphia museum in 1971.

The success of Mrs. Plass's 1956 exhibition and its catalogue marked the beginning of a period of the increased display, publication, and exposure of the African collections of The University Museum. Until then only a few of the works had been well known, and many treasures had remained in storage, hidden even from scholars. Mrs. Plass was appointed Research Associate for Africa in 1957, and in her first year in the post published a handbook on the African collections to accompany a new installation in the museum (see Plass, 1957). With this impetus the nature and depth of the African holdings finally began to be revealed.

In 1959 Mrs. Plass organized another exhibition for The University Museum, "The Seven Metals of Africa," which featured objects from its own collections as well as loans from American, European, and African sources that highlighted African workmanship in gold, silver, iron, copper, zinc, tin, and lead (see Plass, 1959, *Metals*). She also put together "The African Image" for the Toledo Museum of Art, which included important loans from Philadelphia (see Plass, 1959, *Image*). It was also through her efforts that the much-needed rearrangement and refurbishing of the storage areas for African art were undertaken. In the years since

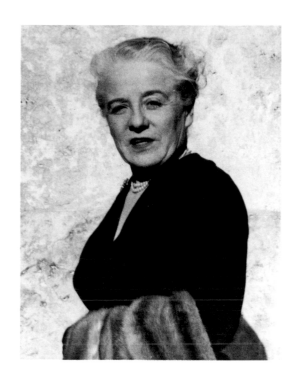

Margaret Plass, whose long and dedicated involvement in the exhibition, publication, and acquisition of The University Museum's African collections began in the mid-1950s (negative 137247, UMA)

Mrs. Plass spearheaded the reawakening of interest in The University Museum's African collections, the museum has been represented in most major surveys of African art as well as in more specialized exhibitions. Mrs. Plass was named Honorary Curator of African Art in 1965, a position she continues to hold.

David Crownover, who joined the museum staff as Chief Preparator in 1956 and became Manager of Exhibitions two years later, also played a role in the expansion and popularization of The University Museum's African collections. He designed the installations for the two Plass exhibitions in Philadelphia and also for the new African gallery that opened in 1957. During his years at the museum, Crownover, who served as Executive Secretary from 1963 to 1980 and was named Research Associate in the African Section in 1977, maintained his interests in the collections, which included finding objects for acquisition, mostly from dealers in New York and Paris (see nos. 3, 10, 13b, 27, 35, 72). The funds for these acquisitions sometimes came from general acquisition endowments and at other times from Mrs. Plass for specific purchases (see no. 13b).

The University Museum, University of Pennsylvania, Philadelphia (negative 22422, UMA)

Another important phase in the history of The University Museum began when Froelich G. Rainey, who became Director in 1947, arranged for cross-appointments between the museum and academic departments within the university, which allowed courses relating to the museum's work to be offered. Three anthropologists, Igor Kopytoff, Robert Netting, and Nicholas C. David, held various curatorial positions for African art from the early 1960s through the early 1980s. Kopytoff did fieldwork among the Moato of the Ivory Coast in 1964, followed by work in the Cameroon grasslands. Netting worked with the Goemai and Kofyar of Nigeria in 1966–67, and David carried out an archaeological survey in the Benue River valley of Cameroon in 1967. The materials they collected were of more ethnographical or archaeological than artistic interest, but at least the museum had at last begun to send some of its personnel into the field in West Africa. Sandra Barnes, whose extensive fieldwork in West Africa included study among the Yoruba of Nigeria, was appointed Assistant Curator of the African Section in 1974 and became Associate Curator of African Ethnology in 1981. In 1982 she was named a Consulting Curator for the department.

Paula Ben-Amos joined The University Museum's staff as a Research Associate in the African Section in 1977 and became Keeper of Collections in 1982. A few gifts and purchases were made during her tenure, the most notable being the Cross River dance crest (no. 22) that had been on loan for some years from Christian Humann, a collector of Southeast Asian sculpture, and was purchased from his estate in 1982. Ben-Amos left the museum in 1984, and the African collections are now temporarily without a full-time keeper.

When considering the history of The University Museum's African collections, it should be remembered that the bulk of the holdings came through purchase. Their quality and content have been partially eclipsed by other, better known groups of objects acquired through well-publicized and sometimes spectacular archaeological discoveries from such sites as Piedras Negras, Memphis, Nippur, Gordion, Ur, Gibeon, and Hasanlu. However, by buying most of its African collections, The University Museum had the advantage of being able to acquire a broader range of expressions and object types than could have been gathered through a series of localized expeditions. The museum was nonetheless subject to the vagaries of the market. Representation of certain styles is therefore very strong from areas such as Zaire, Gabon, and Nigeria, while others, including those from the Sudan, the Guinea Coast, and the Ivory Coast, are much underrepresented. During its most active purchasing years, from 1912 to 1930, the museum bought whatever was available. If it had been able to maintain the pace of this activity into the 1950s, it would have been possible to present a broader survey of West African styles within its collections.

The early dates of acquisition and the quality and artistic importance of the objects give The University Museum's African collections their distinction. Although museums in Europe were active in the formation of collections of African art and ethnography during the eighteenth, nineteenth, and early twentieth centuries, no other American museum was as dedicated to the building of such holdings. Except for a handful of adventurous private collectors, the dealers of London, Paris, Hamburg, and New York had few outlets for their stock. It was especially during the era of George Byron Gordon and Henry Usher Hall that the museum became known for its interest in African art, for it was the farsightedness of these two men that gave The University Museum the core of its African collections and the foundations upon which it will continue to build.

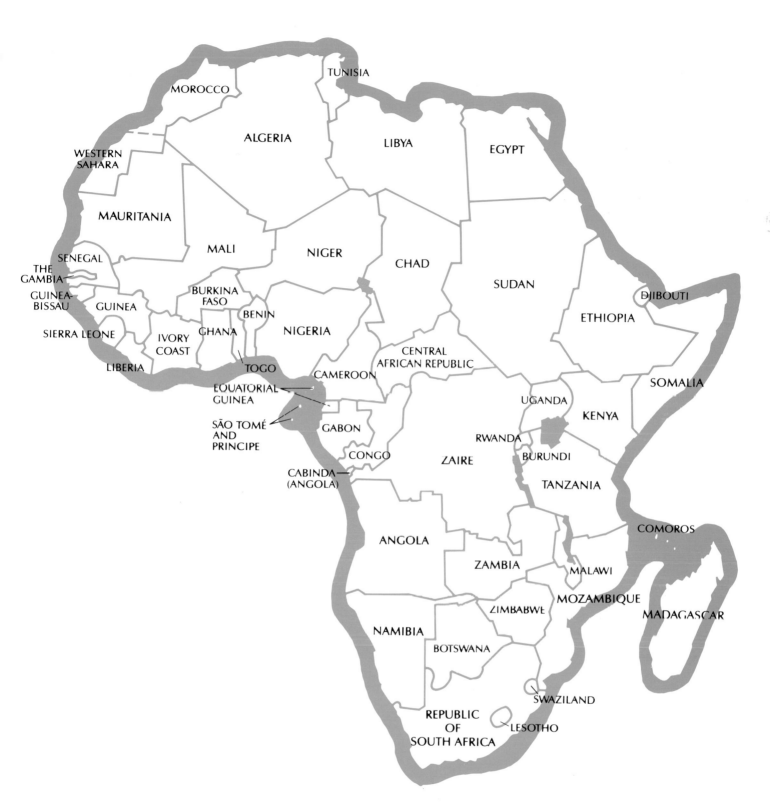

MOROCCO
TUNISIA
WESTERN
SAHARA
ALGERIA
LIBYA
EGYPT
MAURITANIA
MALI
NIGER
CHAD
SUDAN
DJIBOUTI
SENEGAL
THE
GAMBIA
BURKINA
FASO
ETHIOPIA
GUINEA-
BISSAU
GUINEA
BENIN
NIGERIA
SIERRA LEONE
GHANA
IVORY
COAST
CENTRAL
AFRICAN REPUBLIC
SOMALIA
LIBERIA
TOGO
CAMEROON
UGANDA
KENYA
EQUATORIAL
GUINEA
SÃO TOMÉ
AND
PRINCIPE
GABON
CONGO
RWANDA
ZAIRE
BURUNDI
TANZANIA
CABINDA
(ANGOLA)
COMOROS
ANGOLA
ZAMBIA
MALAWI
MOZAMBIQUE
MADAGASCAR
ZIMBABWE
NAMIBIA
BOTSWANA
SWAZILAND
REPUBLIC
OF
SOUTH AFRICA
LESOTHO

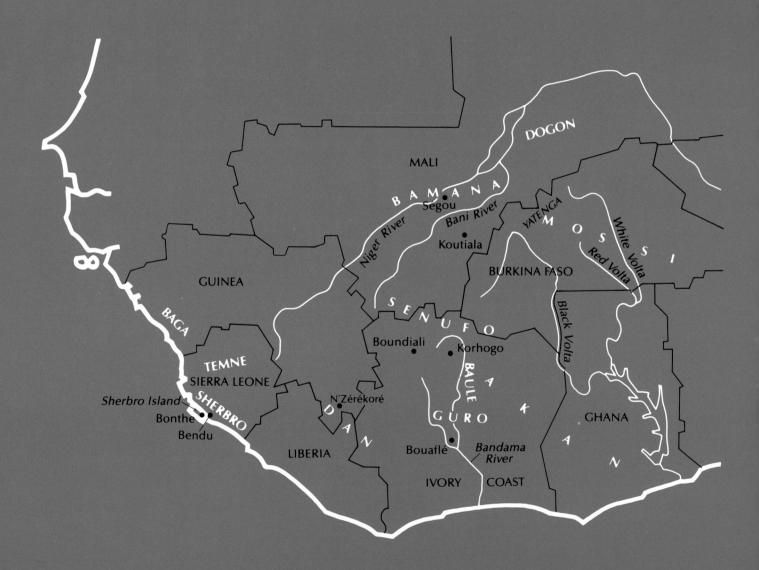

MALI

DOGON

B A M A N A

Ségou

Niger River

Bani River

YATENGA

M O S I

White Volta

Red Volta

Koutiala

GUINEA

BURKINA FASO

Black Volta

BAGA

S E N U F O

TEMNE

Boundiali

Korhogo

SIERRA LEONE

Sherbro Island

SHERBRO

BAULE

A

Bonthe

N'Zérékoré

Bendu

G U R O

GHANA

D A N

K

LIBERIA

Bouaflé

Bandama River

A

IVORY COAST

N

30 Guinea Coast and Western Sudan

GUINEA COAST
AND
WESTERN SUDAN

1 Standing Female Figure

According to information published by M. A. Chevrier in 1906, Baga figures of this type, which can be either male or female, represent dieties that had potentially both good and evil influence over the life of the community. They were kept in shrines outside the villages and were associated with plant and human fertility. The sculptures themselves did not serve as abodes for spirits, but rather as intermediaries between them and the people. Offerings were left for the spirits at the shrines, and the figures were greatly respected in the hope that they might bring good fortune and benefits from the spirits (see Vogel and N'Diaye, 1985, p. 116, no. 2; Roy, 1985, p. 42). Frederick Lamp (1986) states that there is much misinformation concerning the significance of Baga sculpture, and future studies are expected to supersede current knowledge.

All Baga sculpture has been said to be associated with fertility, a concept that is embodied in the powerful rhythmic and curved forms of figures such as this. The cantilevered head is supported by hands at the chin. The curves of the nose, the forehead, and the crested coiffure follow the shape of the chin, which is repeated as well at the abdomen, the buttocks, and the calves.

Earlier examples of such figures have been smoothed down after carving so that they do not exhibit such obvious evidence of adzing on the body and the face. The detailing of the body and the coiffure is also more deeply and finely cut on older images. Many show a standardized pattern of facial scarification that is absent here.

Published: Hall, 1927, repros. pp. 181, 184, 185

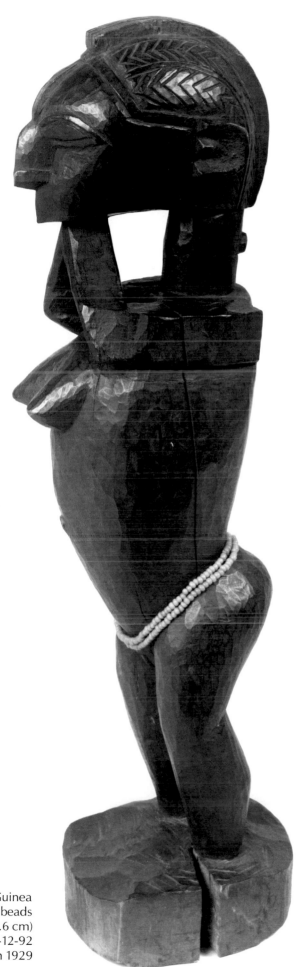

Baga, Guinea
Wood with glass beads
Height 18¾" (47.6 cm)
29-12-92
Purchased from J. Laporte in 1929

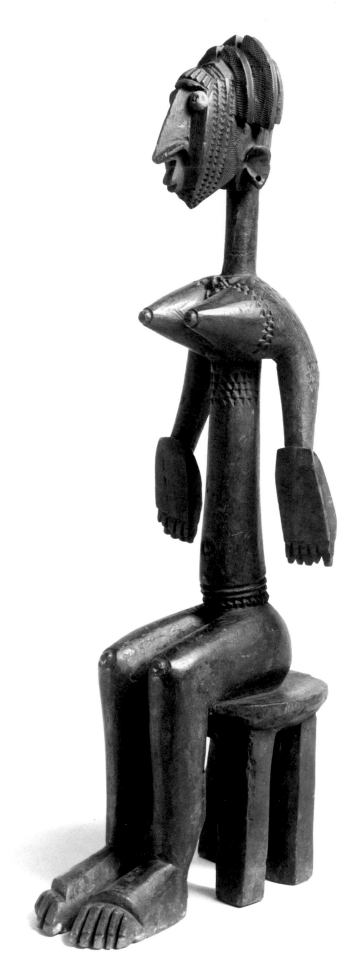

Bamana, Mali
Wood with brass tacks
Height 20⅞" (53 cm)
AF 5365
Acquired before 1927

2 Seated Female Figure

Although the antelope headpieces of the Bamana are their most famous creations, they have also made a number of sculptures in human form that show excellent workmanship and can be attributed to various regional substyles. The author originally grouped this object with a few other figures and masks that are carved in the same style. He suggested that they might come from the region around the town of Ségou in Mali and that they were the work of several identifiable hands (see Wardwell, 1966). A more recent study has added considerably to this corpus of works, which now numbers forty-seven objects and includes antelope headpieces as well as figures and masks. The workshop has been localized to an area "somewhere between [the villages of] Segu and Koutiala near the River Bani" (Bassani, 1982, n.p.). At least three hands have been identified with this workshop (see Bassani, 1978). Wherever the center for their manufacture might ultimately prove to be, the figure style can be identified by such notable characteristics as the elongated torso and neck, the large, spadelike hands, the forward thrust of the head, the three-tiered coiffure, and the carefully applied scarification patterns on the head and upper body.

Little is known of the use or significance of seated female sculptures such as this. Margaret Plass (1956, p. 16) suggests that they may have been used in funerary ceremonies in connection with the propitiation of ancestors, while Robert Goldwater mentions that they are often "called fertility figures, and are said to have been placed near, or around altars" (1960, p. 17). A seated female figure from the Malinke (Maninka) group, just to the west of the Bamana, was collected by Carl Kjersmeier with the information that it was used by young girls as a fertility charm and carried by them in dances (Fagg, 1970, p. 46, cat. no. 35).

The University Museum's example is the best of the Bamana seated figures. It is a beautifully balanced work, perfectly symmetrical when seen frontally. The outstretched hands and their exaggerated size somewhat mitigate the vertical composition. In profile, the forward thrust of the head is matched by the conical shape of the breasts and the heavy horizontal form of the thighs, while the large feet root the image to the ground. Softly curving arms set up a balanced counterrhythm.

Published: Hall, 1927, repros. pp. 174, 178, 179; Wingert, 1948, pl. 1; Wingert, 1950, pl. 1; Christensen, 1955, p. 33, fig. 4; Plass, 1956, p. 16, no. 2-A (text only); Goldwater, 1960, pp. 48, 49, fig. 78; Vancouver Art Gallery, 1964, no. 126; Wardwell, 1966, p. 113, figs. 1, 2; Parrinder, 1967, repro. p. 22; Bassani, 1978, vol. 43, p. 220, pl. 16

Dogon, Mali
Wood with white, red, and black pigment and twine
Height 38¼" (97 cm)
69-15-13
Purchased in 1969

3 Mask (Kanaga)

The Dogon have created about eighty types of masks to represent different concepts and characters in the many masked ceremonies they hold. Those in the *kanaga* form are the most common. They are worn in large numbers in funeral dances and during the six-day ceremony that marks the end of a period of mourning. The Dogon use such dances to lead the homeless souls of the deceased to their final resting places, where they then become a part of the ancestor realm.

There is much confusing information as to what is represented by the so-called cross of Lorraine form of the crest that defines the *kanaga* mask. Marcel Griaule claims that it depicts a bird, while Carl Kjersmeier sees it as a mythical crocodile, an interpretation perhaps corroborated by the designs suggesting feet at the four corners. For their part, the Dogon can give no account for the origin of this form (see Fagg, 1968, no. 1).

Kanaga masks are made by their wearers. This example, of average quality, has been included to show the Dogon sculptural style, in which right-angled forms are carved to depict minimal, abstract representations of human and animal faces and forms. The square eyes, thin planes of the nose, and sharply projecting mouth of this mask are typical of this geometric expression.

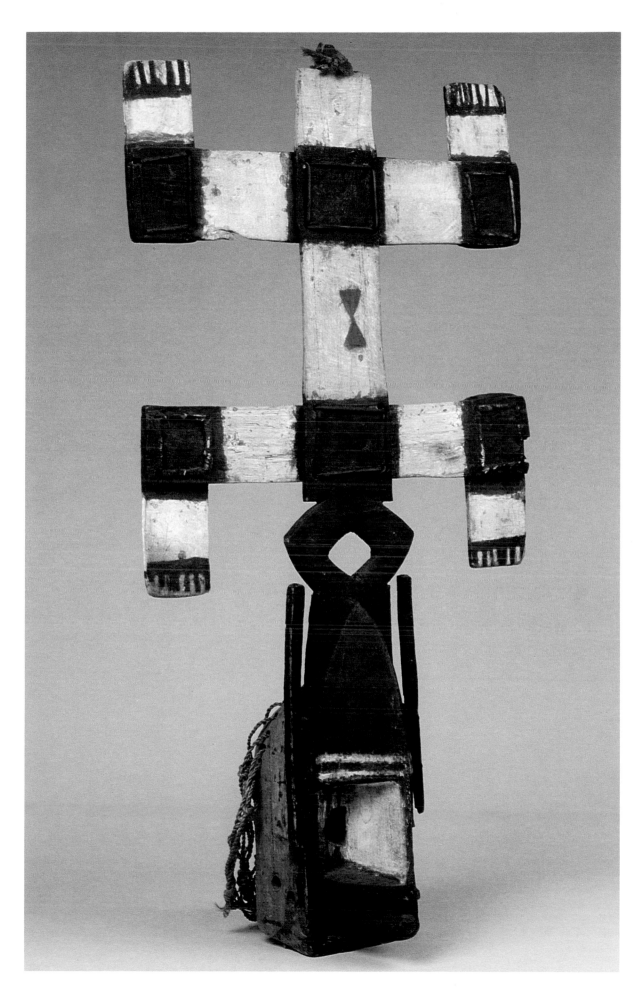

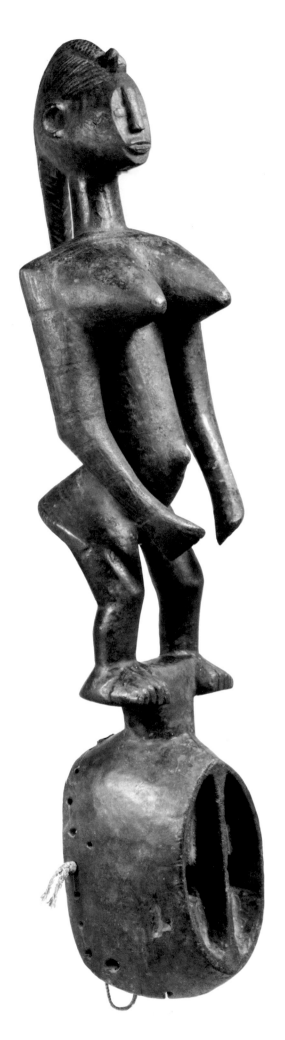

Mossi, Burkina Faso, Yatenga region
Wood with twine
Height 35″ (89 cm)
68-35-2
Given by Katherine Reswick in 1968

4 **Mask** (*Karan Wemba*)

Masks of this kind are a rarer form of the more common Mossi type, which consists of a geometric openwork plank rising three or four feet above a face with the same simplified features. Examples such as this, with a female figure on the crest, come from the Yatenga region in the northwestern corner of Mossi country. The Mossi name for such masks is *karan wemba,* meaning "mask with a carved wooden figure" (Roy, 1979, p. 40 n. 7).

This work is one of at least eight now known (see Roy, 1985, p. 38). Such masks represent a female ancestor spirit who returns to the earth during funerals. They are worn in dances to honor deceased male and female elders, appearing at burials to assure that the rites are properly carried out and at later commemorative ceremonies during the dry season. When not in use, they are stored in a clan house and occasionally brought out to serve as altars, receiving sacrifices so that the represented ancestor might aid the living (see Roy, 1979, pp. 139–77).

The figure atop the mask stands in a typically dynamic Mossi pose with prominent breasts and buttocks, arms held to the sides, and a crested coiffure. The mask face, also diagnostic of the Mossi, is a simple, abstract form consisting of square eyes and a concave oval bisected by a ridge. In his discussion of this piece, William Fagg remarks on its "stolidity" and the lack of any real formal integration between the figure and the mask itself (1968, no. 36). The strong forms of both elements nonetheless provide a sense of balance to the sculpture.

Katherine Reswick White, who gave this mask to The University Museum, was a major collector of African art from the late 1950s until her death in 1980. She left her collection of more than two thousand objects to the Seattle Art Museum.

Published: Fagg, 1968, no. 36

5 Standing Female Figure

Not many Temne objects have been identified because little fieldwork has been done in the region, and sculptures from this area that lack provenance are usually attributed to the better known Mende, living just to the south. In fact, in the treatment of the coiffure, the round, full volumes of the face, the heavy forms of the hips and legs, and the full breasts, this figure does show a relationship to the Mende expression. However, the slim, attenuated arms, gracefully narrowed waist, and small feet and ankles give the sculpture a sense of lightness and movement that is absent in the heavy, frontal, and more rigid conception of Mende female figures.

The significance of this well known Temne carving is not known. In a letter to The University Museum Curator Henry Usher Hall dated June 10, 1924, Jack L. Buck (the famous animal trapper and adventurer who also collected and sold African art) stated that it represented a "Porroh mother (Head woman of native woomens [sic] secret society)..." (Hall Correspondence, 1917–23). It is known that the Mende used standing female figures for a variety of purposes, including for display during important events such as Sande Society initiations (see nos. 6a,b), for guarding powerful herbs and medicines, and perhaps for divining (see Hart, 1984, p. 85).

Published: Plass, 1959, *Image*, p. 11, no. 31 (as Mende); Leuzinger, 1963, p. 99, cat. no. F9; Fagg, 1964, p. 42, pl. 6; Fagg and Plass, 1964, repro. p. 31; Fagg, 1965, pp. 6, 7, repro.; Leiris and Delange, 1968, p. 235, pl. 267; Trowell and Nevermann, 1968, repro. p. 107; Fagg, 1970, p. 38, cat. no. 24; Leuzinger, 1972, pp. 98, 99, no. F4; Leuzinger, 1978, pl. 23; Anton et al., 1979, repro. p. 357; Lamp, 1985, p. 34, fig. 10

Temne, Sierra Leone
Wood
Height 22⅛" (56.2 cm)
29-94-10
Collected by Jack L. Buck in Sierra Leone in
1923–25, and purchased from him in 1927

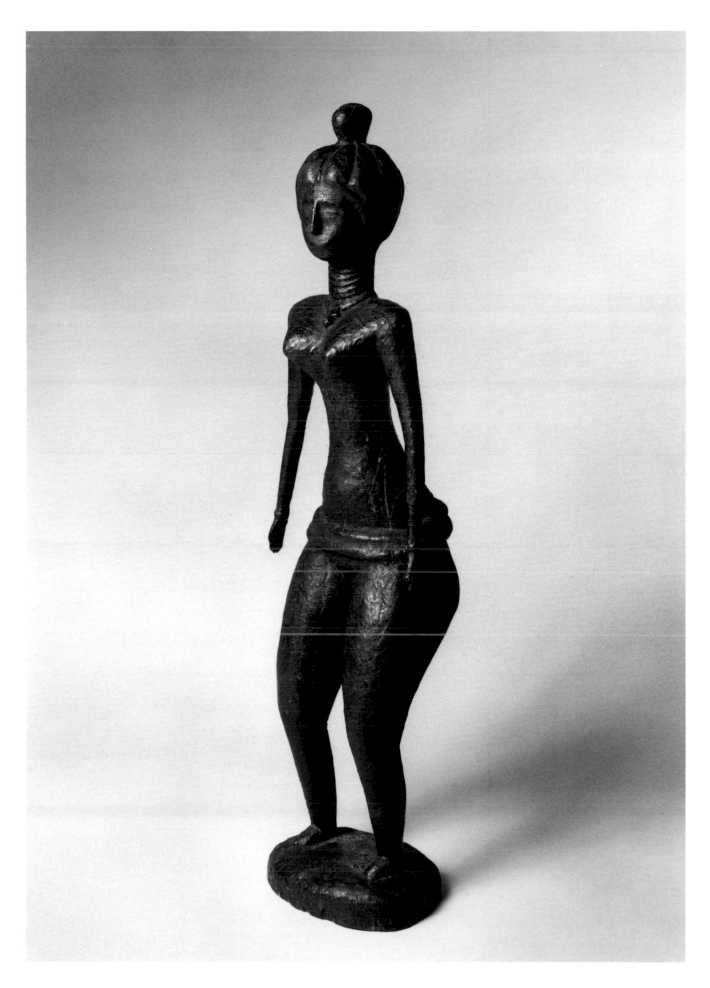

6 Helmet Initiation Masks (*Sowei*)

Many helmet masks of this type are made in a broad region inhabited by the Sherbro, Mende, and related groups that stretches from northern Liberia through a large part of Sierra Leone. In this area it is the custom for young girls to attend bush schools to prepare for initiation into the Sande Society, which is one of the few West African secret societies that educates women. For up to three years, the girls are taught about their forthcoming responsibilities in the community as adult women. Skills of cooking, farming, dancing, and singing are acquired, as is a knowledge of herbal medicine, child care, and economics. When the initiates emerge, they are ready for marriage.

These masks are called *sowei,* which is the title of the primary Sande officials who own and often wear the headpieces during certain phases of the initiation and when the initiates come out of their seclusion. They are worn with a costume of raffia, black cloth with the sleeves sewn together, and black stockings that completely obscures the wearer from view so that the spirit evoked by the mask can only enter from within. This apparition symbolizes Bondo, the primordial ancestress who was the first to nurture the young and is the guardian spirit of the Sande Society. Those who wear this awe-inspiring costume pronounce judgments, execute law, and otherwise instill respect for the traditions of the group among both initiates and adults.

When a woman reaches the proper grade in the Sande Society, she can commission her own *sowei* mask from a male carver. In form the masks follow the same principles throughout the region. They are conical helmets of light bombax wood with small facial features compressed into a triangular area and a broad, smooth forehead. An elaborate coiffure and concentric neck rings are part of all examples. With their downcast eyes and composed,

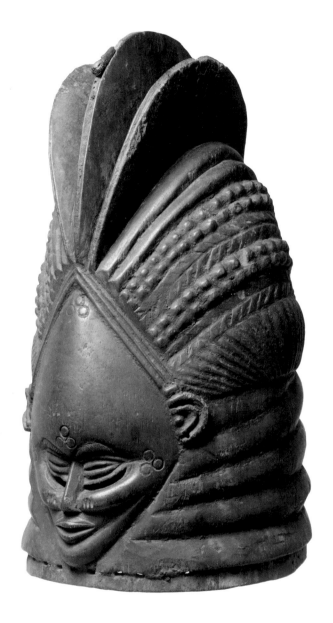

a. Sherbro, Sierra Leone, Bendu region
Wood
Height 15¾″ (40 cm)
37-22-266
Collected by Henry Usher Hall on The University Museum's expedition to Sierra Leone in 1936–37

meditative expressions, the masks reflect Mende
ideals of female beauty. Special attention is lavished
on the coiffure, which represents the female as a
power that brings order and human refinement. It is
in the treatment of the hairstyles and facial details
that the masks show most variety (see Lamp, 1985;
Phillips, 1980).

These two masks are the finest examples among a
large group collected for The University Museum by
Henry Usher Hall (see photograph, p. 25). The
helmet now missing its fiber attachments (no. 6a)
has a particularly well carved coiffure and fine,
sharply cut facial features that include decorative
scarification patterns on the cheeks, forehead, and
temples. Hall's notes on the object's accession card
state that he purchased it from the "Paramount
Chief Bahū of Bendu," which is a town on mainland
Sierra Leone, opposite Bonthe on Sherbro Island
(see Hall, 1938, p. 1 and map).

The mask with the raffia still attached (no. 6b)
shows an unusual coiffure with two horns and the
addition of a shell ornament. Amulets of such
material add power to the headdress. On the mask's
accession card Hall recorded that it was purchased
from "Mama Nyama, Soko [chief] of Bondo at
Makola," near Yoni in the Sitia chiefdom of Sherbro
Island. The use of white and red pigment around
the face is unusual, and caused William Hommel to
suggest that this helmet represents Gonde, a
comedic character whose appearance with the
sowei mocks the ideals of beauty (1974, no. 23).
This seems unlikely, however, as the grotesque
Gonde masks, with their large, open eyes, wide,
gaping mouths, and exaggerated features, are the
antithesis of what is seen here.

Published (no. 6b): Plass, 1957, pp. 24, 25, repro.; Hommel, 1974,
no. 23

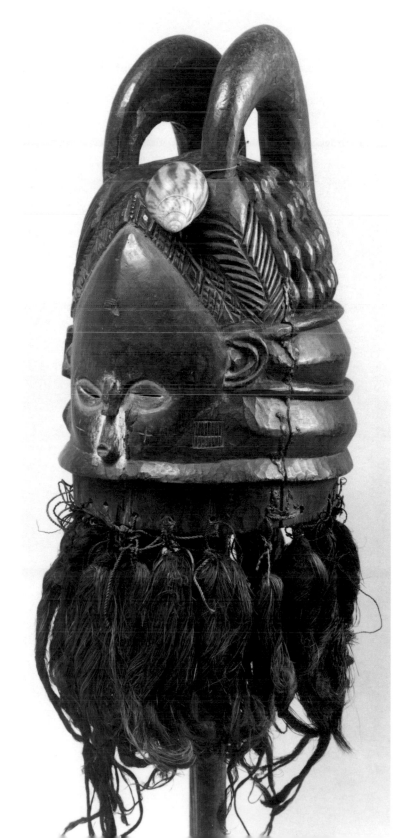

b.　Sherbro, Sierra Leone, Sherbro Island
Wood with raffia, twine, shell,
and white and red pigment
Height without raffia 15⅜" (39 cm)
37-22-264
Collected by Henry Usher Hall
on The University Museum's
expedition to Sierra Leone in 1936–37

7 **Mask** (*Tankagle*)

The life of the Dan people is governed by the Poro Society, an organization for men that trains and initiates boys in the community's laws and in general maintains order and traditions. Many different masks are used for the society's ceremonies. Judges, protectors, diviners, and watchmen all have an identifying mask type, and others are made to use in circumcision rites, to guard against trespassers, and to collect food that is brought back to the boys in their Poro initiation camps. One form is even worn by a guardian who sees that women extinguish their fires at noon during the dry season.

This *tankagle* (dancing, miming) mask represents a beneficent woman and, with its smooth surfaces, naturalistic details, well carved facial planes, and half-closed eyes, is understandably regarded as beautiful by the Dan. Such masks are worn by performers who appear sometimes with an attendant and at other times with a chorus or orchestra. They dance, sing, tell proverbs, and bless the onlookers. A cone-shaped cap is worn on the top of the mask. Certain individualized masks are given their own names associated with their appearance and behavior (see Fischer and Himmelheber, 1984, pp. 23–27; Fischer, 1978, p. 21).

Most of the Dan live in Liberia, but a small number occupy part of neighboring Guinea. Accession card information states that this mask is from the region of N'Zérékoré, which would actualiy place its origin in Guinea, just outside the northern Liberian border. Eberhard Fischer (1985, personal communication) believes it to be by the same hand as two other Dan masks, one in a Swiss private collection and the other in the Museum für Völkerkunde, Basel (Fischer and Himmelheber, 1984, pp. 27, 28, no. 22).

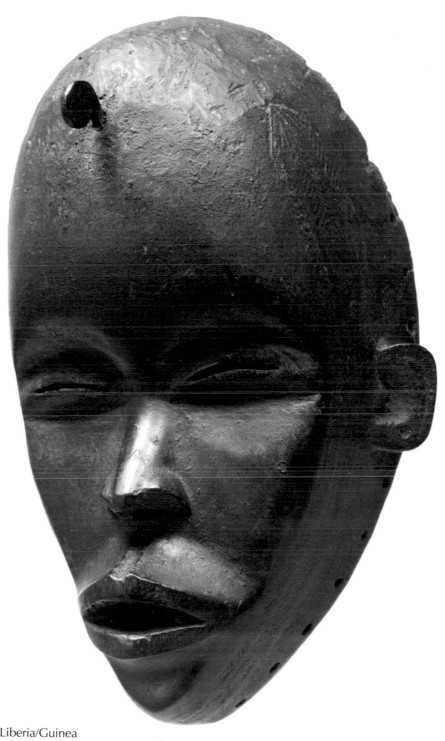

Dan, Liberia/Guinea
Wood with iron
Height 9⅝″ (24.4 cm)
33-39-2
Given by J. Laporte through
Henry Usher Hall in 1933

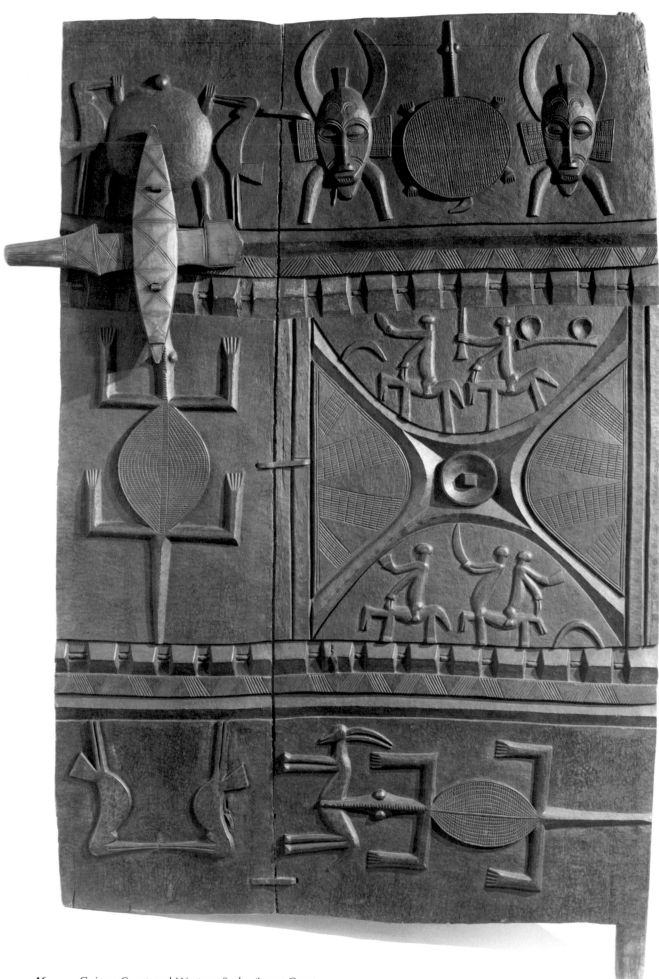

8 Door

The large doors of the Senufo are used both on shrines owned by clans in which ceremonial paraphernalia is kept and at the entrances of the houses of chiefs and other important members of the community to show their wealth and prestige. Although the reliefs carved on these doors make general reference to Senufo ceremonies, concepts of fertility, and elements of the landscape, they serve more of a decorative than religious purpose.

This particularly fine and well preserved example displays practically the full range of design elements to be found on Senufo doors. The dominant pattern of four radiating lines at the center, long said to depict the sun, actually represents the maternal umbilicus; the scarification patterns around the navels of Senufo women are in similar forms (see Glaze, 1975, p. 28, fig. 13). The turtles and hornbills at the top and left symbolize two of the five original living creatures in Senufo cosmology, and the crocodile devouring an antelope carved at the lower right is emblematic of male aggression and physical power as well as of the importance of hunting to the Senufo. Two Lo Society *kpelie* masks (see no. 9) appear at the upper right, and the mounted figures carrying swords in the center are identified by Anita J. Glaze as spirit hunters in the analysis of a similar door in the Tishman Collection (in Vogel, 1981, p. 51, no. 24).

All such doors are fitted with geometrically carved locks of Arabic inspiration that were sold to the Senufo by traders from the north. As seen here, the lock is rarely integrated into the overall design of the door. Robert Goldwater (1964, p. 29) compares this door to one collected in the area of Boundiali in the western part of the Senufo country, a provenance corroborated by Glaze for the Tishman example. This door has been published as from the collection of Colonel Alfred-Amédée Dodds, who led a French expedition that defeated the kingdom of Dahomey (in what is now southern Benin) and established a protectorate in 1892 ("Ivory Coast Door," 1930, p. 22).

Published: "Ivory Coast Door," 1930, p. 21, pl. VIII; Sweeney, 1935, p. 39, no. 168; Wieschhoff, 1945, p. 49, fig. 15 (as Dahomey); Brooklyn Museum, 1954, no. 20; Christensen, 1955, p. 41, fig. 21 (as Dahomey); Plass, 1957, pp. 10, 11, repro.; Elisofon, 1958, p. 22, no. 5; Goldwater, 1964, p. 29 (text only); University Museum, 1965, repro. p. 110; Leiris and Delange, 1968, p. 129, no. 131; Holas, 1978, frontispiece (detail); Horne, 1985, p. 13, no. 3

Senufo, Ivory Coast, Boundiali region
Wood with iron
Height 65" (165 cm)
30-10-1
Purchased from Sumner Healy in 1930

9 **Mask** (*Kpelie*)

Every Senufo male is initiated into the all-important Lo Society. There are three grades of membership, each achieved after seven years of instruction in the obligations of young boys, adolescents, and men, respectively. *Kpelie* masks, which are female and represent ancestors, are the most common Senufo masks. They are worn at Lo Society initiations and funerals and at other times when ancestors are venerated. According to B. Holas, who has completed considerable fieldwork among the Senufo, the masks illustrate a metaphysical philosophy, revealing "to the neophyte the imperfection and precariousness of the human condition" (quoted in Goldwater, 1964, p. 15), a concept progressively taught to the men as they enter the upper Lo Society grades.

Although the *kpelie* masks themselves are quite narrow, the entire face and body of the wearer are covered with a cloth and fiber costume that completely obscures the human agent (see ibid.,

nos. 8, 21, 22). The basic components of these masks are the ram's horns at the top, which represent a sacrificial animal, the rectangular flanges at the side, and the two "legs" projecting downward from the cheeks (both broken away from this example), which signify the hornbill, one of the five original animals in Senufo cosmology (see Dolores Richter in Vogel, 1981, p. 38, no. 18). The crest identifies the particular caste of the owner of the mask, in this case perhaps farmers.

The *kpelie* mask's elongated face, long, thin nose, and projecting mouth relate the Senufo style to that of the Guro (see nos. 11, 12). Although damaged, this example is well carved. It shows the delicate and sensitive features of feminine beauty that distinguish *kpelie* masks from the bolder and more aggressive animal helmet masks also made by the Senufo (see no. 10).

Published: Einstein, 1915, pl. 99

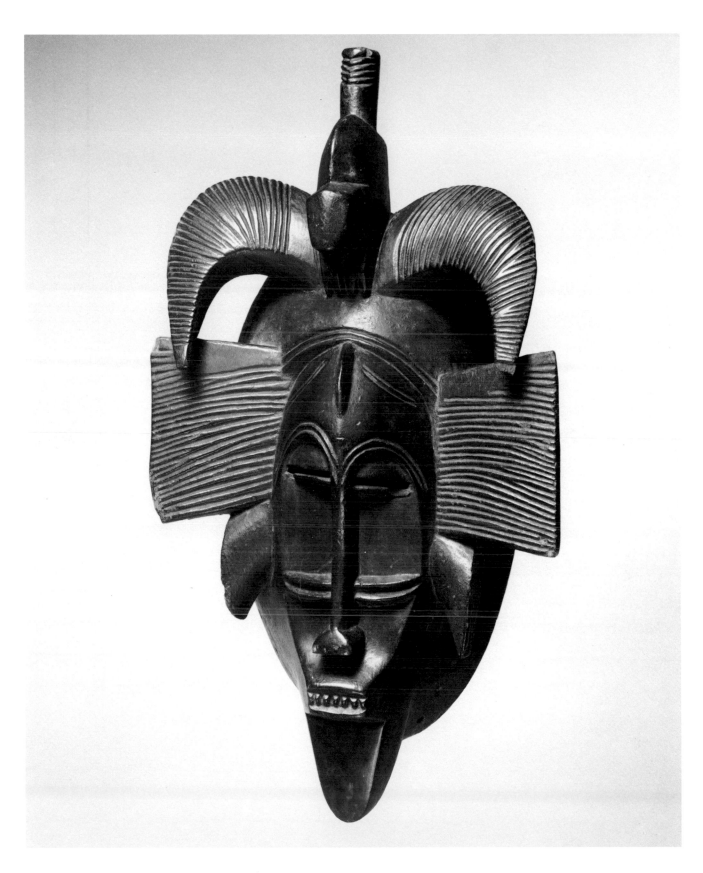

Senufo, Ivory Coast, Korhogo region
Wood
Height 13" (33 cm)
AF 5368
Purchased from the estate of John Quinn in 1926

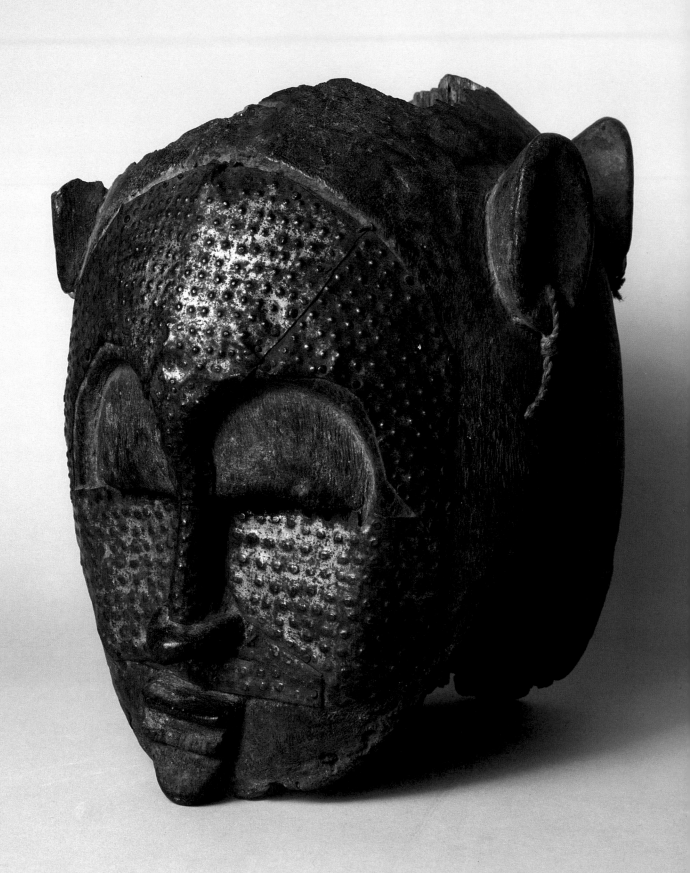

10 Janus-Faced Helmet Mask

In addition to creating the small, elegant *kpelie* masks (see no. 9), the Senufo also make a variety of helmet masks, mostly in animal form. Helmet masks with human features as seen here are not common, and their use and significance are not yet recorded.

This unique janus-faced mask displays Senufo attributes in the long, concave nose, the large, convex eyes, the extended mouth with pursed lips, and the erect, oval ears. The application of stippled tin sheets on one of the faces is an unusual form of embellishment that adds to the dramatic appearance of this mask. (The opposing face seems never to have been overlaid with metal.) The Marka, a subgroup of the Bamana some distance to the north in Mali, created a mask type covered with metal sheets, usually of brass (Goldwater, 1960, pp. 60, 61, nos. 105–9). Knowledge of this technique may possibly have inspired its use by the Senufo here.

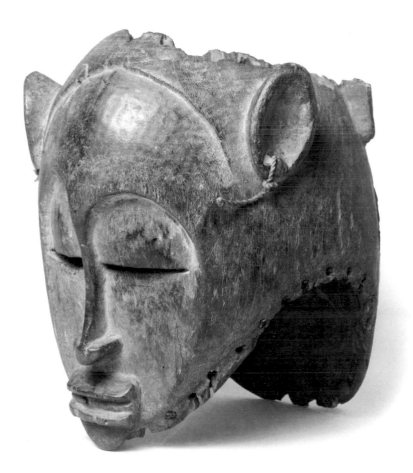

Senufo, Ivory Coast
Wood with iron tacks, tin, and raffia twine
Height 11⅜" (29 cm)
81-11-9
Reaccessioned in 1981

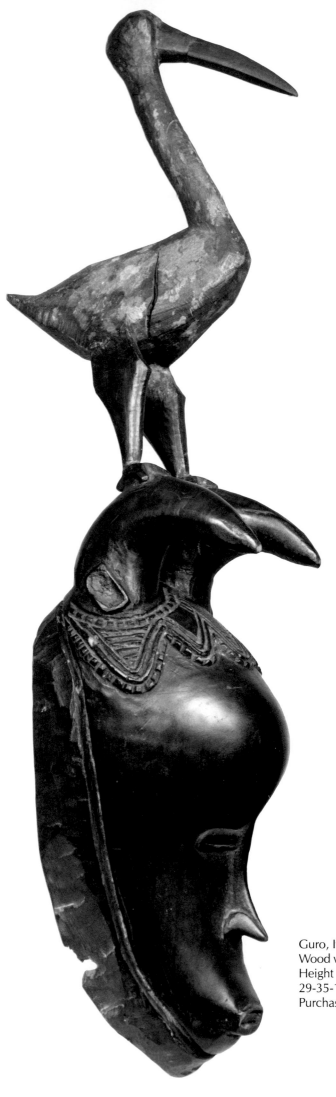

Guro, Ivory Coast
Wood with traces of white pigment
Height 20⅜" (51.8 cm)
29-35-1
Purchased from Lena H. White in 1929

11 **Mask** (*Seri*)

The Guro are known for their elegant, elongated, naturalistic depictions of the human face, particularly on masks (see also no. 12) and heddle pulleys. Of the several types of Guro masks, the one represented by this example is the rarest. According to Eberhard Fischer (Fischer and Homberger, 1985, pp. 203–5), masks of this form are owned by a group of young men in a village and used by the most talented male dancer for entertainment in the *seri* dance. The masks, which have human or animal figures carved on their crests, have no religious or particular iconographic significance but are merely decorative. While most Guro masks come from the northern part of the Guro country, these crested entertainment masks are all from the southwestern region. Apparently this mask type was developed recently, in the first part of the twentieth century.

The bird perched on top of this mask represents an ibis, and, as is characteristic of all examples, the entire work is carved of one piece of wood. This mask is the finest of the type known. It is particularly striking in profile, for the smooth, curved forms that peak in accented points build a flowing rhythm that moves from the mouth and nose of the face to the horns and climaxes with the sharp beak of the ibis. (The beak has been restored, but most probably follows the original form.)

Published: "Baule Mask," 1930, p. 4, pl. I (as Baule); Wieschhoff, 1945, p. 47, fig. 14; Wingert, 1948, pl. 25; Wingert, 1950, pl. 25; Brooklyn Museum, 1954, p. 43, no. 78 (text only); Christensen, 1955, p. 39, fig. 16; Plass, 1956, p. 21, no. 9-B (text only); Plass, 1957, pp. 18, 19, repro.; University Museum, 1965, repro. p. 116; Pericot-Garcia, Galloway, and Lommel, 1967, p. 158, fig. 211 (as a Zamle [Zamble] Society mask); Vansina, 1984, p. 79, pl. 5.1; Fischer and Homberger, 1985, p. 206, fig. 168

12 **Mask** (*Gu*)

Gu, a mythical female figure in Guro iconography, is represented by this mask. She is the wife of Zamble, and masks depicting the couple are worn at memorial ceremonies and to commemorate significant exploits. The Gu mask appears after Zamble has performed and is followed by Zamble's brother, Zauli, whose dance, features, and actions are rough and wild in contrast to the refinement of the others. When not in use, offerings are made to the masks through diviners to bring good luck and health (see Fischer and Homberger, 1986, p. 20).

The pure elegance of the Guro style is well depicted by this example, which in its form epitomizes female beauty. The high, domed forehead, offset by the simple, angular hairline, and the small and beautifully integrated features of slanted slit eyes, sharply pointed nose, pursed lips, and receding chin are the characteristics of the Gu masks. The jagged border running around the outside of the mask is a decorative ruff, not a beard.

Stylistically, this example belongs to a well-defined group of works from the hand of the Bouaflé Master, an artist who worked near the town of that name in the beginning decades of this century and is known for his masks and heddle pulleys. All show oval heads, carved in curvilinear rhythms, with the facial features restricted to the lower third of the sculpture. The domed forehead, slanting and subtly modeled eyes and brows, and a crest of either horns, as here, or an animal shape are among the hallmarks of his style (see Fischer and Homberger, 1985, pp. 43, 44, figs. 35, 40, 41; pp. 94–96, nos. 16–18).

Published: Hall, 1932, pp. 170–71, pl. XII

Guro, Ivory Coast, Bouaflé region
Wood with white, red, and orange pigment
Height 19⅜″ (49.3 cm)
29-35-3
Purchased from Lena H. White in 1929

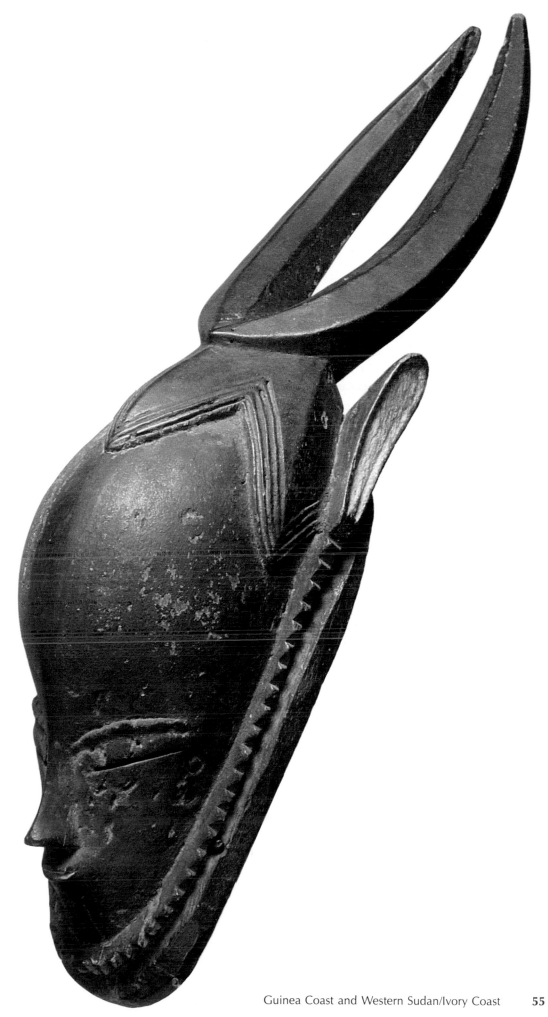

13 Heddle Pulleys

In West Africa pulleys are hung from the top of a man's loom to support the heddles, which are raised and lowered to separate the alternate warps and allow the shuttle to pass through. It is unclear whether the masks and figures that adorn some of the pulleys have a deep significance. These decorations may represent ceremonial objects that are the property of the family of the weaver, who is always a man (see Fagg, 1968, no. 88). If they do have additional meaning, it may be known only to the weaver himself. As is true also with the art of the Guro, the carvings on the pulleys may well be made for the sake of art alone (see Fischer and Homberger, 1986, p. 12).

Decorated pulleys are made by many West African groups, including the Dogon, Asante, Bamana, Mende, and Yoruba, but those of the Baule and Guro are the most numerous and of the finest quality. The Baule type is distinguished by the arch shape of the support and the uniform depth of volume from the front of the carving to the back (Vogel, 1986, p. 48). The animal and human forms on the pulleys represent in miniature the basic elements of the Baule sculptural style as well as some of their different mask and figure types.

Both of these decorated pulleys are missing the small wheel that was attached to the bottom through which the cord supporting the heddle passed. The example with the single head (no. 13a) shows fine, detailed carving, particularly in the treatment of the coiffure and the scarification patterns on the face. It was acquired from the composer Harold Rome, who formed a notable collection of African pulleys during the 1950s and 1960s. The pulley with two nearly identical faces (no. 13b) is carved with the elegant, restrained naturalism characteristic of the Baule style. Another by the same artist, and perhaps even from the same loom, is in the Museum Rietberg, Zurich (Leuzinger, 1963, pp. 106, 107, no. 62).

Baule, Ivory Coast
a. Wood
Height 8¼″ (21 cm)
63-24-1
Acquired from Harold Rome
by exchange in 1963

b. Wood
Height 7⅜″ (18.6 cm)
66-4-1
Purchased through gift of
Margaret Plass in 1966

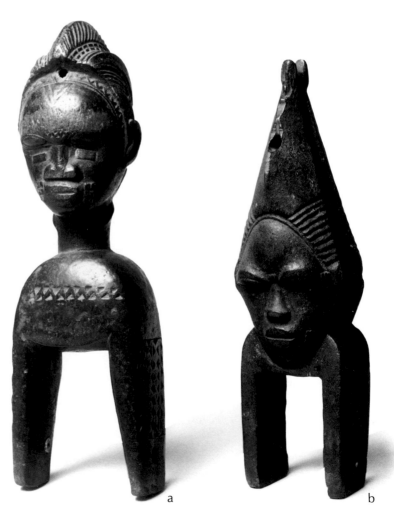

a b

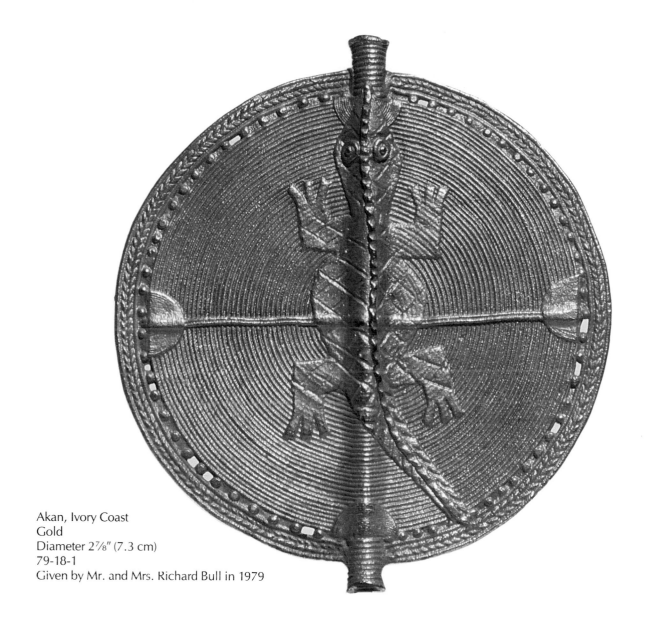

Akan, Ivory Coast
Gold
Diameter 2⅞" (7.3 cm)
79-18-1
Given by Mr. and Mrs. Richard Bull in 1979

14 Pendant

Gold has long been an important natural resource to all of central West Africa, for the rich deposits of the precious metal in the Ivory Coast have brought much trade to the area from both Europe and within Africa itself. Ornaments cast from gold, such as this pendant, are used both for decorative and trade purposes. Although they are usually attributed to the Baule, there is such stylistic similarity among the gold works of almost the entire Ivory Coast that it is more accurate to place them with the Akan-speaking people as a whole.

Objects like this pendant are cast by the lost-wax method, and because the goldworkers undergo long periods of apprenticeship to learn their craft, the quality of Akan goldsmithing is excellent (Vogel, 1986, p. XI). Pendants are worn by chiefs as prestige items and, along with other gold pieces, are sometimes attached to stools, staffs, swords, and ritual paraphernalia of various kinds. The many different animal forms that appear on the pendants do not seem to have particular significance, with the importance of the object derived more from the inherent properties of gold than the image it bears. Crocodiles appear quite frequently; an example similar to this is in the Storrer Collection, Zurich (Fischer and Himmelheber, 1975, pp. 53, 57, no. 76).

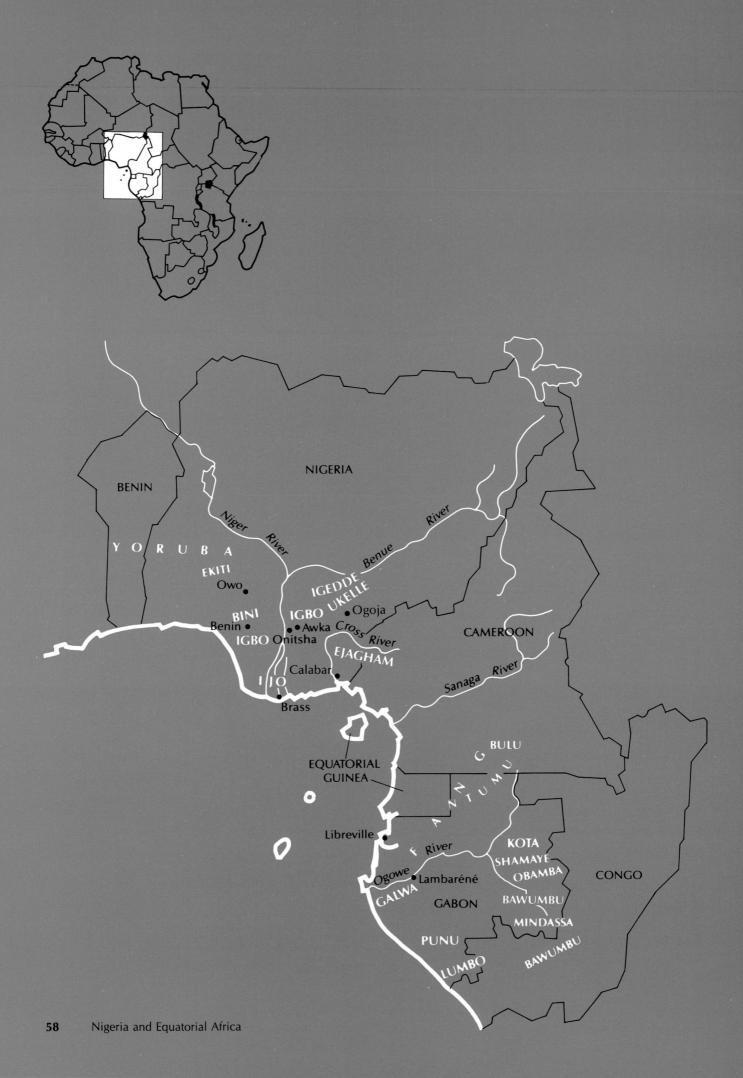

BENIN

NIGERIA

Niger River

Benue River

Y O R U B A

EKITI

Owo●

BINI

Benin●

IGEDDE

IGBO UKELLE

Ogoja●

IGBO

●Awka

Onitsha

Cross River

CAMEROON

EJAGHAM

●Calabar

Sanaga River

I J O

●Brass

EQUATORIAL
GUINEA

F A N G

BULU

N T U M U

Libreville●

Ogowe River

KOTA

SHAMAYE

OBAMBA

CONGO

Ogowe●

●Lambaréné

GALWA

GABON

BAWUMBU

MINDASSA

PUNU

BAWUMBU

LUMBO

NIGERIA AND EQUATORIAL AFRICA

15 Janus-Faced Headdress Mask (Jagunjagun)

Every two years the Ekiti people in the northern part of Yorubaland hold a dance festival to ensure the continued fertility and well-being of their society. Ceremonies take place for three days in March to honor Epa, one of the major heroes in the Yoruba pantheon, and consist of dances that reenact important historical events. During these dances different mask types, including the form seen here, emerge from the forest in sequence (see also no. 16). Although the figures carved on the superstructures of these masks are not portraits, when the masks are worn they are identified as specific individuals, and the stories and songs that accompany them tell of their exploits. In this way, the morals and values of the society are reaffirmed and passed on.

The helmet part of the Epa festival mask is always carved in the form of a grotesque human face, often (as here) Janus-faced, having large, protruding eyes and a broad, open, rectangular mouth. It represents the spirit of a deceased ancestor, and the abstract qualities of the carving stand in contrast to the idealized naturalism of the mask's superstructure. An aesthetic distinction is thus made between the depiction of the living and the dead in the two different sections of the headdress.

The second or third mask to appear during the Epa dances is called jagunjagun (the warrior), and represents a mounted warrior surrounded by attendants. The histories that accompany the mask concern success in warfare, a reference to the spread of the Oyo culture that had preceded the Yoruba. As seen here, a triumphant hero atop the mask holds a staff in his right hand and wears the conical headpiece emblematic of royalty. His mount is not a horse but a mule, for mules, unlike horses, are not affected by the threat of disease carried by the tsetse fly in this country.

Epa masks are washed and then painted by their owners prior to each use. Offerings are made and a cock is sacrificed to the mask, with his blood and chest feathers rubbed on the surface of the helmet; this accounts for the thick patina found on such older examples as this. Palm leaves are then affixed to the base of the helmet to cover the shoulders of the wearer. The mask is then returned to the owner's house, where it is admired before it is worn.

Epa masks can weigh eighty pounds or more, and one of the actions required of the wearer is that he jump on a mound of earth some three feet high without allowing the mask to fall or become damaged. Good hunting and farming are assured if he is successful; if he is not, offerings and sacrifices must be made to nullify the powers that caused him to fail (see Fagg and Pemberton, 1982, pp. 20–22, and captions for pls. 10, 13, 40, 47, and 68).

Epa himself is thought to have been a good carver, and some of the best sculptors therefore employ their greatest skills to create headpieces for the festival honoring him. This example, which like all Epa masks was carved from a single block of wood, exhibits great restraint and dignity, for other warrior masks often show more elaborate carving and as many as a dozen attendant figures.

Published: Hall, 1917, opposite p. 53, fig. 18; Hall, 1920, p. 49, fig. 30; Hall, 1932, pp. 168, 169, pl. XI; Wieschhoff, 1945, p. 53, fig. 18; Wingert, 1948, pl. 39; Wingert, 1950, pl. 39; Christensen, 1955, p. 41, fig. 23; Plass, 1956, p. 29, no. 15-F (text only); Plass, 1957, repro. p. 8; Robbins, 1966, p. 133, no. 163; Barnes and Ben-Amos, 1983, p. 9, fig. 5

Yoruba, Ekiti subgroup, Nigeria
Wood with white pigment and iron staple
Height 46½" (118 cm)
AF 2002
Purchased from W. O. Oldman in 1912

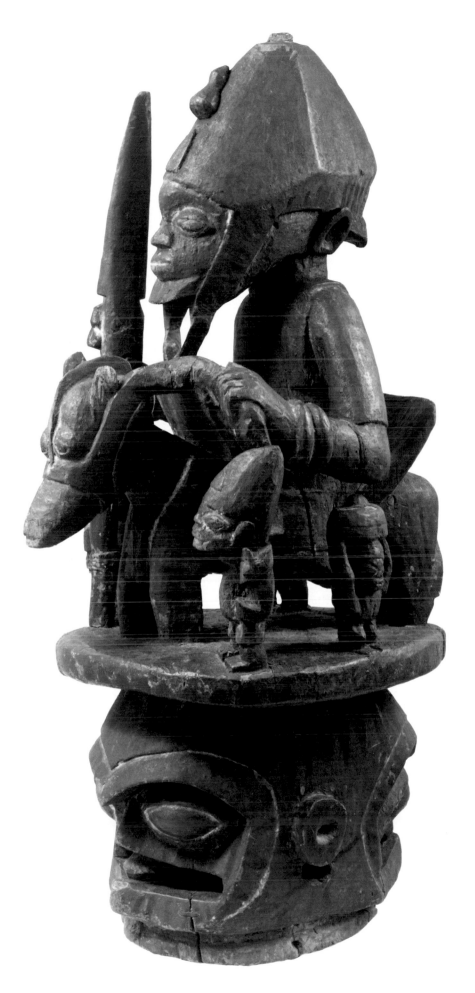

16 **Headdress Mask** (*Olumeye*)

This example of one of the mask types used during the Epa festival of the Yoruba (see also no. 15) shows a female figure holding a child with three small children at her back, thus representing the power of women to bear children. It appears at the end of the festival with another mask that signifies the role of men in ruling and organizing the life of the people (see Fagg and Pemberton, 1982, p. 188). William Fagg cites four names with related meanings for these masks: Olumeye or Olomopupo ("the mother of children"), Eyelashe ("the mother of a devotee"), and Omoniyi ("it is honorable to have children") (ibid., p. 22). This headdress and the other in this selection (no. 15) are two of three Epa masks purchased from W. O. Oldman in 1912 for forty-one pounds. (In a letter to The University Museum Director George Byron Gordon of October 27, 1911, Oldman described them as "exceedingly old pieces" that were "far too massive to have ever been worn" [Oldman Correspondence, 1908–16]). Although in style this headdress is somewhat heavy and lacks the fine, detailed carving of others now known, it is nonetheless important for being among the first Epa masks to come into an American museum.

Published: Hall, 1917, p. 56, fig. 22; Hall, 1920, p. 45, fig. 26; Plass, 1956, p. 29, no. 15-G (text only); Plass, 1957, repro. p. 9

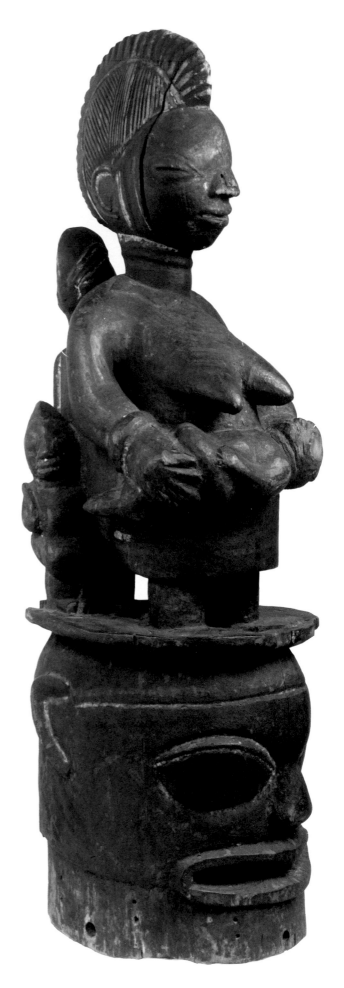

Yoruba, Ekiti subgroup, Nigeria
Wood with white pigment
Height 40¾" (103.5 cm)
AF 2000
Purchased from W. O. Oldman in 1912

17 **Veranda Post** (*Opo*)

Among the important elements of Yoruba architecture are the verandas that encircle the courtyards of houses of elders, royal dwellings, and shrines. Their roofs are supported by carved posts that often represent figure groups, mounted horsemen, seated figures, and certain types of people who serve important roles in Yoruba society. Because these pillars are used on both sacred and secular buildings, they do not serve a religious purpose but rather emphasize the prestige and power of the rulers and others whose dwellings they decorate. Sculptures of human figures on objects whose function is support provide an obvious metaphor for the assistance given by certain members of the community and the court in maintaining the powers and institutions of Yoruba society (see Drewal, 1980, p. 22).

This veranda post, or *opo*, shows a squatting male figure holding a rifle, which, like the bag slung over his shoulder, identifies him as a hunter.

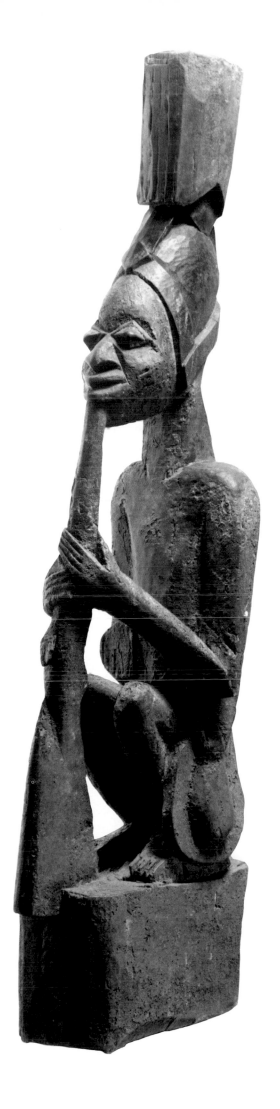

Yoruba, Ekiti subgroup, Nigeria
Wood with organic encrustations
Height 55⅛″ (140 cm)
71-13-1
Collected by Oushigalo Nouhoun in the region of the Ekiti in 1971, and purchased from him in the same year

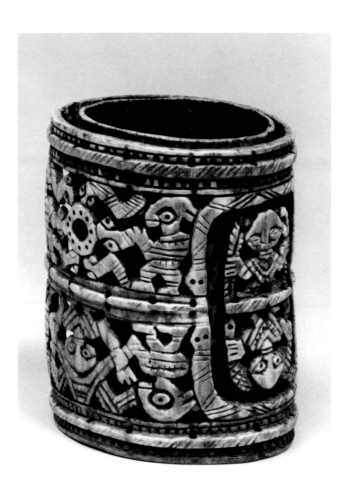

Yoruba, Nigeria, Owo region
Ivory
Height 4⅛" (10.5 cm)
29-93-5
Given by the estate of George Byron Gordon in 1927

18 Armlet

The Yoruba are superb carvers of ivory (see no. 19), and specific schools of this art can now be identified. Some of their best and most complex creations are made in the Owo area on the eastern side of the Yoruba country. Owo carvers are known for producing double armlets that consist of two interlocking cylinders, both made from the same ivory tusk. The outside is carved with figures in relief, and the inside is decorated in a stippled pattern that provides a background for the carving on the outer bracelet.

This example, cut in low relief, demonstrates the Owo tendency toward the grotesque. Serpents, birds, and human figures in kneeling, attendant, or heraldic poses are carved upside down and upright in two bands. Because bird and serpent figures denote rank in Yoruba culture, such armlets are worn by Yoruba chiefs to emphasize their authority.

Other Owo armlets are carved in higher relief, and some were made to hold pendants (see, for example, Ezra, 1985, p. 22, figs. 18, 19; Fagg and Pemberton, 1982, p. 49, fig. 57). This bracelet is simpler, and most probably from a provincial workshop. It came to The University Museum from the estate of its late Director George Byron Gordon, who had a collection of ivories from around the world.

Published: Wieschhoff, 1945, p. 65, fig. 24 (as Benin); Plass, 1956, p. 30, no. 15-R (text only); Plass, 1957, repro. p. 35

19 Cup Stand

Certain Yoruba ivories are very close in style to those that were made for the Benin courts, and it is sometimes difficult to be certain which of the two styles is represented by a particular carving. This cup stand, which was a prestige object used as part of the setting of a court table, falls into that category, and in fact was published as Benin by Margaret Plass in 1957. In general form, it relates somewhat to the Benin ivory saltcellars depicting Portuguese traders that were made as early as the late fifteenth century (see Ezra, 1985, p. 12, fig. 9). One of the figures on this example even shows the Christian cross pendant often found on the Portuguese figures in the earlier carvings.

If this cup stand is Benin, it would be a late example of the style, dating from the end of the nineteenth century. It is here attributed to the Yoruba because of the comparatively broadly cut ornamental bands at the top and bottom that are not as fine as those on most Benin objects, the lack of intricate detail of the costume and coiffure, and the presence of what William Fagg calls the "Yoruba mouth," which he describes as "two parallel ridges not meeting at the corners" (Fagg and Pemberton, 1982, p. 49).

Published: Hall, 1926 (as Benin); Plass, 1957, pp. 36, 37, repro. (as Benin)

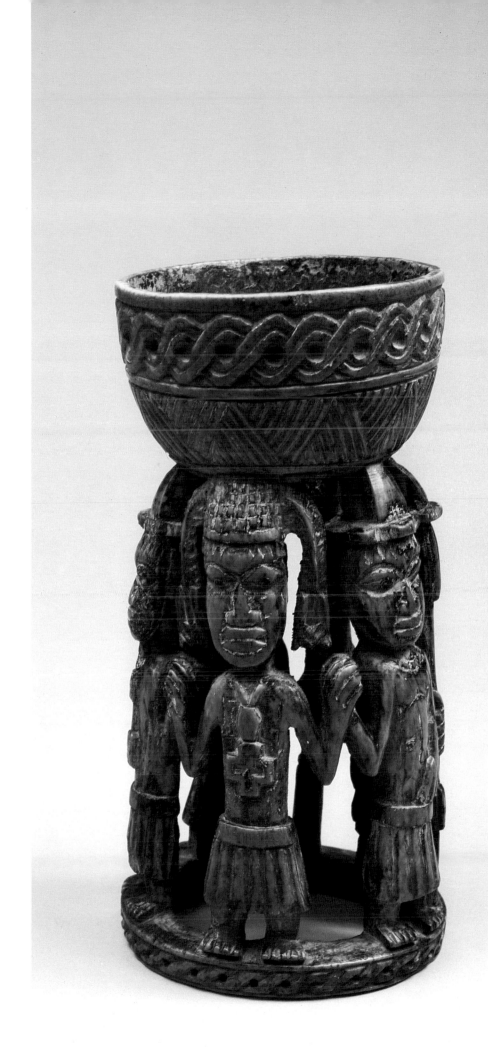

Yoruba, Nigeria
Ivory
Height 7⁵⁄₁₆″ (18.6 cm)
29-94-2
Purchased from W. O. Oldman
before 1929

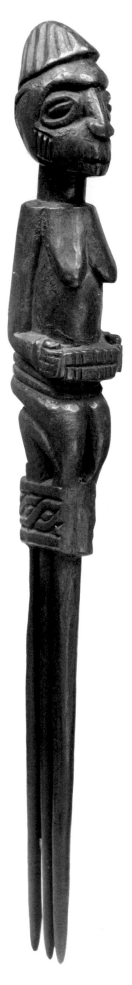

20 Comb

Art pervades every aspect of Yoruba society. Because much of it is of a relatively large scale or of great religious significance and interest, smaller objects of daily use are often ignored. However, well-carved domestic items are owned by the wealthy and, no matter what their size, serve as symbols of prestige and status.

The subject of the small Yoruba carvings is often emblematic of power (see Fagg and Pemberton, 1982, p. 128). This finely carved comb, for example, shows a kneeling female figure holding an offering, a common theme in Yoruba art that represents the concepts of respect and acceptance of authority. When worn in the hair, the comb served as a small but nonetheless significant symbol of the wearer's importance. The woman's large, bulging eyes, fleshy nose, and prominent mouth identify the Yoruba style. The interlocking braided motif below the figure is also a common Yoruba decorative detail (see no. 19).

Yoruba, Nigeria
Wood
Height 12¾" (32.4 cm)
AF 2040
Purchased from W. O. Oldman in 1912

21 Antelope Head

Among the Bini and Ishan, carvings of ram or antelope heads or human heads with ram's horns are placed on the altars of ancestors of chiefs to honor them. Each year, at the beginning of the yam harvest, sacrifices are made to the images, as it is believed that the ancestors so revered can make contact with the dieties whose life forces can ensure the fertility of crops (Fagg, 1963, pl. 102).

This sculpted antelope head is beautifully conceived to illustrate its role as an intermediary between man and god. The elongated, tapering, cylindrical form of the base is rare. One related example, in the Brighton Museum, was collected between 1905 and 1910 at the Igbo village of Isele-Uku in southern Nigeria (Bankes, 1975, no. 3). Most other images of this sort are heavier, and almost all are in the form of ram heads with downward curving horns (see de la Burde, 1972). Here, however, the elegant base supports the animal head, whose tall, slim horns and ears stretch to the sky. A stick was inserted into a hole cut into the back of the carving and made to rattle when sacrifices were made to the image.

This work is thought to have been made in Owo, a town about sixty miles north of Benin City. It has been published as having been collected at Benin during the Punitive Expedition launched by the British in 1897 (Plass, 1956, p. 30, no. 15-L). The carving was sold to The University Museum by W. O. Oldman with a group of Benin objects in 1921, and appears as number 9 on his list of objects offered for sale on February 4 of that year (see Oldman Lists, 1921–28). Oldman, however, does not state that it was part of the Punitive Expedition booty. If it was in fact collected at Benin City, it would have been taken from an altar in the quarter where the people from the Owo area lived.

Published: Hall, 1922, p. 165, fig. 76; Plass, 1956, p. 30, no. 15-L (as Owo, Yoruba); Plass, 1957, pp. 32, 33, repro. (as Owo, Yoruba); Plass, 1959, *Image*, p. 19, no. 98; Arts Council, 1960, no. 117 (text only); Fagg, 1961, cat. no. 101 (text only); Kunsthalle Basel, 1962, p. 28, cat. no. 82 (text only); Fagg, 1963, pl. 104b; Robbins, 1966, no. 151 (as Yoruba); Parrinder, 1967, repro. p. 67; de la Burde, 1972, p. 33, fig. 12

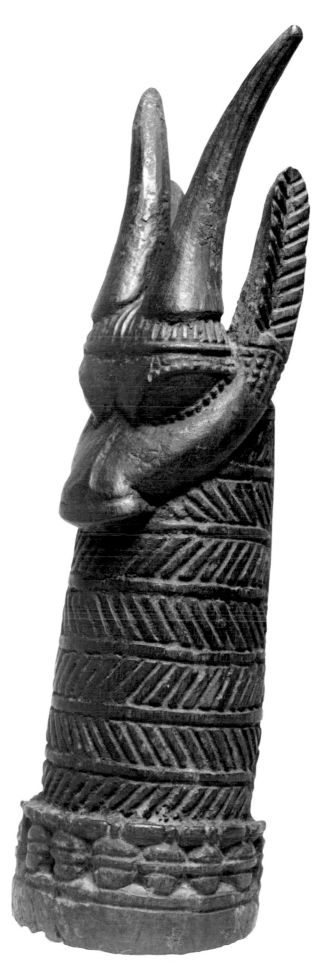

Bini, Nigeria, Owo region
Wood
Height 14¹⁵⁄₁₆″ (38 cm)
AF 5078
Purchased from W. O. Oldman in 1921

22 Dance Crest

The skin-covered headpieces of the middle and lower Cross River region of Nigeria and Cameroon are unique in the art of the world. Such sculpture, consisting of a wood core carved in the form of a human head over which animal skin has been stretched, is not found elsewhere. Although essentially naturalistic, these remarkable objects are often aggressive in their realism, and their forms are exaggerated almost to the point of caricature. Nonetheless, one of the principal fieldworkers in the area, Kenneth C. Murray, can write that these headdresses are "some of the most beautiful and striking works of art to be found in West Africa" (quoted in Nicklin, 1974, p. 8).

Skin-covered dance crests such as the one seen here are used by different societies whose membership is based on such criteria as age, sex, status, and accomplishments in hunting, warfare, and the like. They are worn at funerals, initiations, entertainments, and other occasions to benefit society members in various ways. There are, therefore, many forms of these headpieces (see no. 23). The most common type, represented by this example, is mounted on a small cap and worn on the top of the head with the aid of a string that is tied around the chin of the wearer, whose body is completely covered by a long gown. The appearance of the large crests, looming over the onlookers, is awesome.

This headdress represents a woman with a most elaborate coiffure composed of three spiral forms and two braided tresses in the rear, each made separately and then mortised into the head. Keith Nicklin attributes this crest to the Ejagham of the lower Cross River area. According to him, such headpieces were worn by members of the Nsikpe Society for the *ikem* masquerade; membership in this association was open to anyone who could pay the entry fee (see ibid., p. 68). He states further that this crest is the product of the Efut school of carvers who worked in the town of Calabar (1986, personal communication). Some crests of this type serve purely commercial purposes, but this one shows signs of ritual use.

Published: Horne, 1985, p. 14, no. 5 (as Ekoi or Ejagham)

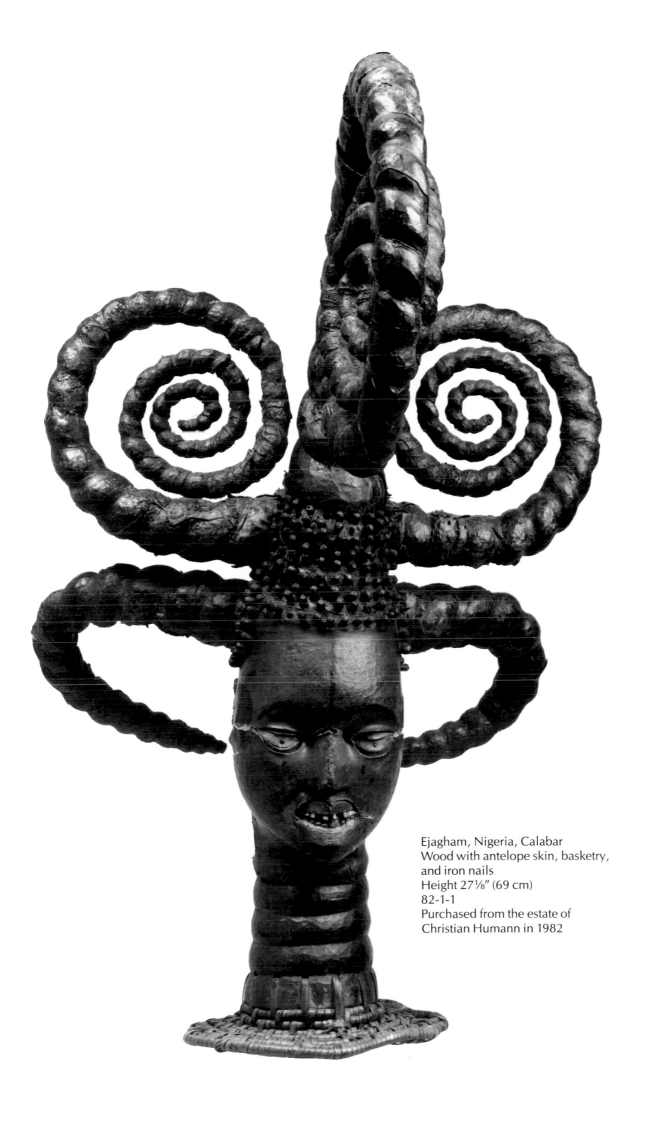

Ejagham, Nigeria, Calabar
Wood with antelope skin, basketry,
and iron nails
Height 27⅛″ (69 cm)
82-1-1
Purchased from the estate of
Christian Humann in 1982

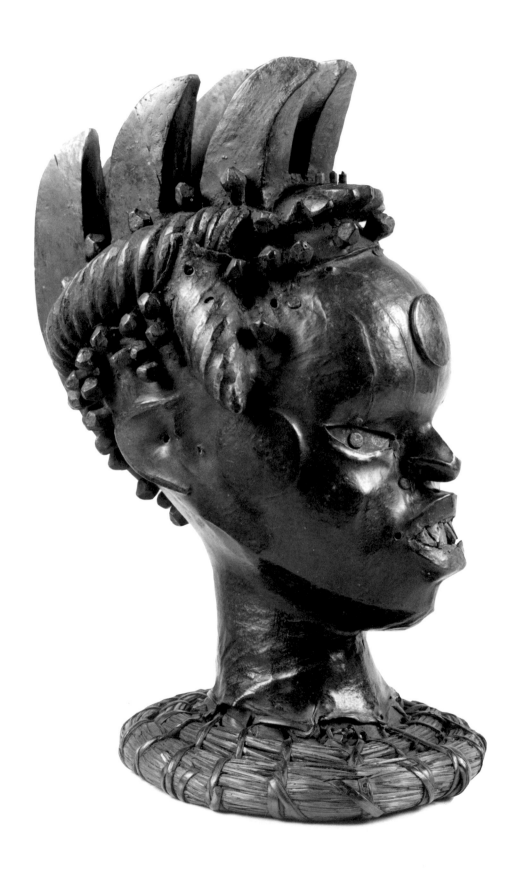

23 Dance Crest

Although on a smaller scale than the Ejagham dance crest (no. 22), this skin-covered headpiece makes an equally strong statement through its somewhat grotesque, even ugly naturalism. The open mouth with protruding, crooked teeth, slanting eyes, sharp, pointed nose, and jagged coiffure give great presence to the sculpture. This is clearly not an example of idealized court portraiture. Rather, its appearance is inspired by religious beliefs, and an overall otherworldly effect is created through the crest's strong, overbearing quality.

This cap mask is similar to those made for use by the Ekoi men's Oshirikong Society in funeral or entertainment ceremonies (see Nicklin, 1974, pp. 12, 67, fig. 13). Keith Nicklin believes this example is most likely the work of the Ukelle or Igedde, who live in the Ogoja area of the middle Cross River region (1986, personal communication). The raised disk forms on the forehead and temples are group markings often incorporated on crests to indicate ownership. The thick patina and dark brown color are the result of the frequent application of palm oil to maintain the object's power and the exposure to smoke from cooking fires when the crest was stored in the house of its owner.

Ukelle or Igedde, Nigeria, Ogoja region
Wood with antelope skin, basketry, glass beads, and iron nails
Height 11³⁄₁₆″ (28.4 cm)
73-2-1
Purchased from M. Hueguenin in 1973

24 **Maiden Masks** (*Agbogho Mmuo*)

Both of these masks were made for use in the same ceremonies in the early twentieth century, and both come from the northern part of the Igbo country around the towns of Onitsha and Awka. Worn by male dancers at the funerals of important women, they represent young women in the prime of their beauty. Young, beautiful women are important in Igbo society as a source of pride and an anticipated sum of bride-wealth for their fathers, which is paid at the time of their marriage. Igbo ideals of beauty are expressed here in the masks' long, straight, ridged noses, protruding mouths with well-shaped

a

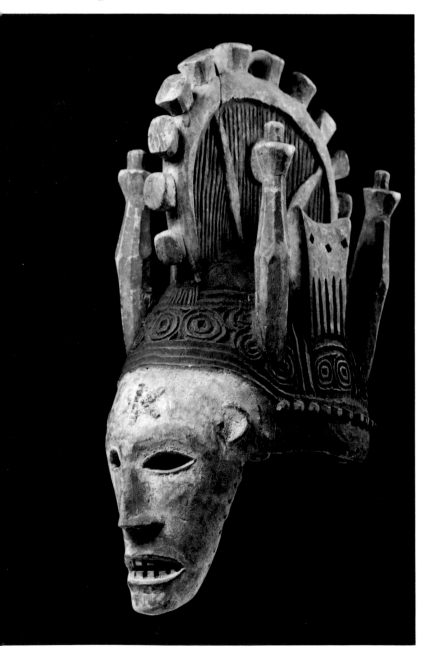

teeth, elaborate facial tattooing, and crested coiffures. The type is known as *agbogho mmuo*, which, loosely translated, means "adolescent female mask" (see Cole and Aniakor, 1984, pp. 120, 121).

The men who wear such masks instruct the carvers to incorporate certain details into the crests. There is therefore considerable variety in their appearance even though they are used for the same purposes. The costumes worn with *mmuo* masks are colorful compositions of appliquéd symbols, mirrors, feathers, and red and yellow pigments. The groups of dancers imitate the behavior and actions of Igbo women, often in slow and dignified movements. Other masks worn in the same ceremonies represent the mothers of the young maidens, thus signifying the presence of the maternal spirit.

These two fine maiden masks are notable for the subtle and naturalistic carving of their facial planes. They have comparatively simple crests that include animal forms and combs. Masks made more recently exhibit increasingly elaborate crests (ibid., p. 128, and figs. 224, 226, 233, pl. 25).

Published (no. 24a): Hall, 1920, pp. 46, 47, figs. 27, 28; Pijoán, 1931, p. 201, fig. 271 (as from the Ivory Coast); Philadelphia Museum of Art, 1969, repro.

Published (no. 24b): Wieschhoff, 1945, p. 55, fig. 19; Wingert, 1948, pl. 45; Wingert, 1950, pl. 45; Plass, 1956, p. 36, no. 18-G (text only); Plass, 1957, pp. 58, 59, repro.; Fagg, 1964, pl. 41; Fagg, 1966, p. 27, no. 24; Robbins, 1966, no. 196; Leiris and Delange, 1968, p. 315, no. 363; Cole and Aniakor, 1984, fig. 232

Igbo, Nigeria
a. Wood with white and black pigment
Height 18¾" (47.5 cm)
AF 3661
Purchased from W. O. Oldman in 1912

b. Wood with white, black, yellow, and red pigment
Height 17½" (44.4 cm)
AF 5371
Purchased from the estate of John Quinn in 1926

b

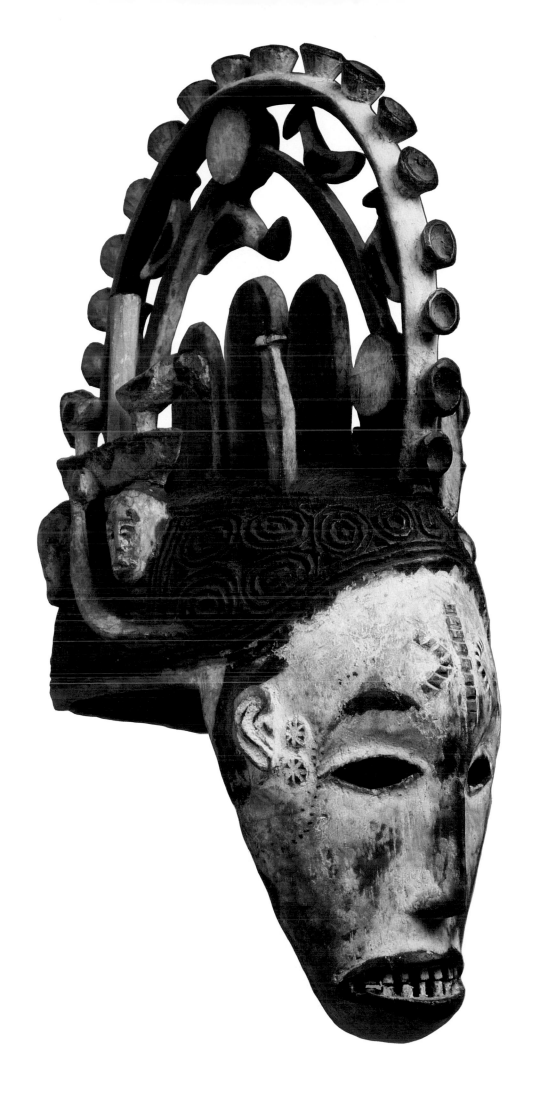

25 Squatting Figure

Stylistically, this fine and dynamically posed figure belongs to the Igbo group. The parallel ridges in the coiffure and neck, open mouth, pointed nose, half-closed eyes, disk forms on the temples and forehead, and white color are all diagnostic of this expression. The carving combines finely cut details with an energetic, forceful stance.

Unfortunately, there is no information concerning this object's use. None of the many figure sculptures of the Igbo are related to this squatting example, as they are usually shown standing upright or, rarely, in a seated position (see Cole and Aniakor, 1984, pp. 90–99, figs. 165–83, 185, pls. 18–21). Herbert M. Cole, who places the origin of the figure in the north-central region of the Igbo country near the towns of Awka and Onitsha, also suggests the possibility of its use in a shrine, noting that the Igbo did not make much secular sculpture (1985, personal communication). If so, this might have been a supporting figure for a larger god image that was placed along a shrine wall as part of a group, as such sculptures are often displayed (see Cole and Aniakor, 1984, p. 98, pl. 18).

Igbo, Nigeria
Wood with white, yellow, orange, and black pigment
Height 11½" (29.4 cm)
AF 3657
Purchased from W. O. Oldman in 1912

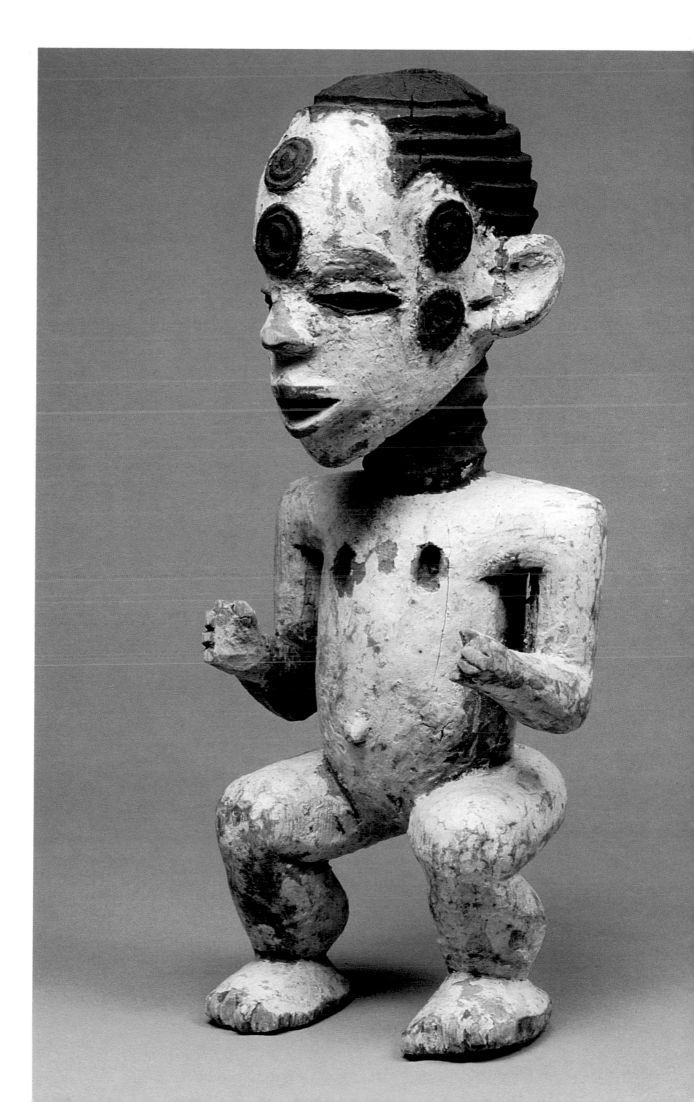

26 Seated Female Figure

This seated female figure displays a great sense of dignity and presence and demonstrates the skill of its carver in creating naturalistic representations of specific individuals. The sculpture is from the port of Brass, located on the Niger River delta. The town is so named because it became a major point of entry of European brass into West Africa during the nineteenth century. Its ruling chief Ockiya established a monarchy as he became wealthy and powerful from the trade. Following the earlier Nigerian sculptural traditions of Ife and Benin, he developed a realistic style of royal portrait sculpture to represent himself and members of his family, living and dead. This was unlike sculpture from other parts of the delta, which is considerably more abstract and is often in the form of animal spirits (see no. 27). It is probable that continued exposure to Europeans and their art (especially, as William Fagg has suggested [1963, pl. 111], to the figureheads of their ships) also influenced the growth of this unusual naturalistic expression.

At the end of the nineteenth century, when the family of Ockiya converted to Christianity, they gave the royal portrait sculptures of the deceased members of their family to missionaries, who sent them back to London, where they were dispersed to various collections. One example, a seated male figure, went to the Manchester Museum (ibid.), and three others were in the J. T. Hooper Collection in 1960 (Arts Council, 1960, pl. XXI, nos. 217–19; see also Hooper and Burland, 1954, p. 158, pl. 62).

Although smaller than most other known examples of this court style, The University Museum's figure is the best of the group in terms of the quality of its carving and the manner with which it projects the importance of the individual portrayed. The head and torso are typically carved of one piece of wood, but the now-missing arms, which are still in place on the Manchester figure and one of the Hooper objects, were made separately and attached with pegs at the shoulders.

Although the museum records show that this sculpture was acquired in 1917, its numbering suggests it belongs to the same series as a group of works purchased from H. Vignier in 1921 and sent to the museum in 1919. Both this figure and another, which is known to have come from the dealer (no. 36), were published in 1915 by Carl Einstein in his pioneering picture book on African sculpture (1915, pls. 51, 46). Einstein also illustrated the Senufo kpelie mask (no. 9) that The University Museum purchased from the Quinn estate in 1926 (ibid., pl. 99) and the Tshokwe staff (no. 69) that was acquired before 1929 (ibid., pl. 68).

Published: Einstein, 1915, pl. 51; Hall, 1919, cover, p. 81, fig. 26; Hall, 1920, p. 48, fig. 29; Pijoán, 1931, p. 170, fig. 231 (as from Gabon); Plass, 1957, pp. 46, 47, repro.; Plass, 1959, *Image*, p. 6, no. 3; Arts Council, 1960, no. 220b; Fagg, 1961, cat. no. 212 (text only); Kunsthalle Basel, 1962, p. 41, cat. no. 200 (text only); University Museum, 1965, repro. p. 115; Robbins, 1966, no. 194; Willett, 1971, p. 88, pl. 67 (with the Manchester figure); Price, 1975, repro. p. 123

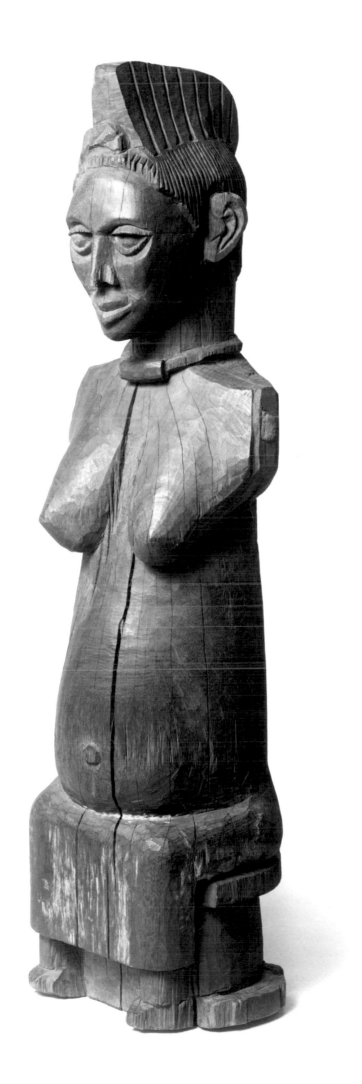

Ijo, Nigeria, Brass
Wood with white pigment
Height 33½" (85 cm)
AF 5122
Acquired in 1917

27 Headdress Mask

The Ijo people who live along the lower reaches of the Niger River delta are fishermen. Their houses are built on piles and rise above innumerable meandering creeks in the mangrove swamps. Their religion venerates water spirits with dances directed at balancing the forces of nature. As many as fifty such dances are held, each with its own costumes, masks, music, and movements, thus accounting for the great variety of Ijo water-spirit masks. These bold and disturbing works of art often combine human forms with such animals as hippopotamuses, sawfish, pythons, sharks, and, as seen here, crocodiles. Some lack specific reference to known animals and represent supernatural beings. The horizontal construction of these headpieces is obviously intended to imitate the floating and swimming of the creatures themselves, as do the motions of the dancers when they are worn.

This example, although smaller than many other water-spirit masks, is an extremely powerful work, full of aggression and predatory menace. As an expression, it is obviously different from many of the other naturalistic and classically beautiful creations of West Africa, and would be considered ugly by any standards. However, African carvers effectively employ such an aesthetic formula in some of their works to satirize, to show the effects of disease, to frighten away intruders, or, as here, to represent the unknown and not always benevolent supernatural world.

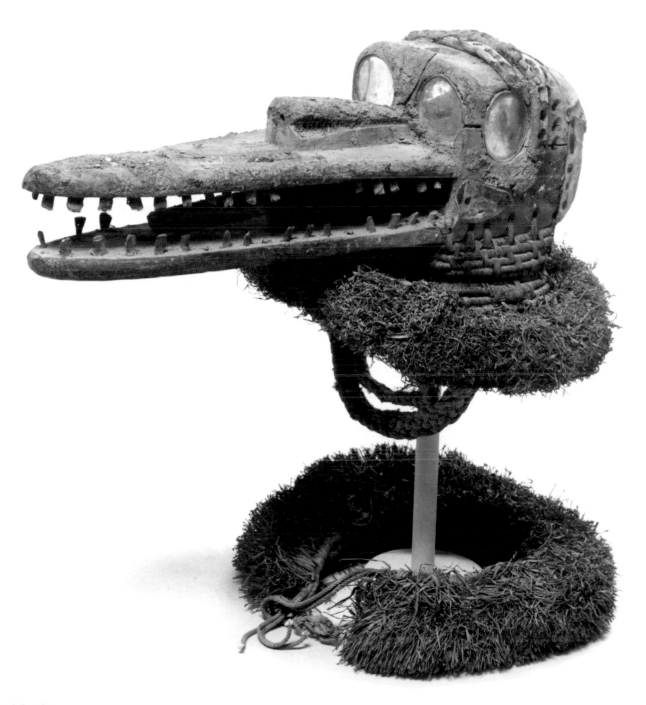

Ijo, Nigeria
Wood with mirrors, animal skin products, iron nails,
cotton cloth, raffia, basketry, and encrustations
Length 18⅛″ (46 cm)
70-8-1
Purchased from Georges Rodrigues in 1970

28 Male Reliquary Guardian Figure

A basic tenet of Fang philosophy is that the successful person is one who in bearing and actions can achieve a balance between the opposites that exist in the world and within the individual. Right and left, male and female, vitality and tranquillity, and determination and deliberation are among the opposing forces that must be brought into equilibrium (see Fernandez, 1966). In their conception as sculptures, the reliquary figures, masks, and other works of the Fang often reflect this philosophy. With this carving, for example, the frontal, symmetrical pose and meditative expression are offset by the full, rounded, dynamic forms of the legs and shoulders (see also no. 29).

Reliquary figures of the Fang are used for the same purposes as the Kota metalwork guardian images (see nos. 30a–c). They are placed with containers holding bones of ancestors to protect them from evil influences and from contact with women and uninitiated boys. This reliquary's high polish, particularly around the head, is the result of the repeated application and rubbing of palm oil to maintain its purity and power.

This male image comes from southern Cameroon, the home of the Bulu, and its close relationship to the better known guardian figures of the nuclear Fang region in Gabon is immediately apparent. William Fagg attributes it to the Bulu, pointing out that figures made by this group hold an animal horn, as here, while Louis Perrois places it with the Ntumu, a small group living south of the Bulu, just north of the Gabon border. The Reverend Matthew Henry Kerr, the Presbyterian missionary who collected the sculpture, worked among the Bulu in the Cameroons, which accounts for the attribution here. A snapshot of the figure appears in Kerr's field album, but unfortunately he gives no further information (see Kerr Field Album, 1893–99).

Published: Fagg, 1970, p. 69, cat. no. 67; Perrois, 1972, p. 195, figs. 113, 114 (as Ntumu)

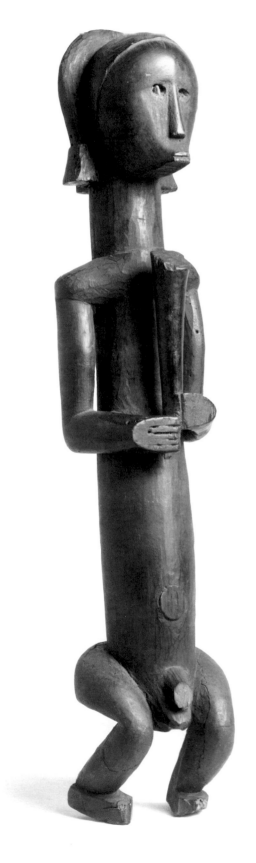

Fang, Bulu subgroup, Cameroon
Wood with inset tooth
Height 23¼" (59 cm)
68-18-1
Collected by the Reverend Matthew Henry Kerr in the Cameroons between 1892 and 1899, and given by his daughter-in-law Mrs. S. Logan Kerr in 1968

29 Standing Figure

Although this image is similar to the reliquary guardian figures of the Fang (see no. 28), certain aspects suggest that it may not have been placed with a reliquary container. Instead of having been rubbed with palm oil, for example, the body was painted white and the legs and hair were colored black. Furthermore, the post extending from the buttocks that is often found on figures of this type and would have anchored it to the reliquary container is also missing.

Despite its somewhat unusual nature, this sculpture could have served as a protective figure of some kind. Especially notable are the large, round, "all-seeing eyes" so often emphasized on objects designed to be watchful for threats, particularly those that might come at night (see Vogel, 1986, pp. XVI, no. 98; pp. 126, 127). In its conception as a metaphor for the Fang philosophy of achieving balance in all things, this figure is even more successful than the Bulu image (no. 28). The use of white and black and the suggestion of an inner energy in the full and bulging muscular forms that are balanced against a completely frontal and symmetrical pose provide visual references to this belief.

Stylistically this work falls into Louis Perrois's "longiform" category of Fang sculpture, which places it in the northern Fang area, probably among the Ntumu, a subgroup in northern Gabon, eastern Equatorial Guinea, and southern Cameroon (1985, pp. 139–41, cat. nos. 62–64). A smaller example of the same type of figure, which has been called a reliquary guardian, was collected by Dr. Albert L. Bennett in the 1890s and is now in the Denver Art Museum (see Batkin, 1979, p. 29, fig. 11).

Published: Plass, 1956, p. 44, no. 28-I; Plass, 1957, pp. 56, 57, repro.

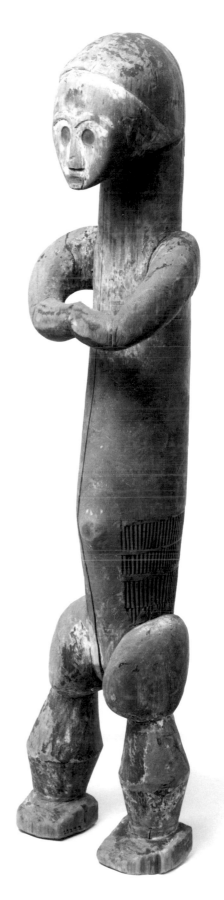

Fang, Ntumu subgroup, Gabon/Equatorial Guinea/Cameroon
Wood with traces of black and white pigment
Height 30½" (77.5 cm)
AF 22222
Collected by the Reverend Robert Hamill Nassau at
Lambaréné, Gabon, between 1874 and 1891,
and given by Dr. Thomas G. Morton in 1901

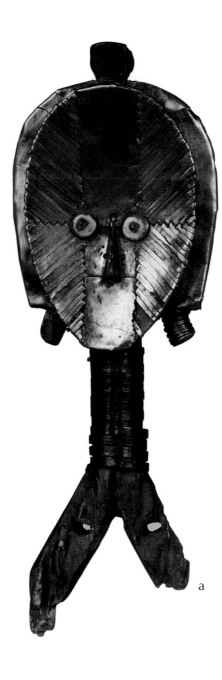

a

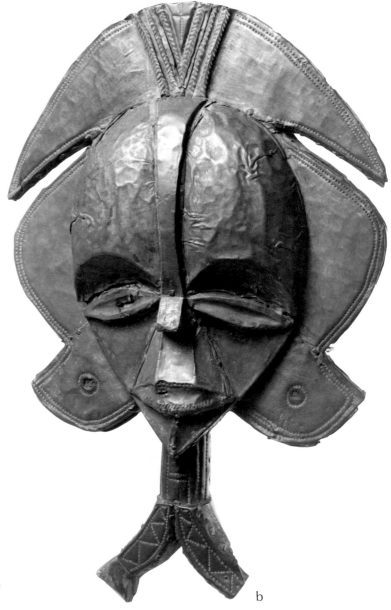

a. *Bwete*
Kota, Shamaye subgroup, Gabon
Wood with copper, brass, and ivory
Height 13¼″ (33.5 cm)
29-12-240
Purchased from J. Laporte in 1929

b. *Mbulu Ngulu*
Kota, Obamba subgroup, Gabon
Wood with copper and brass
Height 17⅜″ (44 cm)
29-12-191
Purchased from J. Laporte in 1929

c. *Mbulu Ngulu*
Kota, Mindassa-Bawumbu subgroup, Gabon/Congo
Wood with copper, brass, and iron
Height 18⅞″ (48 cm)
29-12-227
Purchased from J. Laporte in 1929

b

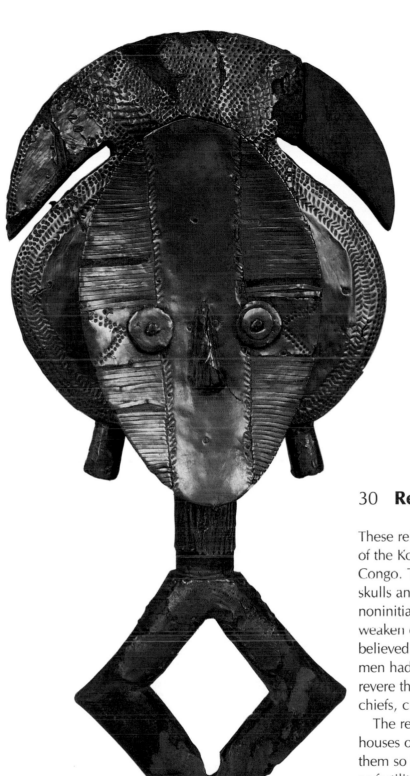

c

30 **Reliquary Guardian Figures**

These reliquary objects come from three subgroups of the Kota people of eastern Gabon and western Congo. They were placed on baskets containing skulls and bones of ancestors to guard them from noninitiates and evil forces that threatened to weaken or pervert the power of the relics. It is believed that skulls retain the powers that certain men had during their lifetime. The Kota especially revere the remains of those who were judges, chiefs, craftsmen, or religious practitioners.

The relics and their guardians are kept in the houses of family heads, and offerings are made to them so that they will bring the family such benefits as fertility, success in hunting, health, and prosperity. At times, all the relics of a village are brought together and danced with in *bwiti* ceremonies to help and protect the entire community (see Siroto, 1968). Each guardian figure has its own name and reputation, and, despite the restrictions imposed by such a proscribed sculptural style, no two of the hundreds known are exactly the same (see, for example, Chaffin and Chaffin, 1979). Their presence in such large numbers in Western collections is the result of their owners' willingness

to sell the figures, which can be replaced, whereas the relic baskets themselves are almost always carefully kept.

In general, Kota reliquaries are two-dimensional reliefs consisting of a large wooden head over which brass and copper strips and sheets have been applied. A crescent-shaped coiffure rises above the head, and two broad forms flare out at both sides to form the lower part of the coiffure. The open, diamond-shaped base (on nos. 30a,b this has partially eroded away), which is an abstraction of the arms of the figure (see no. 31), is partially covered when the image is set into the reliquary basket. To stress the reliquaries' role as protectors, the eyes are large or emphasized in other ways to reinforce the sense of watchfulness they would transmit to any intruder.

The copper and brass used in these figures were obtained from large European basins, known as neptunes, that were brought into Gabon by traders and used for prestige display and currency. These metals were also available in rolls of wire and bars. The monetary value of copper and brass to the Kota is an important factor in determining their use in the manufacture of the guardian figures.

These three examples were chosen from a group of fifty-eight Kota reliquaries that came to The University Museum in 1929. They give some idea of the variations on a single theme that are to be found in this unique sculptural expression. The names, places, and style attributions assigned to these images have been drawn from the work of Louis Perrois, who has categorized and localized Kota styles (1976, pp. 151–209, figs. 12–26; 1985, pp. 42–50). The Shamaye figure (no. 30a) is of a type known as *bwete,* a name that refers to an ancestor cult of certain Kota groups (see Perrois, 1985, p. 50, category II, variation 1, and p. 231; see also p. 189, no. 6). The term *mbulu ngulu* (meaning "reliquary basket with a face," with the word *ngulu* designating the image itself) is applied to sculptures such as these from the Obamba (no. 30b [see ibid., p. 51, category V, variation 3, and p. 232; see also p. 191, no. 10]) and the Mindassa-Bawumbu (no. 30c [see ibid., p. 50, category III, variation 1, and p. 232; see also p. 190, no. 8]).

Kota reliquaries have long been popular among collectors. As works of striking design and fine craftsmanship, they are spectacular and immediately appealing. Appreciation for the Kota form in Europe also gained much from its relationship to the conception of some of Picasso's faces and dancing figures from 1907 (Rubin, 1984, vol. 1, pp. 266–71, 300–303). Paul Klee also adapted the form into a figure study of 1913 (ibid., vol. 2, repro. p. 499).

Published (no. 30b): Hall, 1932, pp. 164, 165, pl. IX; Plass, 1957, pp. 50, 51, repro.

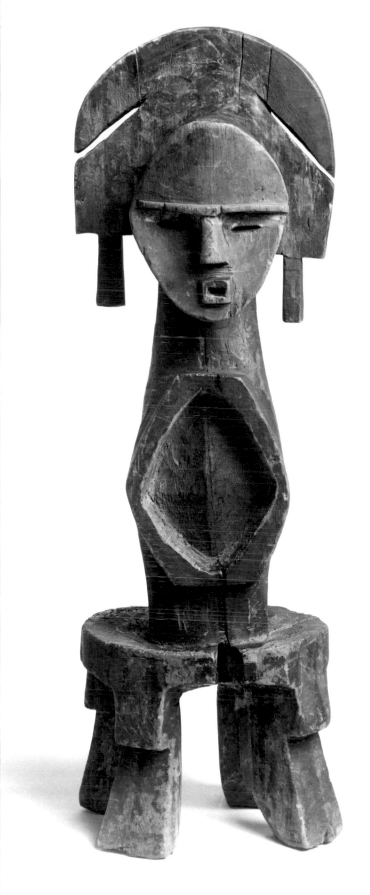

31 Half-Figure on Stool

The Kota are best known for their reliquary figures that are basically two-dimensional sculptural expressions (see nos. 30a–c). Works in the round from this group are extremely rare, and only five such figures, including this example, are known (Plass, 1957, p. 52). It is possible that they represent an earlier style from which the reliquary form developed, but this theory cannot be corroborated by any collection data.

In this half-figure, a close stylistic relationship to the reliquaries is found in the concave form of the face, the domed, convex forehead, the open mouth showing teeth, and the broad, arched coiffure with pendants at the ends. The arms and hands are represented by a simple diamond-shaped abstraction that is clearly related to the openwork lozenge shape of the base on the reliquaries, which is also most likely a depiction of arms.

Nothing is known of the significance of this figure. One of the others in the group, now in the Museum Rietberg, Zurich, is described as an ancestor figure that "the Bakota refer to . . . as 'a portrait of the spirit of the dead'" (Leuzinger, 1963, p. 168, no. 115). Another, in the Musée d'Ethnographie de la Ville d'Anvers, is called a probable guardian figure (Palais des Beaux-Arts, 1966, no. 28). Because of formal similarities The University Museum's work shares with the reliquaries, it could also have been used as a guardian. Certainly its minimal shape and its conception as a series of rigid, geometric forms give it an uncompromising aspect, just the sort of expression expected to be transmitted by an object designed to ward off evil and repel the uninitiated.

Published: Plass, 1956, p. 41, no. 26-A; Plass, 1957, pp. 52, 53, repro.; Fagg and Plass, 1964, repro. p. 36; Robbins, 1966, p. 185, no. 243; Leiris and Delange, 1968, p. 327, no. 376; Trowell and Nevermann, 1968, repro. p. 151; Anton et al., 1979, repro. p. 401; Perrois, 1985, p. 49, fig. 35

Kota, Gabon
Wood with brass staple
Height 22⅝" (57.5 cm)
30-52-1
Purchased from Jan Kleycamp in 1930

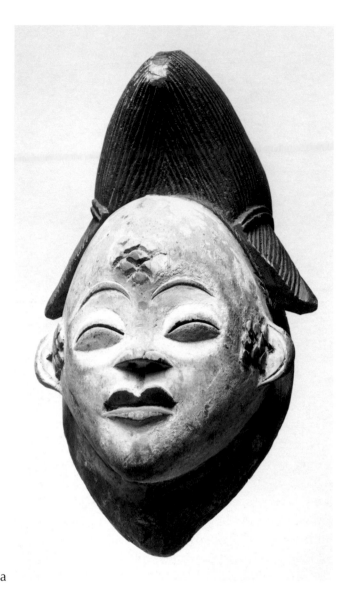

a

33 **Masks** (*Okuyi*)

Masks of this type are traditionally identified as Mpongwe or Lumbo, and specific collection data on them is usually lacking. They became particularly popular among European collectors in the 1920s and 1930s, partly because they were seen to be somewhat similar in appearance to Japanese No masks. Many examples were gathered at various parts of Gabon and sent to the port of Libreville for sale and shipment without any documentation other than that they had come from the Ogowe River area. Recent scholarship has now made it possible to make more exact attributions for the numerous stylistic variations among them. It has been shown that none could be from the Mpongwe of the Gabon estuary for both stylistic and iconographic reasons, and that all were made in regions in the interior to the south and west (Perrois, 1985, pp. 99, 100).

These two fine masks represent the style of Gabonese white-faced masks most commonly found in Western collections, and are from the area of southern and central Gabon near the Congo border inhabited by the Punu and Lumbo (see ibid., p. 206, no. 41). The masks' three-part coiffures, pursed lips, raised eyebrows, naturalistic features, and scarification patterns are characteristic of this expression.

Masks of this sort, which are used by a men's society of both the Punu and Lumbo called Okuyi, represent the spirits of dead maidens who return to participate in funeral ceremonies. As seen here, the *okuyi* masks can be regarded as realistic, but in use they take on quite a different aspect, for they are worn by dancers on high stilts who tower ten to fifteen feet above the ground and wear costumes that reach to their feet as they perform highly skillful acrobatic dances. In context, the faces therefore appear to be small and out of proportion to the elongated figure, and the masks take on ghostly and otherworldly aspects (see Vogel and N'Diaye, 1985, p. 146, no. 62).

Published (no. 33a): Plass, 1957, pp. 54, 55, repro.

Punu or Lumbo, Gabon
a. Wood with white, red, and black pigment
Height 12¾" (32.5 cm)
29-12-171
Purchased from J. Laporte in 1929

b. Wood with white, red, and black pigment
Height 10½" (26.7 cm)
29-12-175
Purchased from J. Laporte in 1929

b

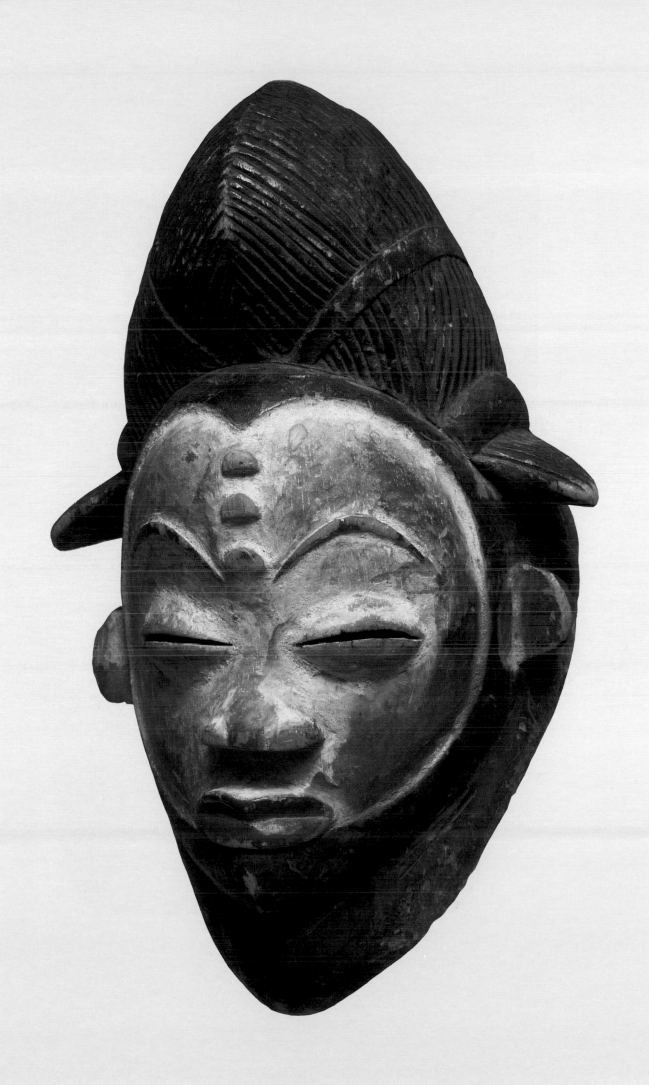

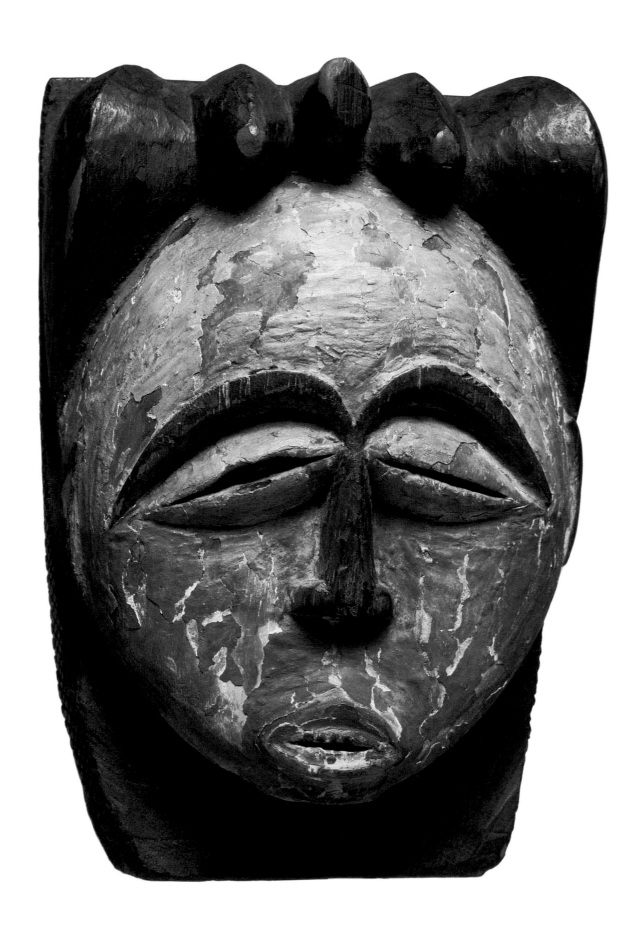

34 Mask

It is difficult to assign this mask to a specific group. It was published by Margaret Plass in 1959 as Kwele, an attribution that it carries without documentation on its accession card. It seems, however, to lack the elegant and curvilinear heart-shaped forms so common in Kwele masks, displaying a rougher and somewhat cruder treatment of the facial features and general shape. In its slit, protruding eyes, bold, arched brows, and pronounced, vertical nose, this mask shows some affinity to the Tsogo mask style, but these details are usually somewhat more flattened on Tsogo sculptures. Leon Siroto suggests that this example comes from central Gabon, possibly even from the Fang or some closely related group (1985, personal communication).

The conception of the mask as a spherical face emerging from a rectangular form is most unusual in West African art. This work has an unsettling aspect caused by the asymmetrical placement of the mouth, the large, bulbous, nearly closed eyes, the thick strands of dark hair, and the use of the white color so often associated with ghost spirits in Gabon.

Published: Plass, 1959, *Image*, p. 25, no. 126 (as Kwele)

Undetermined group, Gabon
Wood with white, red, and black pigment
Height 11¼" (28.5 cm)
29-35-20
Purchased from Lena H. White in 1929

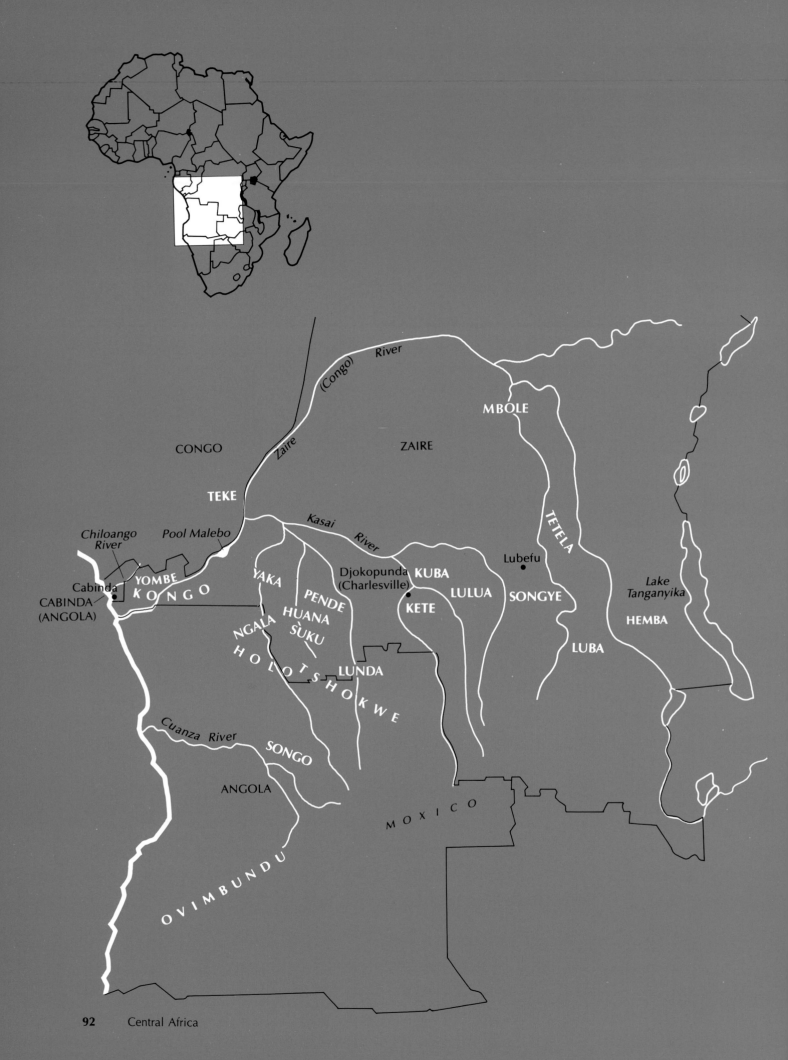

Chiloango River

Pool Malebo

(Congo) River

Zaire

CONGO

ZAIRE

MBOLE

TEKE

Kasai River

Cabinda

YOMBE

KONGO

CABINDA (ANGOLA)

YAKA

PENDE

HUANA

NGALA

SUKU

LUNDA

Djokopunda (Charlesville)

KUBA

KETE

LULUA

Lubefu

TETELA

SONGYE

Lake Tanganyika

HEMBA

LUBA

H O L O T S H O K W E

Cuanza River

SONGO

ANGOLA

M O X I C O

O V I M B U N D U

CENTRAL
AFRICA

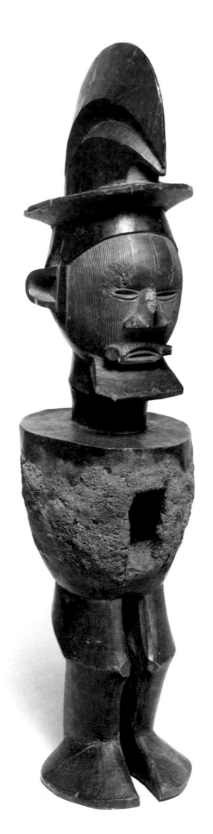

35 Standing Male Figure

Most Teke sculpture is in the form of a standing male magic figure carved with angular, clearly defined details such as can be seen here. The magic material placed around and in the abdomen is sometimes actually modeled to create this part of the body. In this example, this substance has been removed from the rectangular cavity at the navel, but traces remain around the cylindrical torso.

Each such figure is used by a family for a specific purpose, such as to protect children, to ward off evil and disease, and to bring prosperity and success in hunting. The object's power is drawn from ancestral sources, and the magic material contains the hair of elders as well as chalk, which symbolizes their bones (Willett, 1971, p. 160).

The Teke magic figures range in height from about five to twenty inches. As demonstrated by this example, notable features of the Teke style are the broad, rectangular, spadelike beard, the prominent, flattened nose, and the parallel striations on the face that represent scarification patterns. The regular and exact application of these striations is achieved by the use of the iron combs with which the Teke scar their faces. Teke sculpture is related to that of the Yanzi to the south, which also shows parallel facial scarifications and a similarly cubistic, planar treatment of anatomical forms.

Teke, Congo
Wood with black pigment and magic material
Height 16¼" (41.3 cm)
69-2-1
Purchased from Georges Rodrigues in 1969

36 Standing Female Figure

The Teke are known mostly for their small, squat figures that have large amounts of magic material affixed to their bodies (see no. 35). This image is an unusual example of their style, and William Fagg (1970, p. 76) suggests that it might come from a Teke group living close to the Suku or Huana, whose sculpture features the hands-to-chin pose and the elongated body seen here (see no. 46). Fagg states further that this figure may not have been used for a magical purpose because there is no magic material at the abdomen or the head. However, the addition of an animal claw at the back of the head, noted by Henry Hall (1920, p. 28), indicates that it did indeed serve a magical function.

There is a benign quality to this sculpture. The soft modeling and the worshipful positioning of the hands convey the feeling of a benevolent image designed to bring benefits to those who used it rather than an aggressive object conceived to ward off evil forces. It was acquired by The University Museum with the great Luba stool (no. 62) in 1921, and had appeared in Carl Einstein's seminal *Negerplastik* of 1915.

Published: Einstein, 1915, pl. 46; Hall, 1920, p. 28, fig. 11; Sweeney, 1935, p. 49, no. 396 (text only; as from the French Congo); Fagg, 1970, p. 76, cat. no. 76

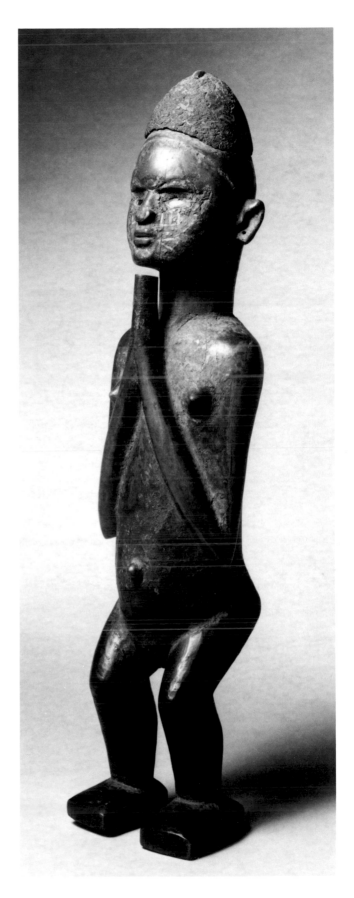

Teke, Congo
Wood with glass, white pigment, and animal claw
Height 23⅞" (60.5 cm)
AF 5119
Purchased from H. Vignier in 1921

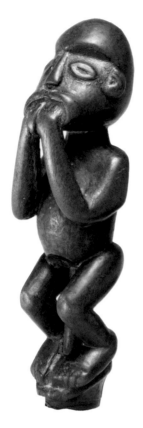

Kongo, Zaire
Wood
Height 3¹¹⁄₁₆″ (9.4 cm)
AF 4701
Purchased from Dikran Kelekian in 1917

37 Standing Male Figure

The Kongo live in the area of Zaire between the Atlantic Ocean and Pool Malebo (formerly Stanley Pool). Because of their location on the coast, they have had contact with Europeans from as early as the late fifteenth century, when the Portuguese made their first appearance. Since then traders, explorers, and missionaries have regularly passed through the region. One result of this continued exposure to Western cultures has been the evolution of a realistic expression in Kongo sculpture that can be found in both their figures and masks.

With the exception of the exaggerated size of the head, the forward-jutting chin, and the almost geometric treatment of the back, the proportions and pose of this figure are extremely naturalistic. The hands-to-mouth pose can sometimes be found on the small magic figures of the Kongo; Robert Ferris Thompson describes it as an "invocatory gesture." At the end of a divining session, a religious practitioner sometimes places his hands to his mouth and whistles to signify that the spirits have been called upon and have received the message (in Vogel, 1981, pp. 208, 210, no. 124).

The even patina and well worn surface of this figure indicate considerable handling. The Kongo people use many objects of decorative art in their daily lives, and this image may have been part of a scepter, fly whisk, or utensil. Henry Usher Hall has suggested that it might have been "the handle of a wooden bell or rattle" (1923, "Woodcarvings," p. 82).

Published: Hall, 1923, "Woodcarvings," p. 82, fig. 12

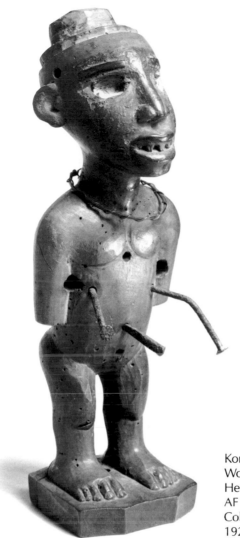

Kongo, Zaire
Wood with iron nails and brass wire
Height 8¾″ (22.2 cm)
AF 5174
Collected by Captain C. Blank in the Belgian Congo before
1920, and purchased from W. O. Oldman in 1924

38 Standing Male Figure

The exact use and significance of the many small Kongo magic figures cannot be known unless they are accompanied by accurate collection data provided by the original owner or the diviner who had given them their specific powers. Each image was sold by its carver to an individual who wanted to fulfill a certain need. The purchaser then took the object to a specialist who added magic materials, named it, and described its functions. There is therefore no relation between the pose and expression of these figures and their magical attributes because the artists who made them had no idea of the purpose with which they would ultimately be charged. In addition, some magic figures now in collections may never have been activated, but simply purchased directly from carvers by foreign collectors (see Volavkova, 1972).

This sculpture is well carved, with naturalistic features and details down to the toenails. It was probably made to be visually appealing both to attract a buyer and to serve as a proper receptacle for its future magical powers. The frontal, forward-leaning pose is quite common among these small, originally privately owned images. Despite the several nails embedded in this example, these sculptures were never used as nail figures (see nos. 39–41), and, as The University Museum's accession book and card both suggest, the nails (and the wire necklace as well) were probably added to enhance its interest to the foreign purchaser, in this case Captain C. Blank, who was in the Kongo area just before 1920. It is thus probable that this is one of those small figures that never was actually placed into use.

39 Nail Figure (Nkisi N'kondi)

The University Museum has a particularly large and fine collection of human sculptures that were used for magic purposes by the Kongo peoples (see also nos. 38, 40, 41). Of the nail figures, this is the finest and probably the oldest example. As a sculptural form, the nail figure is unique to Africa, and it is well known in collections in the West. Such figures are popularly and simplistically referred to as "nail fetishes," and much false information has been written about them. Only in recent years has the true significance of these arresting images begun to emerge.

Nail figures of the size seen here have great power and are the property of an entire village. The image is thought to attract great spirits and is accordingly made appealing to them by the addition of magic material, in this case placed in a container behind the mirror in the abdomen. The figure is charged with its power by special practitioners, who are the only ones who can interpret the decisions of the image or direct its magic to achieve the desired results.

Nail figures are used for such a large number of purposes that their exact significance can only be hypothesized. Among their more important roles are to protect the village from evil, to prove guilt or innocence, to solve other legal issues such as land disputes and disagreements between married couples, and to end threatening events such as drought and famine. An image closely related to this one, for example, was recently described "as surrogate chief, judge, notary, priest, physician, peacemaker, avenger, lie detector, and receiver and transmitter of good and evil forces" (Henshaw, 1985, p. 68).

The Kongo term for a nail figure is nkisi n'kondi: Nkisi refers to the figure itself, while kondi is derived from the verb konda, meaning "to hunt," and indicates the image's role in seeking justice and the correct solution to the problems that are brought before it. Oaths are sworn before such a figure, and a nail or blade is then hammered into the wood to represent the agreement that has been made between the client and the forces within the image. Different types of nails and blades are used to denote specific matters brought before the figure. Some are wrapped with twine or cloth to identify the particular role the spirit is being asked to play. If a dispute is resolved or an individual declared innocent, the nail or blade is sometimes removed.

The symmetrical arms-to-abdomen pose of this example is called pakalala and signifies the presence of a spirit that has the strength and ability to make especially difficult decisions (Thompson and Cornet, 1981, p. 39). The figure's long period of use is indicated by the large number of pieces of embedded metal and the erosion of the wood. With its intense expression, forward-leaning pose, half-open mouth (perhaps to indicate speaking), and powerful, muscular legs, this is a work designed to command respect and awe. Ezio Bassani (1977, pp. 39, 40) has identified it as one of the creations of the Chiloango River workshop, which is known to have produced some of the largest and most impressive nail figures.

Published: "African Sculptures," 1930, p. 60, pl. X; Sweeney, 1935, p. 51, no. 436 (text only); Plass, 1956, p. 46, no. 31-D; Plass, 1957, repro. p. 75; Plass, 1959, Image, p. 28, no. 143; University Museum, 1965, repro. p. 121; Bassani, 1977, p. 40, fig. 8

Kongo, Zaire, Chiloango River region
Wood with iron nails and blades,
mirror, and magic material
Height 41⅜" (105 cm)
30-46-2
Collected at Cabinda, and purchased
from Sumner Healy in 1930

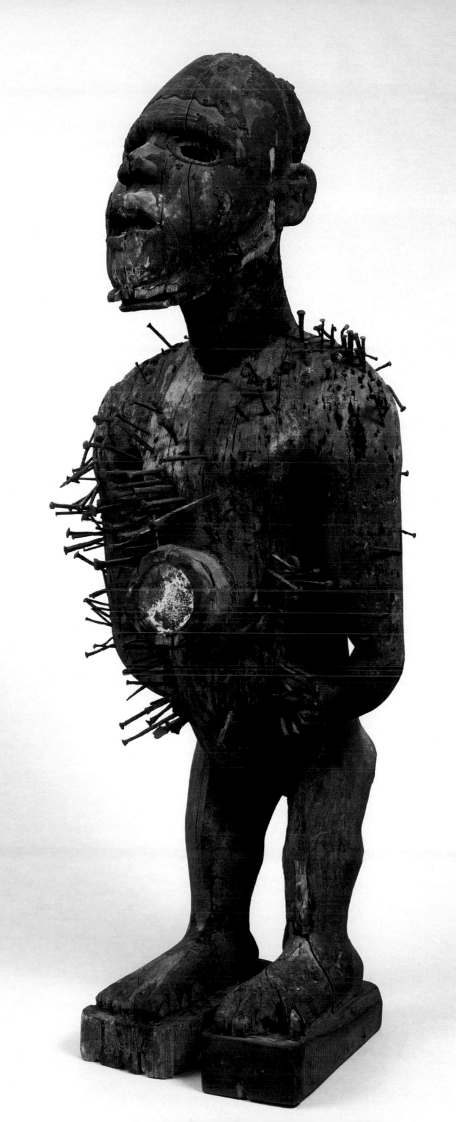

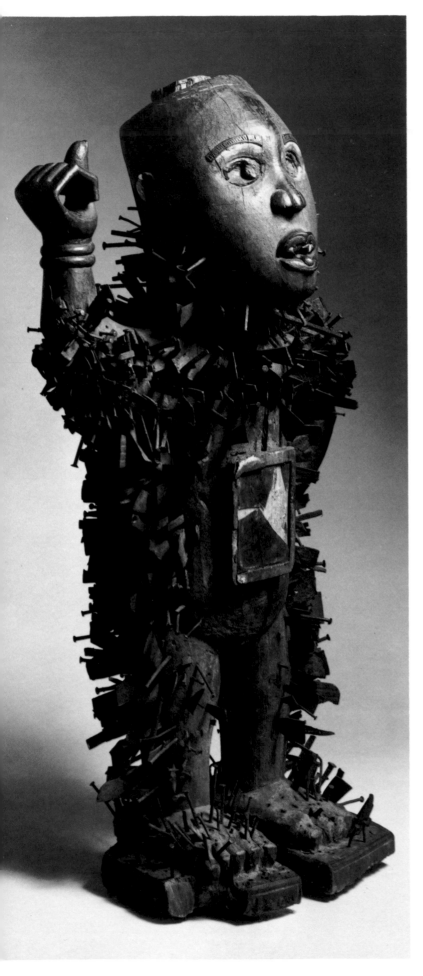

40 **Nail Figure** (*Nkisi N'kondi*)

Although this sculpture, like another in the collection (no. 39), is a large-scale Kongo magic figure for community use, the pose of its arms indicates that it is of a different type. Unlike the other image, which assumes a symmetrical arms-to-abdomen posture, this nail figure stands in an asymmetrical position with its left hand on its hip and its right arm raised to hold a now missing spear. This stance is often interpreted as aggressive and thus suggests a protective function for the image. Many different types of iron nails and blades have been driven into almost every part of the torso, each, as it was added, representing a specific judgment reached or other role performed by the figure.

Despite the fact that the body of this sculpture is almost completely obscured by the nails and blades, the treatment of the face reveals a naturalistic aesthetic. The open mouth suggests that the image is speaking to the beholder (see also no. 39), thereby adding to its supernatural aura. The space behind the mirror in the abdomen holds magic ingredients such as mud from a fertile riverbank, small parts of animals such as bones and teeth, branches, leaves, clay, and blood, all of which give the figure its efficacy. Other powerful materials, originally affixed to the top of the head with a mud paste, are now gone, perhaps removed when the object was deconsecrated and sold to a collector. This, like another nail figure in the collection (no. 41), is attributed to the Yombe subgroup of the Kongo kingdom because of its similarity to others known to have come from this area (see Lehuard, 1980, pls. 115, 119, 121).

Published: Hall, 1924, "Fetish," repro. p. 63; Pijoán, 1931, p. 109, fig. 254; Plass, 1957, repro. p. 75; Plass, 1959, *Metals,* no. C-1; Horne, 1985, p. 15, no. 6 (as Loanga or Yombe)

Kongo, Yombe subgroup, Zaire
Wood with iron nails and blades, mirrors, magic material, and traces of white pigment
Height 33⅛" (84 cm)
AF 5361
Purchased from W. O. Oldman in 1923

41 **Nail Figure** (*Nkisi N'kondi*)

This nail figure is of the same type as another in the collection (no. 40), and is similarly attributed to the Yombe. Once again, it is impossible to know the exact significance of the image without information from those who used it or invested it with its powers (see no. 39). Such figures are generally said to defend against witchcraft, spells, and other evils. The right hand held a spear, and the pose is one of active aggression, which provides a tangible expression for the action of warding off malevolent powers.

The use of mirrors on many Kongo magic images (see also nos. 39, 40) is particularly appropriate. Their placement in the eyes refers to the supernatural abilities of the diviners to see into the world of spirits and look into the future. The large mirror at the abdomen, glued into place by the magic material it covers, serves to reflect and repel evil.

Although this image appears to be old and has a thick patina of magic material and white pigment, the fact that only a few nails have been driven into it suggests that it was not called upon to exercise its powers on many occasions, perhaps because it was found to be ineffective. The dearth of nails studding the torso enables us to study the sculpture itself and note the simplified treatment of the parts of the body that were destined to be covered with nails and thus ultimately obscured from view.

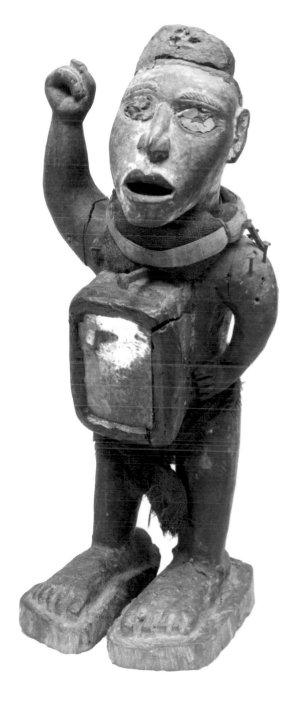

Kongo, Yombe subgroup, Zaire
Wood with iron nails, wool and cotton cloth, mirrors, magic material, and white pigment
Height 15¾" (40 cm)
AF 3684
Purchased from W. O. Oldman in 1912

42 Dance Staff (*Thafu Malwangu*)

The leader of a Yombe boys' initiation society called Khimba carried this staff in dances associated with teaching them the beliefs of the adult community. The seed shells at the base make a rattling noise when the object is used. Collection data states that the two figures seated back to back represent the mythical twins Makuala and Matundu, who are spirits of a rainbow cult (Hall, 1932, p. 164). Additional information accompanying a similar staff in the Clark and Frances Stillman Collection of Congo Sculpture at the Dallas Museum of Fine Arts records that the initiation period for the Khimba cycle lasts four years. The animating spirit for the society is a snake that reaches heaven by climbing a rainbow. The significance of the seated pose of each figure with upraised hands carrying a pole is unclear, but may relate to the rainbow symbol. A similar example, in the Musée Royale de l'Afrique Centrale in Tervuren, Belgium, was collected by Daniel in 1912 (Walker Art Center, 1967, pp. 22, 64, no. I.30).

The style of this staff's carving, with its right angles and somewhat rigid treatment of the human form, is at variance with the more common naturalistic Yombe sculptural expression (see nos. 40, 41). Particularly fine details are the carving of the facial features and the scarification patterns on the abdomens.

Published: Hall, 1920, p. 52, fig. 33; Hall, 1932, pp. 164, 165, pl. IX

Kongo, Yombe subgroup, Zaire
Wood with raffia, kaolin, and sapodilla seed shells
Height 21⅝" (55 cm)
AF 35
Collected by the Reverend W. H. Leslie in the lower Congo River region, Congo Free State, at the beginning of the twentieth century, and given by him in 1905

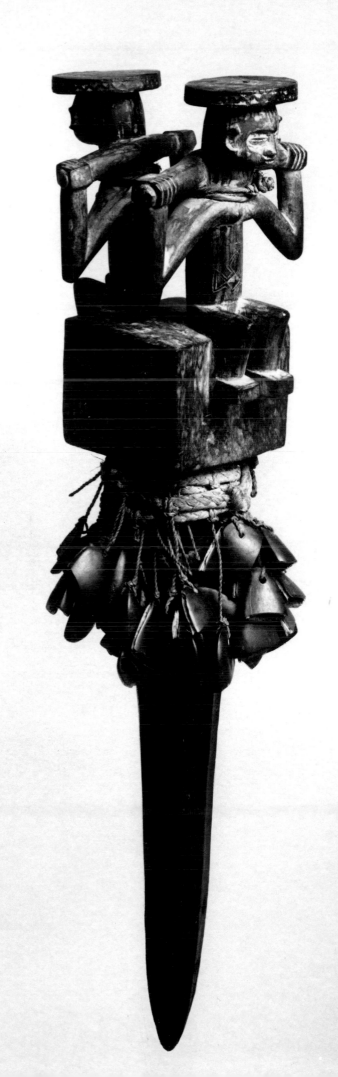

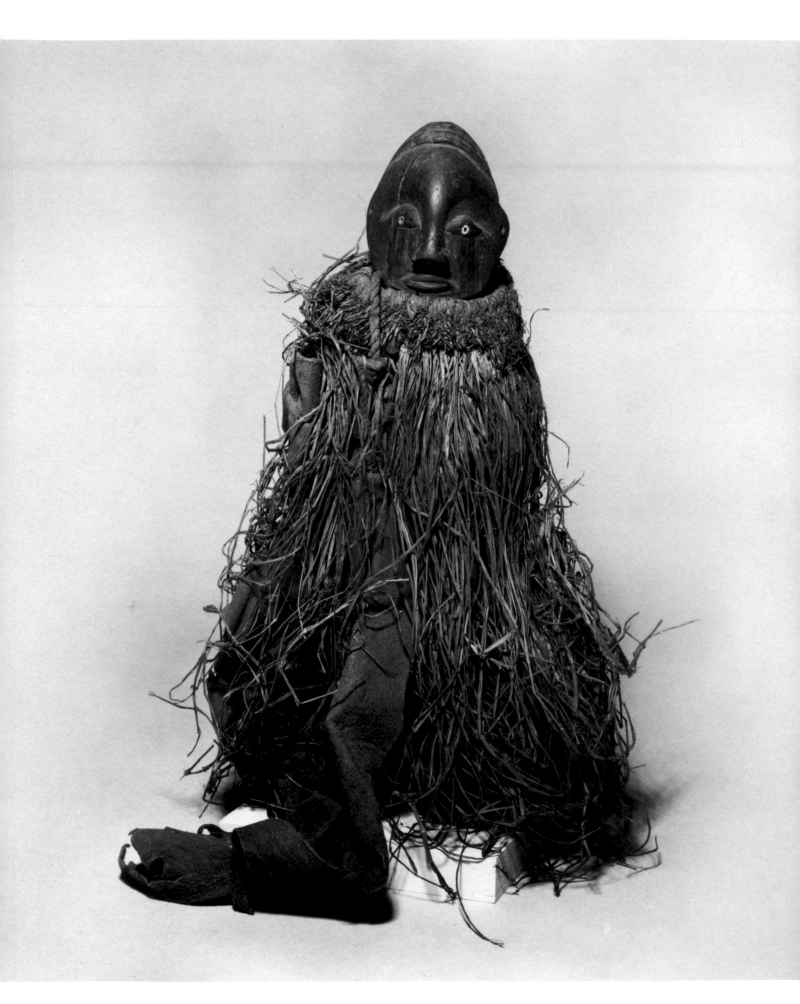

43 Standing Male Figure

Yaka figure carvings are made for a variety of purposes, including to propitiate ancestor spirits, to enlist the aid of supernatural forces for private cults, and to cure illness. Amandus Johnson's collection notes recorded on the object's accession card indicate that this example was used for healing. His notes further suggest that by the time he had reached this part of Africa, Western medicines were already being regarded as more powerful than those in traditional use, for Johnson wrote that although this figure "was in actual use in the village of Kawe," he bought the sculpture "from local medicine man in exchange against my own European medicine against malaria—Quinine tablets."

From the facial details, it is possible to attribute this sculpture to the Yaka style. The prominent, upturned nose, large eyes, and distinctly delineated mouth are Yaka features, although they are somewhat less sharply defined here than usual. The means of exhibiting this image presents an interesting dilemma, for beneath the raffia, animal skin, and rope costume is a fully carved figure displaying other elements of the Yaka style, now obscured from view. Thus to show more of the specific group style, the image should be "undressed." Nonetheless, it has been left intact, as collected, the way it was seen by the people who revered it.

Yaka, Zaire
Wood with raffia, animal skin, cotton rope, and glass beads
Height 11" (28 cm)
29-59-27
Collected by Amandus Johnson at the village of Kawe between 1922 and 1924, and purchased from Henry C. Mercer in 1927

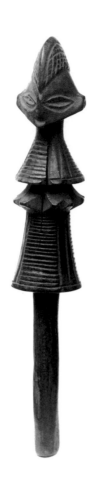

44 Stopper

Various peoples of Zaire, including the Pende, the Suku, and the Yaka, carry palm wine in gourds fitted with wood stoppers carved in the form of human heads or complete figures. Although small, many are gems of miniature carving and show aspects of each group's style.

In this Yaka stopper, the figure is conceived as a series of three cones that rise above one another to represent the legs, shoulders, and head. The face displays the large, sharply cut, protruding eyes typical of the Yaka expression. Other purely decorative objects of exquisite small scale carved by the Yaka that employ the human figure or face in their composition are pipes, combs, and neck rests.

Yaka, Zaire
Wood
Height 5″ (12.7 cm)
AF 684
Collected by Leo Frobenius in the Kasai and Congo river basins, Congo Free State, between 1904 and 1906, and purchased from J.F.G. Umlauff in 1912

45 Helmet Mask (*Hemba*)

The Suku send young boys who are between ten and fifteen years old to initiation camps for a period of seclusion during which they learn the customs and laws of their society. Masks of the type shown here, called *hemba*, are worn when important charms are displayed to the initiates and also, in pairs, when the newly initiated return to their villages. Performances include mourning songs, as these masks are believed to represent "a collective image of all those who have departed" (Bourgeois, 1979, p. 52). For this reason, tears are sometimes shown on the face in the form parallel lines below the eyes. Although the masks are thought to have harmful powers, they can also help to bring such benefits as good hunting and certain cures (see Bourgeois, 1985, p. 15). Magic liquids are rubbed onto the masks and charms are added to give them such powers.

The most common *hemba* mask form, represented by this example, is made of light wood and features a thick raffia fringe and a large, round face surmounted with a bird (as here) or animal crest. The use of the bird form, representing a songbird that symbolizes "good council" (ibid.), the rounded hairline, and the tear marks indicate that a female is depicted by this helmet (Bourgeois, 1979, pp. 50–59, 72–73, 79–82). This mask is a fine, old example of the style and shows evidence of a good deal of use prior to its collection.

Published: Hall, 1919, p. 90, fig. 32

Suku, Zaire
Wood with raffia and white and black pigment
Height without raffia 16¼″ (41.2 cm)
AF 1870
Collected by Leo Frobenius in the Kasai and Congo river basins, Congo Free State, between 1904 and 1906, and purchased from J.F.G. Umlauff in 1912

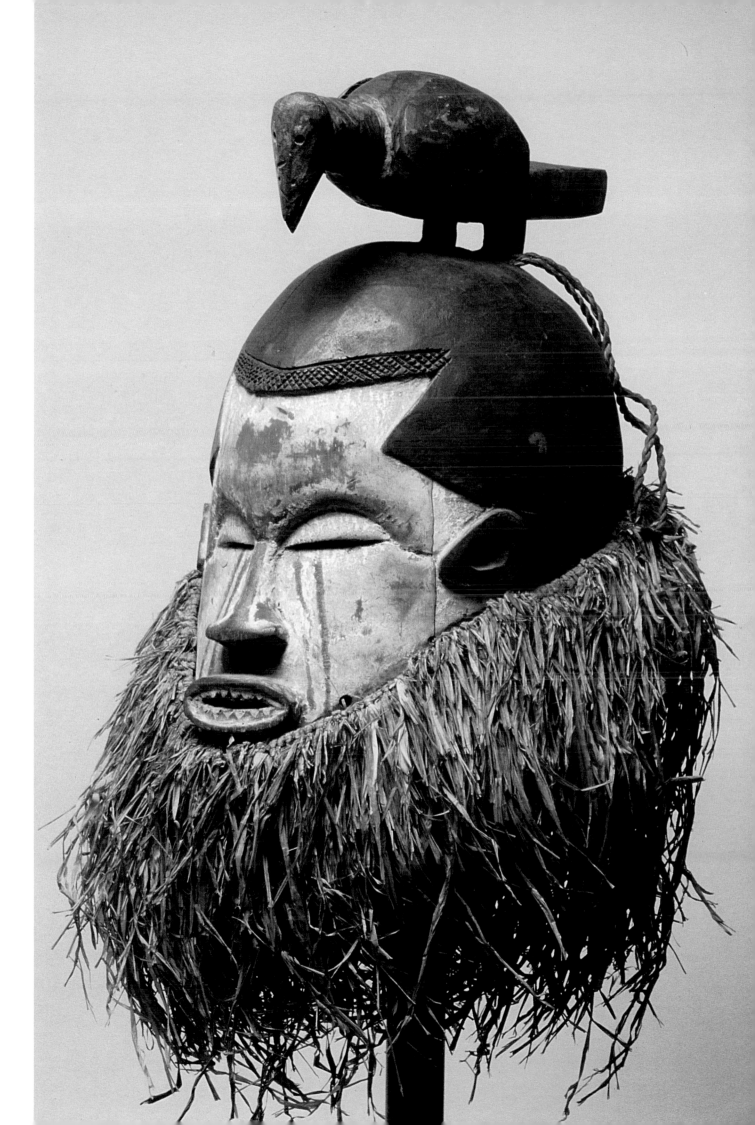

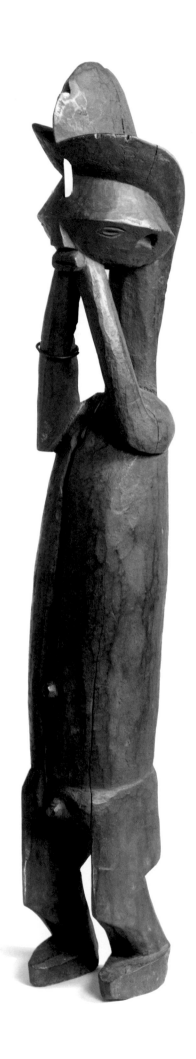

Huana, Zaire
Wood with bone and brass ring
Height 36⅜" (92.5 cm)
AF 5183
Collected by Captain C. Blank in the Belgian Congo before
1920, and purchased from W. O. Oldman in 1924

46 Standing Male Figure

Little research has been done on the art of the
Huana. They are related in origin to the Teke, and
their art bears similarities to that of the Suku and
Mbala. They use only one mask type and are best
known for their beautiful bone and ivory amulets
(see no. 47). Most of their wood sculptures are in
the form of standing figures in a characteristic
hands-to-chin pose, as seen in this image. Beyond
being referred to as "fetish" or cult figures, their
specific use has not yet been recorded, although
Christopher D. Roy suggests that they serve a magic
function (1985, p. 139).

Despite the lack of knowledge concerning the
significance of Huana carvings, theirs is a distinctive
sculptural style. Whether the object is a small ivory
or a larger wood piece, the notable features consist
of a series of strong, thrusting forms that create
balanced rhythms, especially apparent in profile. In
this figure these rhythms are set up by the heavy,
arched coiffure that sweeps over the head and down
the back and by the forward-jutting head, the shape
of which follows the curves of the coiffure and the
arms supporting the chin. The simply carved body
and sharply bent legs provide a solid base for the
sculpture.

Published: Plass, 1959, *Image*, p. 28, no. 144; Fagg, 1970, p. 79,
cat. no. 82

47 Female Figure Amulet

Although the Huana do make wood figures (see no. 46) and helmet masks similar to those of the Suku (see no. 45), their small bone and ivory amulets are the best known of their creations. Some are kneeling figures sculpted fully in the round, while others, such as this, are flatter figural relief carvings.

Despite its small size, this amulet is well carved and conceived. It is composed of a series of diamond and triangle shapes that form the head, eyes, nose, mouth, abdomen, and legs. Although the significance of these bone and ivory amulets is not certain, they may have been badges to indicate that their owners had completed their initiation training. The neighboring Pende made ivory pendants in the form of human heads for this purpose.

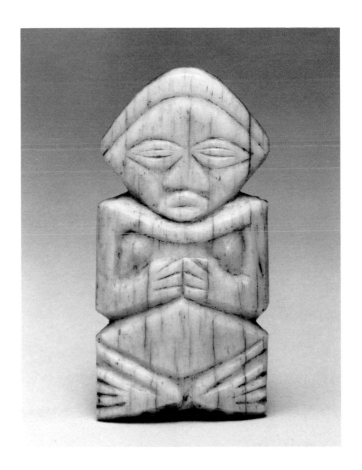

Huana, Zaire
Bone
Height 2″ (5.1 cm)
AF 929
Collected by Leo Frobenius in the Kasai and Congo river basins, Congo Free State, between 1904 and 1906, and purchased from J.F.G. Umlauff in 1912

Central Africa/Zaire **109**

48 Mask (*Mbuya*)

After young Pende men have attended bush schools and circumcision camps to learn their roles in adult life, they give a series of masked performances in different villages that are regarded as both entertainment and evidence that initiation has occurred. The performers are paid, and the money is used to meet the expenses of the schools. Some twenty village characters are represented by different masks that are generically called *mbuya*. Each has its own dance and song, and such types as the fool, the flirt, the diviner, and the widow are depicted. Although the performances are often satirical, they also demonstrate the values and customs of Pende society and the initiates' knowledge of them.

Those *mbuya* masks with beards, as seen here, are said to represent hunters. The hallmarks of the Pende style include the sharply upturned nose, angular eyebrows, bulging forehead, downcast, protruding eyes, pointed, filed teeth, and facial scarification patterns. This is a fine, old example of the style, made at the beginning of the twentieth century and collected by a missionary for the North Illinois Methodist Conference.

Pende, Zaire
Wood with red, black, and white pigment; raffia cloth; and raffia
Height 22⅝" (57.5 cm)
77-4-1
Collected by the Reverend Herbert Langdon at Nyanga, Mukedi Station, near Charlesville, Belgian Congo, between 1920 and 1922, and purchased from his wife, Zelma Z. Langdon, in 1977

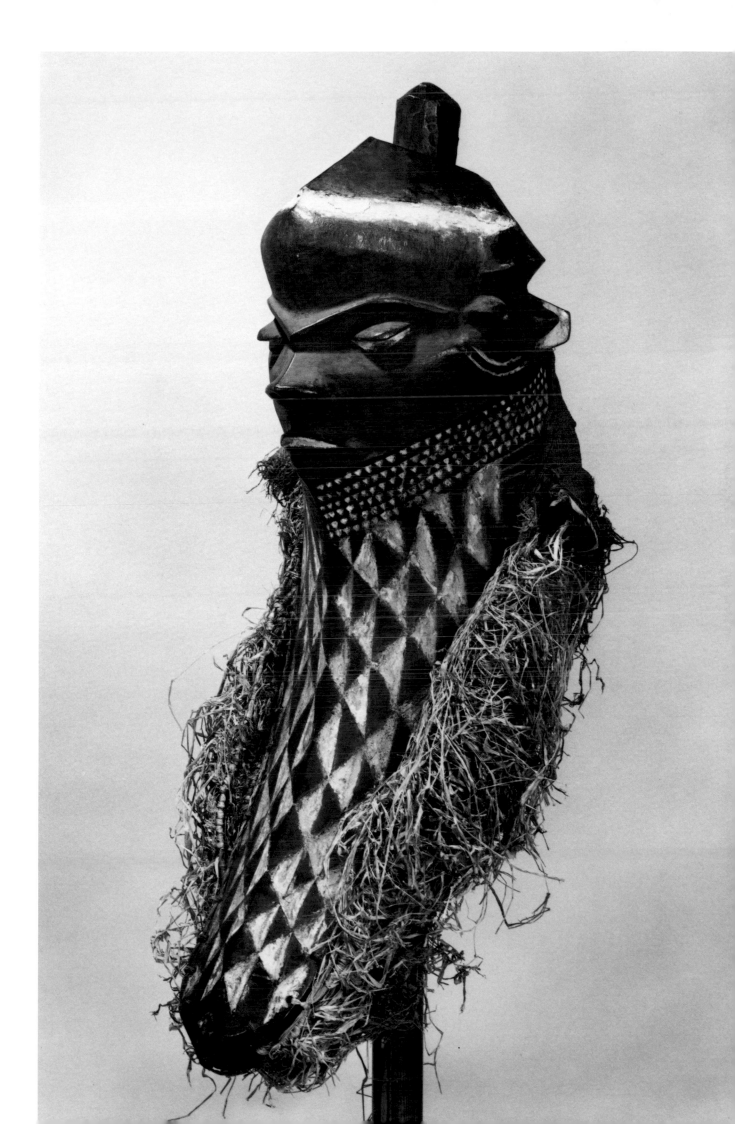

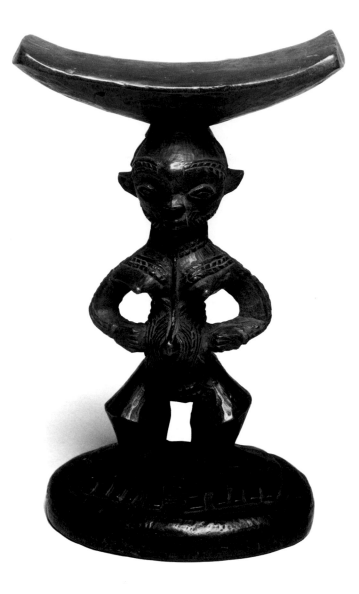

Pende, Zaire
Wood
Height 6¾" (17.2 cm)
AF 5154
Collected by Captain C. Blank in
the Belgian Congo before
1920, and purchased from
W. O. Oldman in 1924

49 Neck Rest

Neck rests are used throughout West Africa in place of pillows for resting and sleeping. They are more comfortable than they may appear to be and are cooler than pillows; more importantly, they preserve the coiffure that is such a significant element in African dress. Indeed, it is reported that in the nineteenth century it might have taken friends and relatives as long as forty hours to create certain hairdos that were expected to last for several months (Vogel and N'Diaye, 1985, p. 159, no. 87).

These small articles of furniture appear in many different forms. Some are simply structural, others show geometric carving on the base, and still other examples feature figures such as animals of various kinds, human heads, and, quite often, as seen here, full caryatids. The choice of motif seems to have no significance other than decoration.

This fine example combines sturdiness, balance, and elegance. The substantial, round base is countered by the functional neck support at the top. The figure itself, with its heavy, bowed legs, strong arms held akimbo, and beautiful face carved with the typically sharp Pende features, is a classic small sculpture of the style. The detailed carving around the face and the scarification patterns of the body are meticulously executed. The huge feet, which are often found on the caryatid stools and neck rests of the Pende and Songye, serve to anchor the object firmly to the ground and thus symbolically reinforce its weight-bearing function. A similar neck rest in the Clark and Frances Stillman Collection of Congo Sculpture in the Dallas Museum of Fine Arts (1978.48McD) is attributed to the Lulua.

50 Comb

The Pende are as well known for their small-scale sculptures as they are for their lifesize mask groups (see no. 48). This exquisitely carved hair ornament probably had no greater or lesser significance than to beautify its wearer. Although the face lacks the sharply upturned nose and protruding eyes and mouth that are typical of the style (see nos. 48, 49, 51), the coffee-bean shape of the eyes and raised brows connect it to the Pende. The geometric pattern below the neck is an imitation of the basketry weave that is used to make other types of Pende combs. The two long and elegantly carved tresses suggest the importance of a well kept coiffure to the Pende, a concept further reinforced by the purpose of this object itself. Henry Usher Hall compares its sculptural shape to the form of a hoe used by the Pende (1923, ''Notes on Woodcarvings,'' p. 119).

Published: Hall, 1923, ''Notes on Woodcarvings,'' p. 114, fig. 23

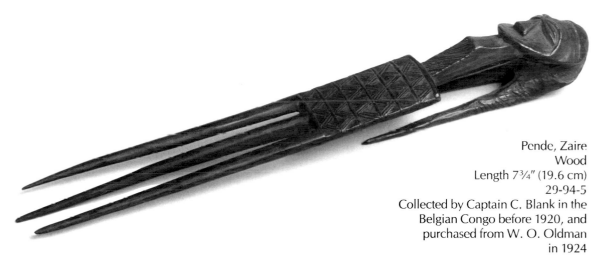

Pende, Zaire
Wood
Length 7¾" (19.6 cm)
29-94-5
Collected by Captain C. Blank in the
Belgian Congo before 1920, and
purchased from W. O. Oldman
in 1924

51 Palm-Wine Cup

Although as decorative artists they are not as prolific as the Kuba (see nos. 54a–d), the Pende embellish many objects that are used in daily life (see also no. 50). This palm-wine cup, for example, was used in the same way as those of the Kuba (see no. 54d), and it similarly proclaimed the taste and prestige of its owner. The form of a standing figure with its hands held to the abdomen is well known among Pende cups. The geometric designs carved in a band behind the arms are inspired by textile patterns, as are those on the Kuba beakers.

Published: Hall, 1924, ''Cups,'' p. 224, fig. 20

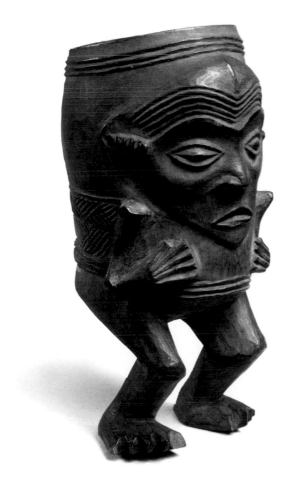

Pende, Zaire
Wood
Height 5¾" (14.6 cm)
AF 1953
Collected by Emil Torday in the Congo
Free State between 1900 and 1907,
and purchased from him in 1913

52 Mask (Ngady a Mwaash)

This type of mask is worn in dances that reenact the origins of Kuba kingship and the founding of the Kuba nation. It appears with two other masks, one representing Woot, a mythical ancestor who was the creator of man and the first Kuba ruler, and the other depicting Woot's brother, Mboom. Ngady a Mwaash, portrayed by this mask, was the wife and sister of Woot and the lover of Mboom (see Cornet, 1971, pp. 138, 141). As is easily imagined, the masquerades for which these masks are worn are complex affairs, sometimes violent or humorous and always dramatic, for they re-create the competition between the two men for the woman's attentions.

This is a typical Ngady a Mwaash mask, with a quite realistically carved face carefully painted with detailed geometric patterns drawn from Kuba textile designs. A band of beads suspended from the bridge of the nose hangs across the mouth. As a mask form, it is a striking and unique conception. The two masks that would accompany it in the dances are equally spectacular collages of beads, bright pigments, shells, and cloth. The use of such materials, which are related to prestige display in Kuba society, provides a connection between the secular and the sacred worlds. The masks thus become metaphors for the mythical beginnings of Kuba kingship and its manifestation in the everyday lives of the people.

Published: Hall, 1919, p. 90, fig. 32; Plass, 1957, pp. 64, 65, repro.

Kuba, Zaire
Wood with orange, white, and black pigment; raffia and cotton cloth; glass beads; cowrie shells; and brass tacks
Height 13" (33 cm)
AF 3685
Purchased from W. O. Oldman in 1912

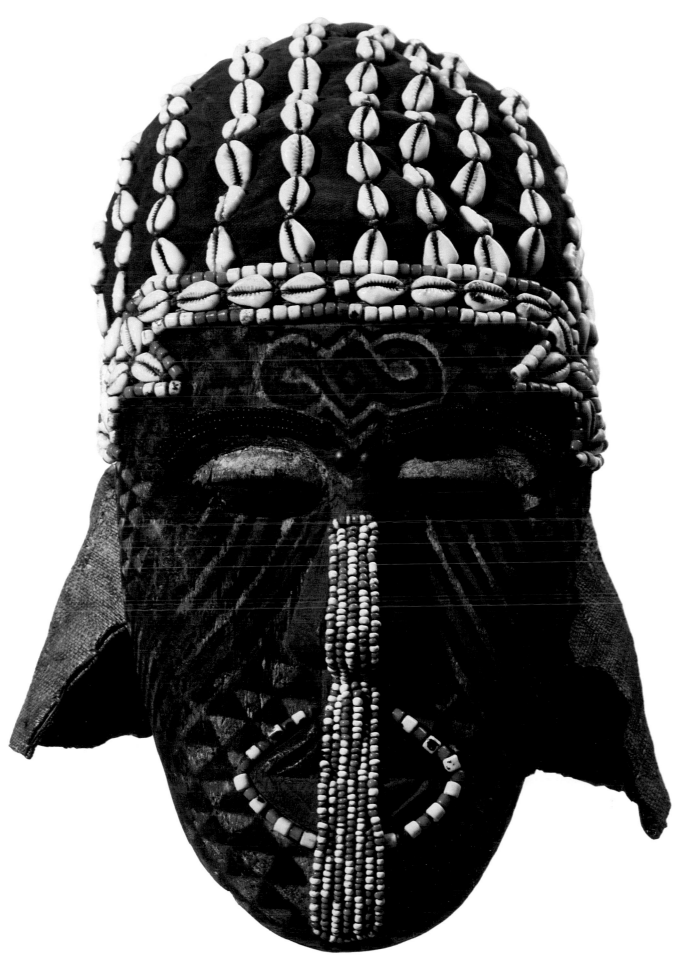

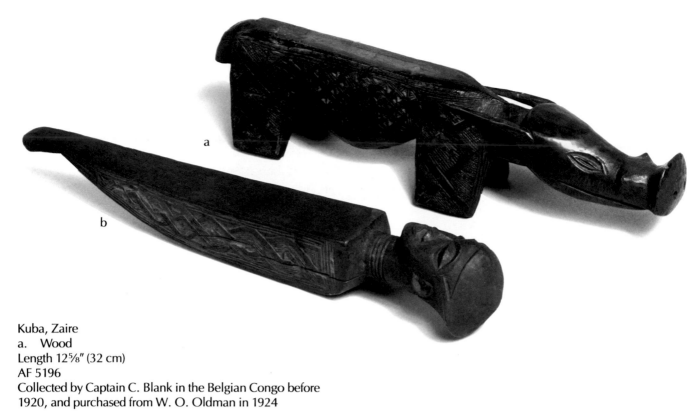

Kuba, Zaire
a. Wood
Length 12⅝" (32 cm)
AF 5196
Collected by Captain C. Blank in the Belgian Congo before
1920, and purchased from W. O. Oldman in 1924

b. Wood
Length 13¼" (33.7 cm)
AF 426
Collected by Leo Frobenius in the Kasai and Congo river
basins, Congo Free State, between 1904 and 1906, and
purchased from J.F.G. Umlauff in 1912

53 Divining Figures (*Itombwa*)

Divining figures, which are sometimes called
friction oracles, are used in large numbers by the
Kuba and their neighbors. They are equipped with a
separate flat, round knob that a diviner rubs across
the back of the figure (*itombwa*) after it has been
lubricated with palm oil. As he rubs the figure with
the knob, the diviner recites the names of people,
places, medicinal herbs, and the like, seeking such
information as the identification of thieves and other
criminals, the location of sorcerers, and the cure for
a disease. When the knob sticks at the mention of a
certain name, the oracle is judged to have spoken.
Some such figures have been used so often that
more than half of the carving has been worn away.

The various human and animal images carved on
friction oracles are chosen for their natural traits or
for the connections they are believed to have with
the spirit world. Crocodiles, for example, are known
for their patience, dogs for their acute sense of smell,
pigs for their persistence, and elephants for their
intelligence. One of the divining figures shown here
is in the form of a warthog (no. 53a), an animal
believed to have a special relationship to spirits. The
other (no. 53b) has a human head carved at the
end. Human heads, which frequently appear on
friction oracles, may represent intelligence or a
specific ancestor who can aid the diviner. The sides
of both figures are decorated with the typical
two-dimensional Kuba designs drawn from textile
motifs (see also nos. 52, 54a–d).

Published (no. 53b): Hall, 1919, p. 95, fig. 34

54 Cosmetic Boxes and Palm-Wine Cup

Besides being superb sculptors of masks and figures, the Kuba are the best known and most prolific decorative artists of West Africa. The crafts and their craftsmen are highly regarded in Kuba society. Thousands of containers and vessels such as these four exist in collections throughout the world, and The University Museum owns a fine and large group collected by Leo Frobenius in the early part of this century. Such objects of daily use are decorated both to please their viewers and to proclaim the prestige, taste, and wealth of their owners.

Cosmetic boxes (nos. 54a–c) are used to hold an aromatic red powder made of ground camwood called *tukula*. The color red is essential to the Kuba concept of beauty, and *tukula* is used to decorate both the hair and body. It is therefore a highly prized possession and an important item of trade. The boxes are assiduously rubbed with *tukula* mixed with oil to give them an antiquelike patina

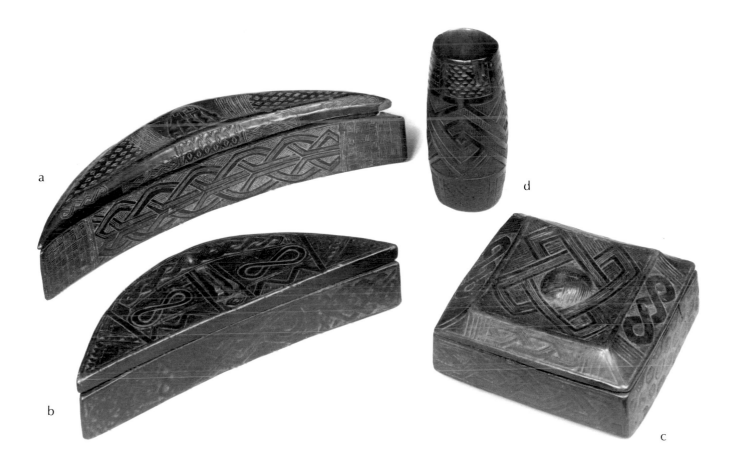

a

b

d

c

Kuba, Zaire

a. Wood
Length 15⅝" (39.7 cm)
AF 509
Collected by Leo Frobenius in the Kasai and Congo river basins, Congo Free State, between 1904 and 1906, and purchased from J.F.G. Umlauff in 1912

b. Wood
Length 12⅛" (30.8 cm)
AF 527
Collected by Leo Frobenius in the Kasai and Congo river basins, Congo Free State, between 1904 and 1906, and purchased from J.F.G. Umlauff in 1912

c. Wood
Width 6⅞" (17.5 cm)
AF 489
Collected by Leo Frobenius in the Kasai and Congo river basins, Congo Free State, between 1904 and 1906, and purchased from J.F.G. Umlauff in 1912

d. Wood
Height 6¾" (17 cm)
AF 466
Collected by Leo Frobenius in the Kasai and Congo river basins, Congo Free State, between 1904 and 1906, and purchased from J.F.G. Umlauff in 1912

that makes many appear considerably older than they actually are.

Cups such as the one seen here (no. 54d) are used for the ceremonial and social drinking of the popular and mildly intoxicating wine made from fermented palm sap. Drinking palm wine is one of the most important regular activities of Kuba men, and it takes place in the early evening, after work has been completed. Some of the most elaborate cups are in the form of human heads and figures, and there is a limitless variety of those decorated with geometric designs.

These four examples of Kuba decorative art are carved with low-relief linear patterns, all derived from textile motifs found in the well-known straw-pile weavings called "Kasai velvets." Textile designs appear throughout Kuba art: on masks (no. 52), figure sculptures (nos. 53a,b), ivories, and even body scarifications. Each pattern has a name and meaning, although a motif is used more for decorative than symbolic purposes.

Published (no. 54a): Torday, 1913, p. 19, fig. 20 (upper right)

55 Helmet Mask

Masks in this style are often attributed to the Kuba. However, although certain details, such as the projection at the top of the head, the extension of the coiffure at the back of the mask, and the triangular shape of the nose, do relate them to some helmet masks of the Kuba, they are now thought to come from the Kete, a closely related group living to the south (see Fagg, 1967, pl. 17).

Beyond the fact that these masks were worn during initiation ceremonies for young boys, information concerning their significance is not clear. A similar mask in the Museum Rietberg, Zurich, is described by Elsy Leuzinger as

representing the protector of the men's secret society, who appears especially at initiation ceremonies (1963, p. 226, no. 175).

This is a fine, old example of the Kete mask type. The face is composed of rounded and triangular shapes that merge into one another to produce a work that is both imposing and serene. White pigment has been sparingly applied to emphasize the eyes and nose.

Published: Rainey, 1947, repro. p. 13 (as Bushongo [Kuba]); Plass, 1957, repro. p. 67 (as Bushongo [Kuba]); Robbins, 1966, pp. 216, 217, no. 311 (as Songye)

Kete, Zaire
Wood with white pigment
Height 16¼" (41.2 cm)
AF 1879
Collected by Leo Frobenius in the Kasai and Congo river basins, Congo Free State, between 1904 and 1906, and purchased from J.F.G. Umlauff in 1912

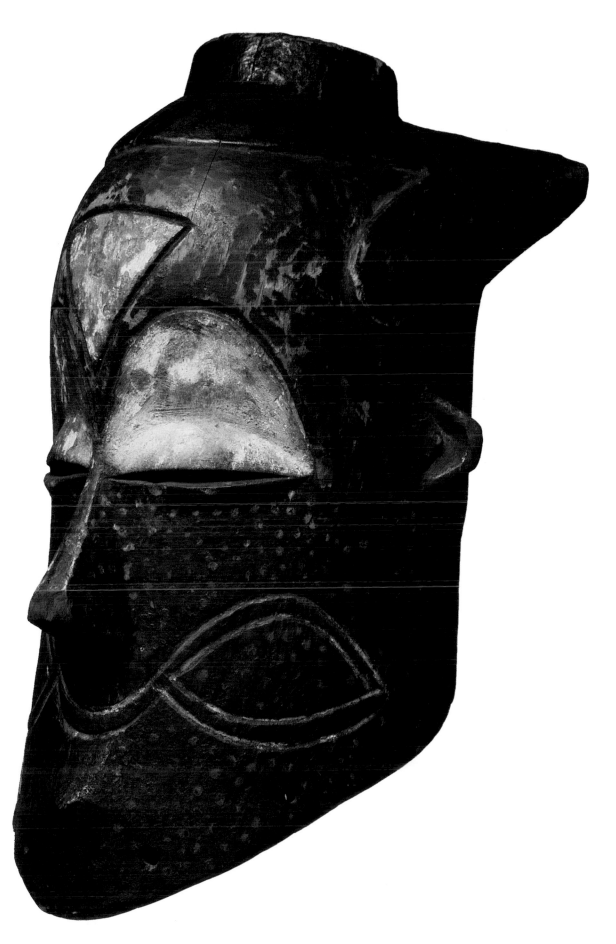

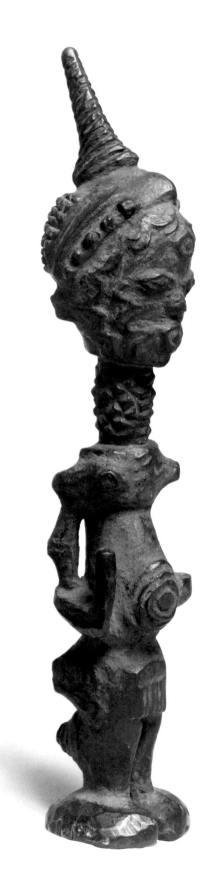

56 Standing Female Figure

Some of the most beautiful small-scale carvings of West Africa are the female figures made by the Lulua. They are used to bring good luck and beauty to their owners as well as to ward off sickness and other evil forces; some, for example, are placed near the beds of newborn children to protect them. The small cup held in the left hand of such figures is used as a receptacle for herbs and medicines that assure the continued effectiveness of the figure.

The Lulua regarded elaborate scarification as a mark of beauty and accordingly developed this form of body decoration to its highest degree. Despite its small size, this sculpture shows intricate scarification patterns, especially on the face. About a century ago, the Lulua ceased to practice this art, and the figures that have been made since then have been carved by artists with no firsthand knowledge of the sophisticated scarification designs worn by their ancestors. This example of their work shows considerable age and was probably made by someone who would have known this body art as a part of his culture. The figure's scarification designs may even have been copied from a living model.

Lulua, Zaire
Wood
Height 9½" (24 cm)
AF 628
Collected by Leo Frobenius in the Kasai and Congo river basins, Congo Free State, between 1904 and 1906, and purchased from J.F.G. Umlauff in 1912

57 Standing Male and Female Janus Figure

This unique sculpture of unknown significance shows a man and woman standing back to back in dynamic, lively poses. It is especially effective in profile, full of abrupt and angular rhythms. A sudden, unexpected asymmetrical detail introduced by the different positioning of the arms of the two figures is a particularly interesting aberration when it is noted that the female figure has been given a beard, presumably to achieve symmetry.

Although this carving lacks the intricate scarification patterns for which Lulua sculpture is renowned (see no. 56), it does show the pronounced angles at the shoulders and biceps seen on the better known works. Here the typically large feet have been carved into a round base cut in relief to show the toes.

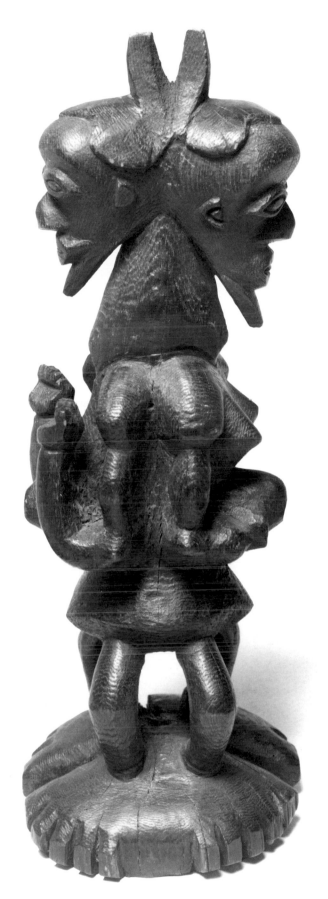

Lulua, Zaire
Wood
Height 9⅞" (25 cm)
AF 5187
Collected by Captain C. Blank in the Belgian Congo before 1920, and purchased from W. O. Oldman in 1924

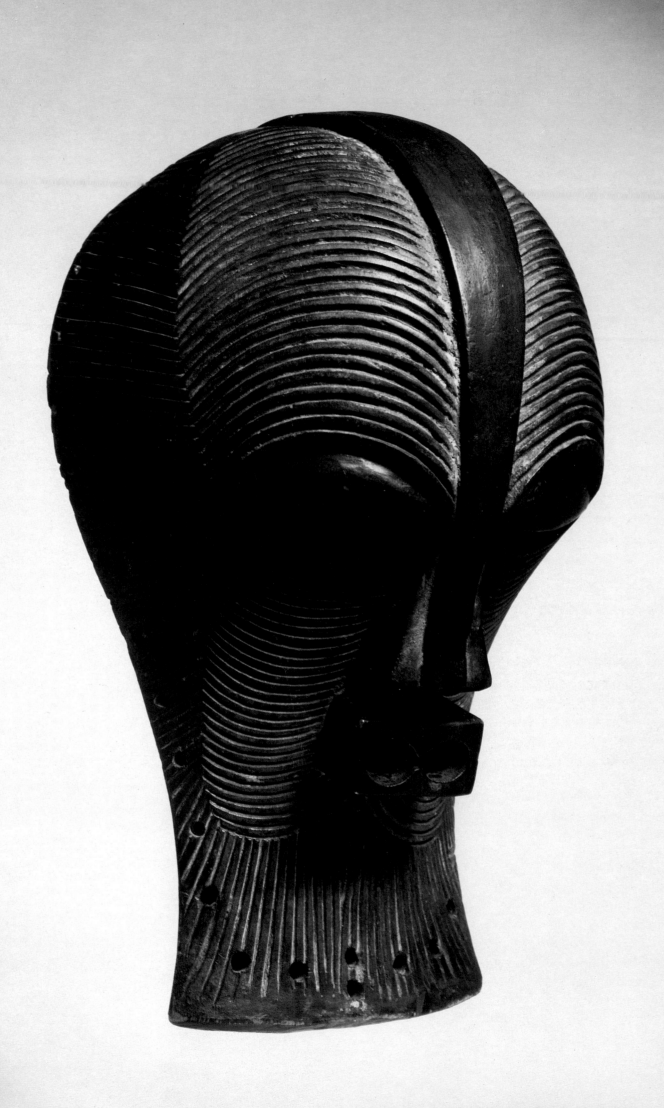

58 Mask (Kifwebe)

This mask type is understandably one of the African sculptures most sought by museums and private collectors alike. The parallel striations carved into the face reinforce the bold sculptural form of the mask, and the transition from the spherical form of the forehead to a square-cut cubist chin is brilliantly achieved. Because such masks have become so popular, there has been more misinformation written about them than about any other objects from West Africa.

These masks are commonly known as kifwebe, which simply means "mask" to the Songye, although this term refers quite specifically to only one type of mask they use. They are erroneously said to have been used in so-called Lion Society dances, at burials, at the investitures of chiefs, at receptions for dignitaries, by a cult of the dead, and by "witch doctors" to ward off evil and prevent illness. Some of this incorrect information was supplied as early as 1913 by Father Colle, a Belgian missionary who, in his writings on the neighboring Luba, probably used the term kifwebe for the first time. Much of it remained firmly entrenched in the literature until 1978, when Alan P. Merriam published the results of his investigations into the use of the masks during his fieldwork with the Songye in 1959–60 and 1973 (he also traced the various references to these masks made by Colle and others; see Merriam, 1978, pp. 60–68).

Although Merriam never saw the masks in use and was only able to report comments made by the elders of one village, he did learn that their use had begun only at the turn of this century. They were apparently worn for one of the Songye cults that did not survive for many years. Nonetheless, these masks had great power, which was directed at exercising "the social control of women and children." They were also worn to extract contributions from wealthy members of the community, which were then distributed to the less fortunate (ibid., p. 94; see also Kate Ezra in Vogel, 1981, p. 218, no. 132).

During the 1930s and 1940s and most probably since then, numbers of these masks have been made for the tourist trade. Because of this example's early date of acquisition and the signs of considerable use on the inside of the face, it was undoubtedly legitimately made for ceremonial purposes. It shows the flattened nose, figure-eight–shaped mouth, and square chin typical of the Songye style. The fine, exact carving of the striations, the contrast of the white pigment with the dark wood, and the overall bold, sculptural form of the mask combine to produce a work that is both dramatic and elegant.

Published: Wieschhoff, 1945, p. 32, fig. 9; Rainey, 1947, repro. title page; Kochnitzky, 1948, repro. p. 57; Wingert, 1948, pl. 97; Wingert, 1950, pl. 97; Christensen, 1955, p. 48, fig. 47; Plass, 1957, pp. 62, 63, repro.; Museum of Fine Arts, 1958, no. 48; Royal Ontario Museum, 1959, no. D49

Songye, Zaire
Wood with white pigment
Height 15" (38 cm)
AF 5115
Purchased from H. Vignier in 1921

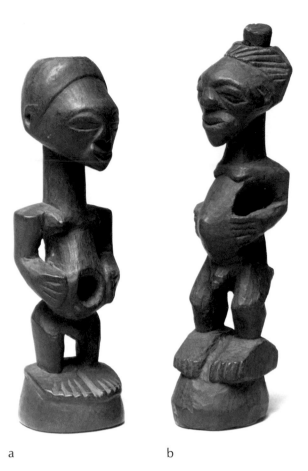

a b

Songye, Zaïre
a. Wood
Height 4¹⁵⁄₁₆″ (12.6 cm)
AF 612
Collected by Leo Frobenius in the Kasai and Congo river basins, Congo Free State, between 1904 and 1906, and purchased from J.F.G. Umlauff in 1912

b. Wood
Height 5¼″ (13.3 cm)
AF 616
Collected by Leo Frobenius in the Kasai and Congo river basins, Congo Free State, between 1904 and 1906, and purchased from J.F.G. Umlauff in 1912

59 Standing Male Figures

Songye families keep small male figures like these in the hope they will offer protection as well as bring such blessings as fertility, prosperity, and healthy children. Magic material, usually in the form of a small animal horn, is installed in the head by a specialist, but is now missing in both of these examples. Other substances are also added to the abdomen to increase their power. Offerings made by their owners assist the figures in interceding with the dieties to effect the desired benefits. Larger figures carved in the same pose, some as tall as five feet, are used by the entire community for protection from such major calamities as disease, drought, crop failure, and war.

These two images display the typical Songye sculptural conventions of the hands-to-abdomen pose, large feet, and thrusting rhythms. The large, heavily lidded eyes, flat, triangular nose, and broad, open mouth are similarly diagnostic facial features of both Songye figure sculptures and masks (see no. 58). Although small in size, all such family images project a sense of inner power in their bold forms. With their thick patina of oil that was applied to keep their powers intact, these figures show evidence of having been actively worshiped prior to collection.

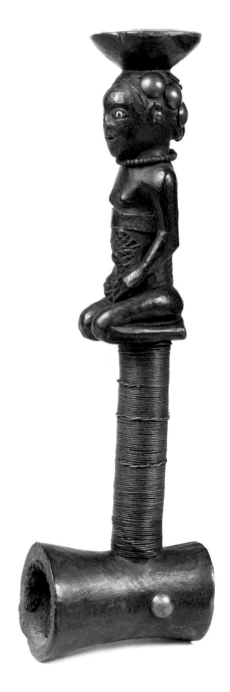

a. Luba, Zaïre
Wood with brass wire and tacks, tin, and glass beads
Height 8⅛″ (20.6 cm)
AF 5157
Collected by Captain C. Blank in the Belgian Congo before 1920, and purchased from W. O. Oldman in 1924

60 Pipes

The custom of smoking was brought to Africa by European traders in the sixteenth century, soon after tobacco had been discovered in the New World. Tobacco was readily cultivated, and smoking became widespread as a pleasurable habit that sometimes also serves a ceremonial function. An individual or carving is occasionally blessed by having smoke blown over the person or object, and smoking is also used to assist in divining or to induce trances in religious practitioners.

When smoking is done socially, pipes become yet another emblem of the user's status, and they are accordingly embellished with fine carvings and other decorative details. The use of important or exotic materials such as beads, tacks, and metal also adds to their value. One of the three examples seen here (no. 60a), a conventional pipe with an undecorated cylindrical bowl, has an exquisitely carved kneeling female figure at the end of the stem. In The University Museum's accession book it is assigned to the Ganguella of Angola, but its naturalistic, smooth forms, kneeling position, and intricately detailed scarification patterns around the abdomen lead to an attribution to the Luba (see also no. 62). The most common type of West African pipe has a human head forming the bowl. The Kuba often carved the head to look back at the smoker, as can be seen in the example here (no. 60b). The pipe with the naturalistically carved head (no. 60c), perhaps from the Kongo, has a huge bowl still containing tobacco.

Published (no. 60b): Hall, 1932, pp. 154, 155, pl. IV

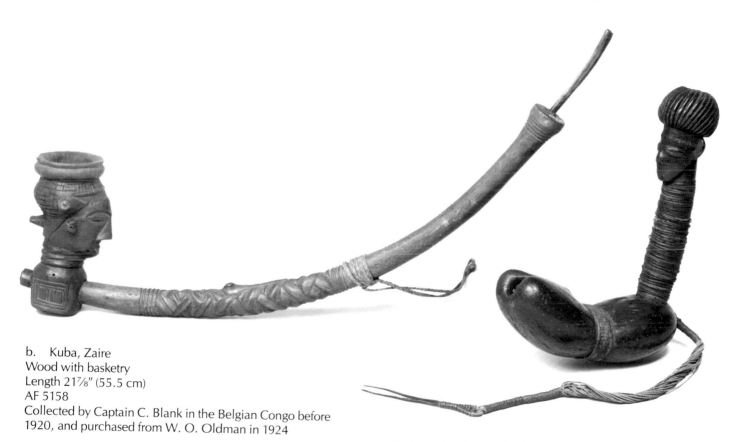

b. Kuba, Zaire
Wood with basketry
Length 21⅞" (55.5 cm)
AF 5158
Collected by Captain C. Blank in the Belgian Congo before 1920, and purchased from W. O. Oldman in 1924

c. Undetermined group (perhaps Kongo), Zaire
Wood with brass wire and tweezers, raffia twine, and tobacco
Height of stem 6⅞" (17.5 cm)
AF 5162
Collected by Captain C. Blank in the Belgian Congo before 1920, and purchased from W. O. Oldman in 1924

62 **Stool** (*Kipona*)

In much of West Africa, stools are used by chiefs and other important members of the community to signify their status. Justice is done, disputes settled, and decisions made by individuals seated on these pieces of prestige furniture. To the Luba, a *kipona,* which means "stool" in most Luba dialects, is particularly significant as it also provides tangible evidence that the owner has legitimate claims to his titles and position. Stools are part of a group of

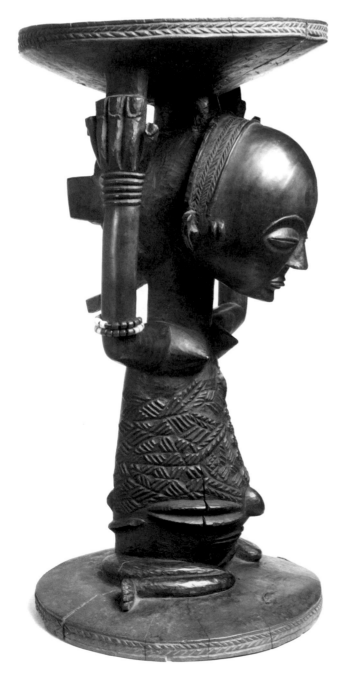

objects, which includes staffs, bow stands, spears, and cups, that are displayed at the investiture ceremonies of chiefs. Each becomes an important part of the royal treasury as a symbol of the chief's prerogatives and proof that the investiture has been held (Nooter, 1984, pp. 29, 63–65).

Some if not all of the objects in such a set of prestige items might be made by the same artist. There are, for example, at least six other Luba works thought to have been made by the carver of this stool. Susan Mullin Vogel has named him the Warua Master from the provenance of this object and a double figure in the Museum für Völkerkunde, West Berlin (Warua being an early Europeanized name for the Luba). She further states that the stool and a bow stand in the Monzino Collection in Venice are "the greatest of his works." She describes the characteristics of his style as "compressed features confined to the lower half of a well-rounded face; sharply carved, almost diamond-hard scarification on the stomach; treatment of the traditional Luba four-lobed coiffure as a large mass positioned low on the neck, with the chin lowered to balance the heavy hair; [and] attenuated, even insignificant limbs . . . " (1986, p. 173).

A stool in the White Collection at the Seattle Art Museum is probably also by the Warua Master (Seattle Art Museum, 1984, repros. pp. 16, 17). It was collected in 1916 by the Belgian Lieutenant Roger Castiau, when he was in the Belgian Congo leading a successful mission against German gunboats on Lake Tanganyika. William Fagg believes it is most probable that Castiau also collected The University Museum's example (Christie's, 1977, p. 34, no. 185).

Published: Hall, 1923, "Notes on Woodcarving," pp. 123, 124, 126, figs. 29–31; Pijoán, 1931, p. 153, fig. 207 (incorrectly as in the Guillaume Collection); Wieschhoff, 1945, p. 17, fig. 4; Wingert, 1948, pl. 102; Wingert, 1950, pl. 102; Plass, 1956, p. 51, no. 36-H (text only); Plass, 1957, pp. 60, 61, repro.; Madeira, 1964, repro.; Parrinder, 1967, repro. p. 61; Leiris and Delange, 1968, p. 195, pl. 217; Flam, 1971, p. 55, fig. 1; Nooter, 1984, fig. 57; Preston, 1985, pp. 72, 73, no. 75

Luba, Hemba subgroup, Zaire
Wood with glass beads
Height 16½" (42 cm)
AF 5121
Purchased from H. Vignier in 1921

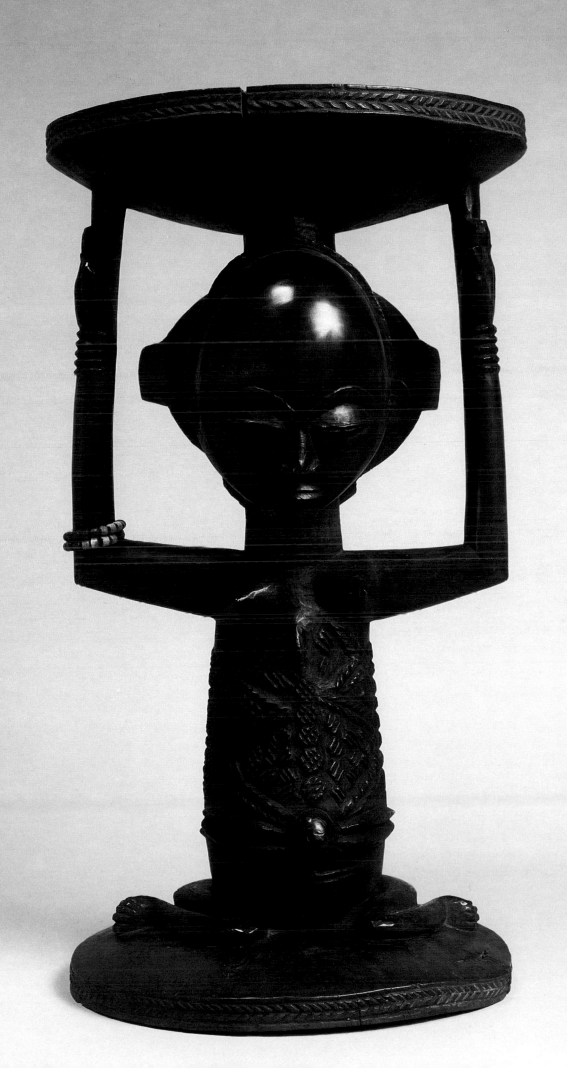

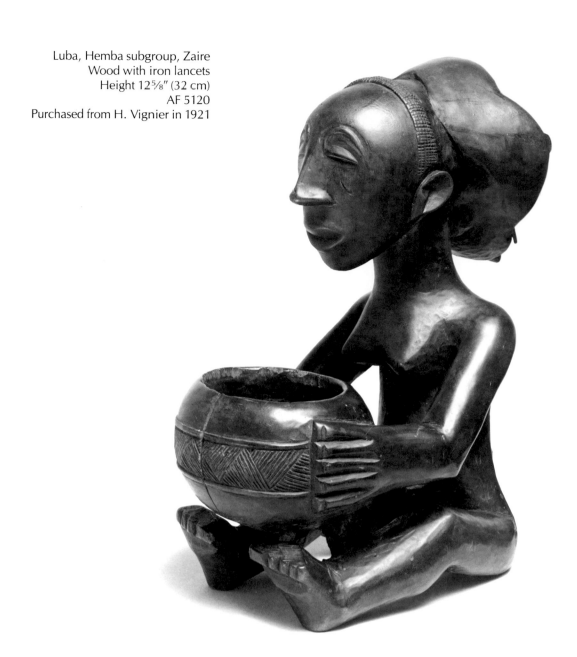

Luba, Hemba subgroup, Zaire
Wood with iron lancets
Height 12⅝″ (32 cm)
AF 5120
Purchased from H. Vignier in 1921

63 **Female Bowl Bearer** (*Mboko*)

Luba sculptures of a sitting or kneeling woman holding a bowl before her (*mboko*) have long been considered mendicant figures that are placed outside the house of a pregnant woman to collect alms. However, as begging is not practiced in West Africa, this interpretation is incorrect, although bowl bearers do serve several roles in Luba society. They are used by diviners who rub a white earth and herbs that are contained in the bowl on a person and the sculpture itself to establish contact with the spirit world. More importantly, they also serve as emblems of the prerogatives of Luba chiefs, and as such are often used in ceremonies of investiture. Each village boasts at least one chief who owns a *mboko*, which functions both to remind the

community of his importance and to bring general prosperity and protection from evil forces. The image is thought to represent the chief's first wife (see Nooter, 1984, pp. 57–60).

This bowl bearer is recorded on its accession card as being from the Warua, as is the great Luba stool (no. 62). It is carved in light wood that has been darkened with oil. The figure epitomizes the Luba ideals of beauty with its high, spherical forehead, elegant, cruciform coiffure, serene facial expression, and calm, unthreatening sense of authority and assurance. The enlarged size of the head and the hands is the only exception to an extreme naturalism that is typical of this style. Along with the stool, it is representative of the central Luba sculptural

expression at its best, and is among the masterpieces in The University Museum's collections.

Published: Hall, 1923, "Notes on Woodcarving," pp. 118, 120, 122, figs. 26–28; Wieschhoff, 1945, p. 17, fig. 5; Kochnitzky, 1948, repro. p. 53; Wingert, 1948, pl. 101; Wingert, 1950, pl. 101; Christensen, 1955, p. 81, fig. 49; Plass, 1956, p. 51, no. 36-G (text only); Plass, 1957, repro. p. 61; Pericot-Garcia, Galloway, and Lommel, 1967, p. 180, fig. 277

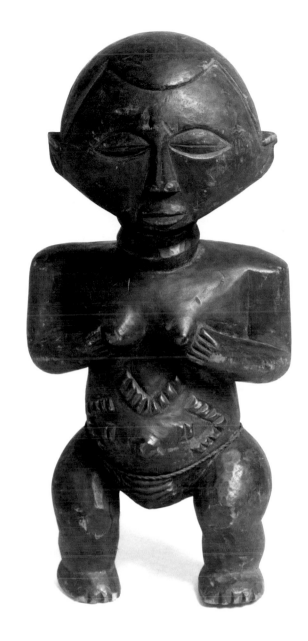

Luba, Zaire
Wood with twine
Height 14" (35.5 cm)
AF 1330
Collected by Leo Frobenius in
the Kasai and Congo river
basins, Congo Free State, between
1904 and 1906,
and purchased from J.F.G. Umlauff in 1912

64 Standing Female Figure

As can be seen from this and the three other examples of Luba sculpture included in this selection (nos. 60a, 62, 63), the style is one of elegant naturalism that most often uses the female figure as its subject. This image maintains certain conventions of the central Luba style, but its squared-off shoulders and angular chin indicate that it comes from the northwestern part of the Luba territory. The flattened, triangular nose and sharp geometric treatment of the shoulders and chin suggest influence from the Songye (see nos. 58,

59a,b), while the full, sensual forms of the torso and the legs and the scarification patterns on the abdomen are clearly related to the nuclear Luba expression.

This figure stands in a serene, frontal pose, her hands held to her breasts to signify her femininity and to refer to the underlying concept of fertility that undoubtedly motivated the carving. Made of an extremely light wood, it is fortunate that this fine example of the northwestern Luba substyle has survived.

65 Hanging Female and Male Figures

Mbole boys between the ages of seven and twelve are required to undergo initiation into the Lilwa Society, during which they are subjected to severe moral training and taught about their forthcoming roles in the adult community. Flagellation and fasting accompany much of the instruction, and these figures, which represent hanged people, are used to illustrate the fate of those who do not keep their vows and transgress the rules of their society. Hanging is the supreme punishment for the Mbole, and as such is used as the penalty for such serious crimes as sorcery, adultery, and homicide. Stories of specific individuals who have been convicted and hanged are told while figures such as these are displayed to impress upon the initiates the seriousness of Mbole law. Although each figure is named for the person it represents, the carving style is quite standardized and the sculptures are not seen as portraits (see Biebuyck, 1976). Certain information suggests that actual mummified bodies were first used for the same purpose and then replaced by these wood effigies (Fagg, 1970, p. 92).

The Mbole sculptural style is related to that of the Fang and Kota (see nos. 29, 31), but the way in which these figures have been conceived to depict the actual position of a hanged person is unique. At their best, as represented by these two images, Lilwa effigies show an attenuated form with shoulders that hunch forward and faces that feature a grimacing, tortured expression. Some examples, including the male figure shown here (no. 65b), are even pierced at the back for suspension, an indication of the manner in which they were displayed to the young boys.

Published (no. 65a): Wingert, 1948, pls. 67, 68 (as Fang); Wingert, 1950, pls. 67, 68 (as Fang); Plass, 1956, p. 56, no. 41-B

Mbole, Zaire
a. Wood with yellow, white, and red pigment
Height 26" (66 cm)
AF 5189
Collected by Captain C. Blank in the Belgian Congo before 1920, and purchased from W. O. Oldman in 1924

b. Wood with yellow and white pigment
Height 30" (76.2 cm)
AF 5188
Collected by Captain C. Blank in the Belgian Congo before 1920, and purchased from W. O. Oldman in 1924

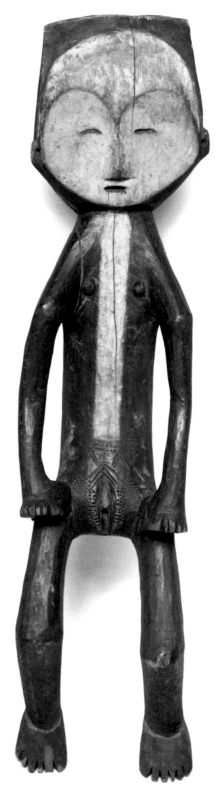

a

b

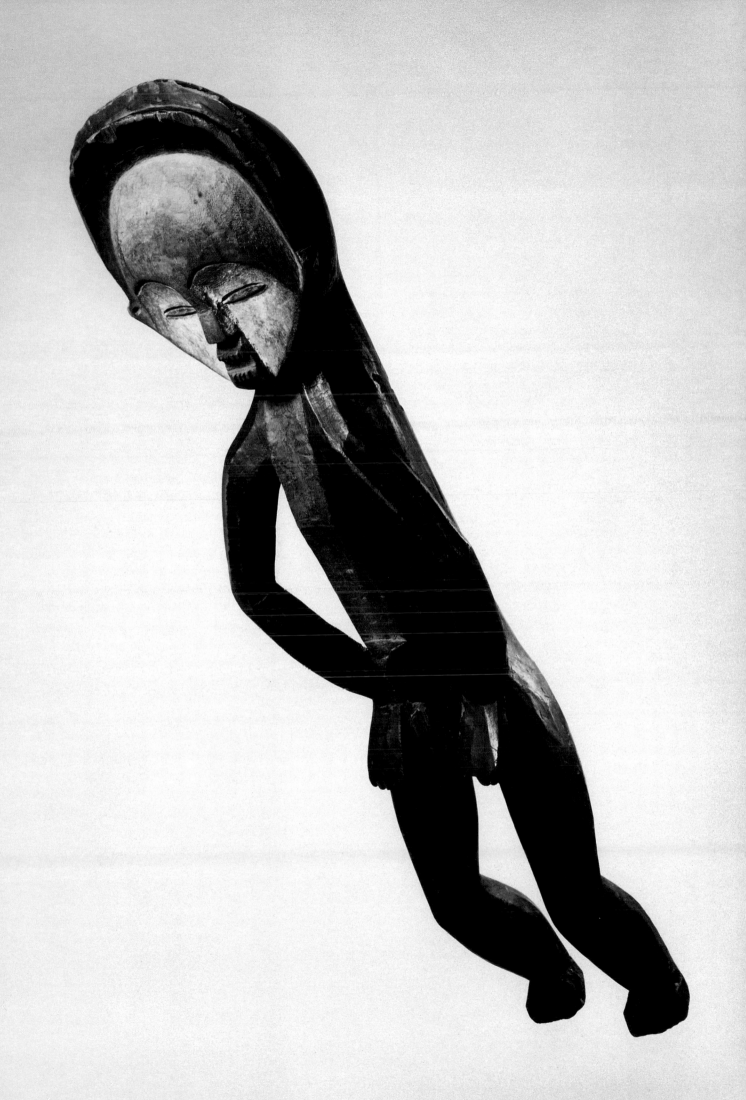

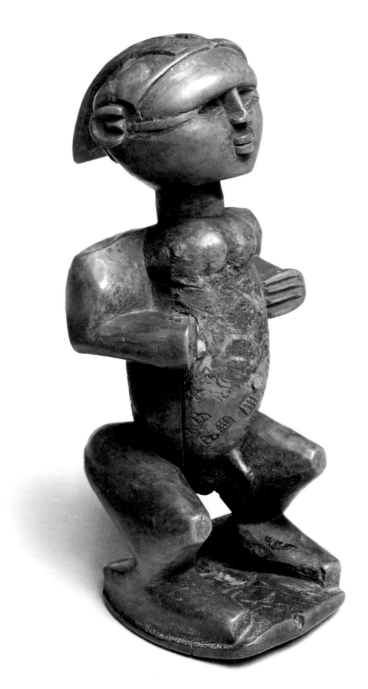

66 Standing Male Figure

This object's accession card indicates that it is from the region of Stanley Pool, the former name of Pool Malebo in Zaire, which would attribute it to the Kongo. However, this image does not show characteristic Kongo stylistic sculptural elements. It lacks the naturalism of the facial and anatomical features, and the conception of such elements as the shoulders, arms, hips, and feet is comparatively rigid. Instead distinctly defined facial features are compressed into a small area of the head, a treatment not found on Kongo works. Most likely the sculpture was purchased by Captain C. Blank at Stanley Pool but created elsewhere.

In style this carving relates somewhat to figures from the northern part of Zaire. Exact localization is difficult, but it bears certain general similarities to a group of figures published by Franz Olbrechts as representative of the "rough sculptural forms of the north" (1959, pl. XXXVIII). When Henry Usher Hall published this image in 1932, he said it had been used "as a memorial to the departed," whose spirit "can be induced by sacrifices" to inhabit the figure "to help the surviving relatives in time of need" (p. 164).

Whatever its origin and significance, this is an interesting work. Each element, whether a small detail or a larger part of the anatomy, is carved to divide the sculpture into a series of segregated areas that are almost independent of each other, thus giving the figure a somewhat fragmented and cubist appearance.

Published: Hall, 1932, pp. 164, 165, pl. IX

Undetermined group, Zaire
Wood
Height 6⅞" (17.5 cm)
AF 5169
Collected by Captain C. Blank in the Belgian Congo before 1920, and purchased from W. O. Oldman in 1924

67 Framed Standing Male Figure

The Holo were first exposed to Christianity in the seventeenth century, when a mission was founded by Portuguese Capuchin monks at Ste Marie de Matambe in Angola. It was not difficult for them to accept the religion because they already believed in a single creator diety. A fusion of Christian and indigenous beliefs accordingly resulted in the rise of the Santu cult, which worshiped Nzambi, God the Creator and Supreme Being, and spread through parts of Angola and Zaire, where it still holds force. The objects made for this cult, which depict a figure with outstretched arms standing in a frame, are kept in special houses and worshiped by their owners to bring good fortune and combat evil. Such a sculptural conception is unique in West African art, and was inspired by images of the Crucifixion and the framed votive pictures that were used and distributed by the missionaries.

This example, which was made shortly before it was collected, was probably intended for trade and not ceremonial use. Amandus Johnson's collection notes, as recorded on the object's accession card, suggest that it represents a robed Catholic priest standing in a church doorway. There are a number of such sculptures in The University Museum, all collected by Johnson at the same time. Earlier carvings often show a hermaphrodite or both male and female figures in similar poses within the frame and give signs of considerable use. The frames often include Byzantine cross motifs and other Christian-inspired designs (see Maesen, n.d., pl. 14; Walker Art Center, 1967, p. 31, no. 6.1).

Holo art shows relationships to neighboring Yaka and Suku styles (see nos. 43–45). The sharply upturned nose and slitlike eyes on this figure, for example, are Yaka conventions.

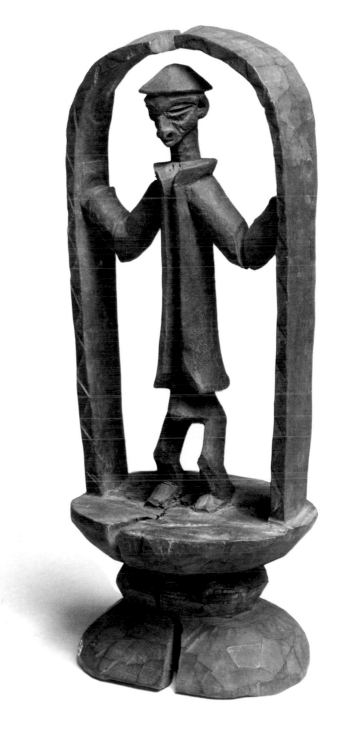

Holo, Angola
Wood
Height 9³⁄₁₆″ (23.4 cm)
29-59-38
Collected by Amandus Johnson in Angola between 1922 and 1924, and purchased from Henry C. Mercer in 1927

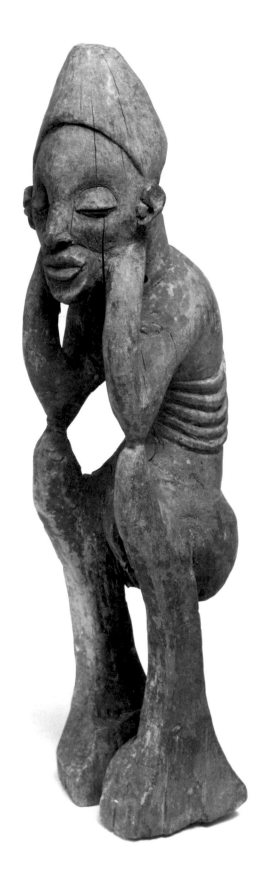

68 Seated Female Figure

The only information that appears in the accession records for this beautiful and contemplative figure, beyond its attribution to the Ngala, is that it was collected from the "Soba Marimba," *soba* being the word used by Westerners to designate a chief. However, although its use and significance are unknown, the facial expression, with its half-closed eyes, pursed lips, and sunken cheeks, indicates that the image most probably had a religious significance.

The seated elbows-to-knees posture is fairly common to West African sculpture, particularly that from Zaire (see no. 61) and Angola. Such a pose sets up strong, angular rhythms that in this case are accented by the large, triangular shape of the feet. These energetic forms are in direct contrast to the facial expression of calm repose. The depiction of the ribcage seen here is a detail sometimes found on figures from Zaire, particularly those of the Lulua.

Ngala, Angola
Wood with traces of white and red pigment
Height 9¹¹⁄₁₆" (24.6 cm)
29-59-11
Collected by Amandus Johnson in Angola between 1922 and 1924, and purchased from Henry C. Mercer in 1927

69 Staff

Tshokwe rulers use many objects to signify their authority, including bracelets, pendants, a mask type, swords, hatchets, and staffs. The scepters are all carved from a hard, highly polished wood, and some examples, which show elaborately rendered seated or standing figures at the ends, are among the masterworks of Tshokwe sculpture. Although this example is comparatively plain, embellished with only a head with a large and simply modeled coiffure, it is skillfully carved and shows the dignified face of a ruler who commands respect with his serene expression.

This face, which appears on many other Tshokwe staffs, is an idealized portrait rather than the representation of a specific individual. Marie-Louise Bastin has identified the provenance of this particular carving style as the region of Moxico, a part of eastern Angola near Luena (1982, nos. 61–64, 114–17, 122, 124). She describes the Moxico facial forms as being "rendered naturalistically with a flat nose, everted nostrils, thick often sinuous lips, almond-shaped eyes, carefully detailed ears, and a rounded chin" (ibid., p. 247), characteristics that perfectly match those of The University Museum's object. The undulating relief pattern on the staff below the face is a particularly pleasing decorative addition.

Published: Einstein, 1915, pl. 68; Hall, 1923, "Woodcarvings,"
pp. 68, 71, 73, figs. 5–7 (as from São Paolo de Loando); Hall, 1932,
pp. 154, 155, pl. IV; Wieschhoff, 1945, p. 23, fig. 7 (as Lunda,
Belgian Congo, Kasai district); Kochnitzky, 1948, repro. p. 67;
Plass, 1957, repro. title page

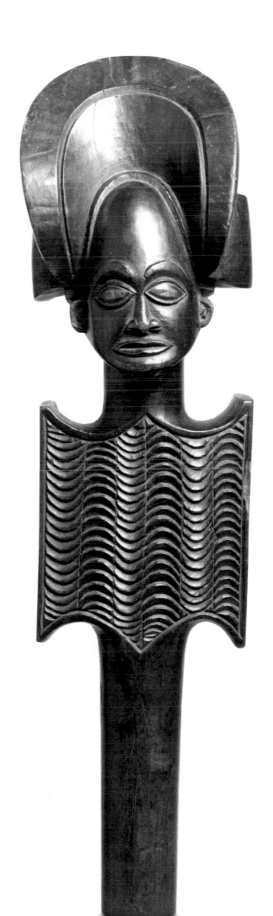

Tshokwe, Angola, Moxico region
Wood
Length of entire staff 23⅝" (60 cm)
29-94-12
Acquired before 1929

70 Staffs

After the rise of many powerful chiefdoms in Angola during the sixteenth and seventeenth centuries, much of the area's art was created for prestige purposes. Chairs, stools, pipes, weapons, objects of daily use, and above all staffs are made in large numbers for social display. Men of importance carry staffs such as these to announce their rank in their society. Chiefs keep such emblems in a special container, and the scepters and other paraphernalia are often turned over to the succeeding ruler.

The University Museum has a large number of staffs collected by Amandus Johnson from groups other than the Tshokwe, who are known for their extremely well carved examples (see no. 69). Those shown here represent three of the different forms that appear outside the Tshokwe area.

The simplest staff (no. 70b) has at its end a human head with well-carved facial features and an undecorated coiffure. Another (no. 70c), also adorned with a human head, has a face carved in relief at each shoulder and on the chest. It is notable for its precisely rendered miniature detail. The third example (no. 70a) likewise features a head that is meticulously worked, especially around the hair. Here, however, a seated female figure, carved from the same piece of wood, sits on top of the head; the two faces are practically identical. According to Marie-Louise Bastin, they probably represent Nana Yakama, the young woman who guarded the chief's treasure, brought rain, and looked after the fire that was relit at his investiture (quoted in Overseas Museum of Ethnology, 1972, no. 395; see also no. 397).

a.　Ovimbundu, Angola
Wood
Length of entire staff 30⅛" (76.5 cm)
29-59-169
Collected by Amandus Johnson in Angola
between 1922 and 1924, and
purchased from Henry C. Mercer in 1927

b.　Lunda, Angola
Wood with iron, brass, and tin
Length of entire staff 34¼" (87 cm)
29-59-207
Collected by Amandus Johnson in Angola
between 1922 and 1924, and
purchased from Henry C. Mercer in 1927

c.　Songo, Angola
Wood with orange pigment
Length of entire staff 23⅞" (60.7 cm)
29-59-181
Collected by Amandus Johnson in Angola
between 1922 and 1924, and
purchased from Henry C. Mercer in 1927

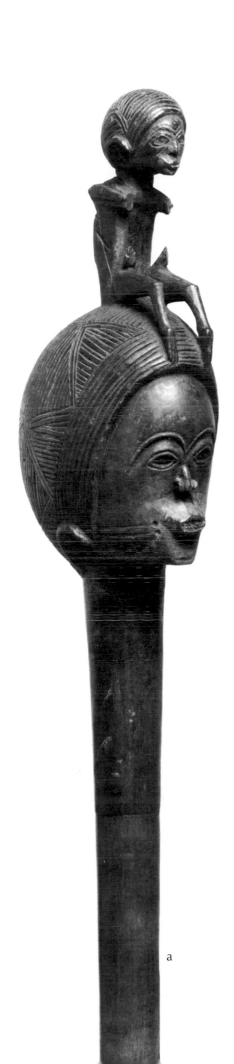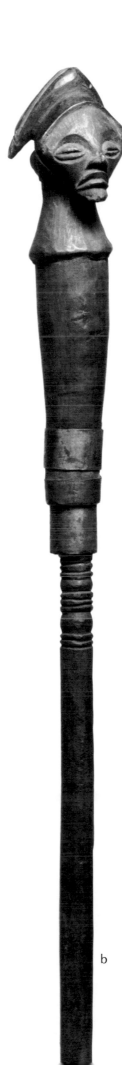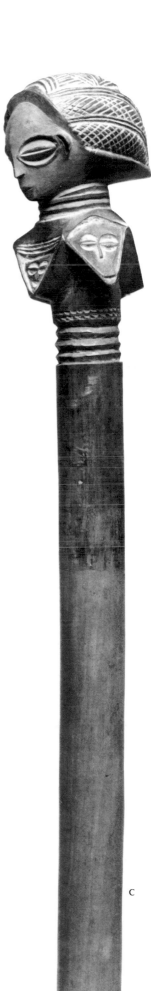

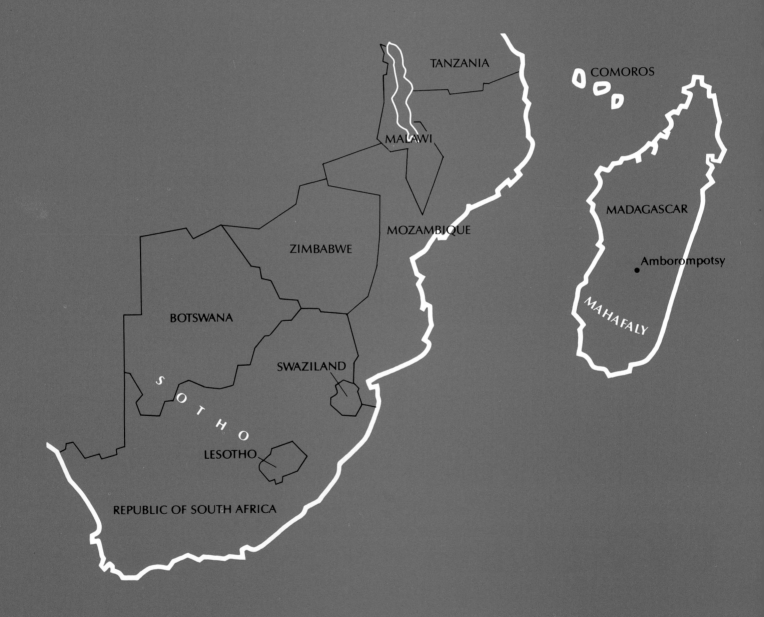

TANZANIA

COMOROS

MALAWI

MOZAMBIQUE

MADAGASCAR

ZIMBABWE

• Amborompotsy

BOTSWANA

MAHAFALY

SWAZILAND

S O T H O

LESOTHO

REPUBLIC OF SOUTH AFRICA

SOUTHERN AND EASTERN AFRICA

72 **Grave-Post** (*Aloala*)

The grave-posts of Madagascar are the most important art form of this island. They are placed in small groups in the center of tombs made of roughly cut stone blocks. Each tomb is owned by a family clan, and the posts serve as both memorials and points of communication between ancestor spirits and the living. The human figures carved on the posts do not represent the deceased but rather illustrate philosophical concepts and views of life after death.

Most grave-posts, like this example, consist of a human figure at the bottom with a geometrically carved openwork shaft above supporting a human or animal form. These images represent the symbolic passage from one world to the next. The pair of birds seen here, which often appear at the top of such posts, are thought to symbolize fertility and perhaps to provide contact between the living and the dead. Other frequently employed figures are male and female couples, mothers and children, colonial administrators in Western dress, and a variety of animals (see Urbain-Faublée, 1963, figs. 7–10, 18, 19, 94, 97–99). This fine example of the style is now seen in isolation, but should be visualized in its intended setting, standing in a group of eight or ten similar sculptures and first seen from afar in a field or on a hillside.

The sculpture of Madagascar is distinct from that of West Africa. There is a decidedly Indonesian flavor to the art (see Vogel and N'Diaye, 1985, p. 165, no. 100), which can be seen in this grave-post in the naturalistic proportions of the figures and the repeated openwork carvings of the central shaft. Exposure to this Southeast Asian expression was brought about by trade via the Indian Ocean to Borneo and the Celebes.

Published: Robbins, 1966, p. 233, fig. 347

Mahafaly, Madagascar, Amborompotsy
Wood
Height 89⅛" (226.4 cm)
62-4-1
Purchased from Peter Marks in 1962

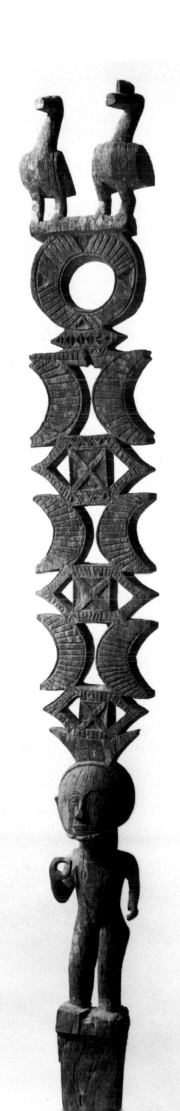

Bibliographic Abbreviations

"AFRICAN SCULPTURES," 1930
"Two New West African Sculptures." *The University Museum Bulletin,* vol. 2, no. 2 (December 1930), pp. 60–63.

ANTON ET AL., 1979
Ferdinand Anton et al. *Primitive Art: Pre-Columbian, North American Indian, African, Oceanic.* New York, 1979.

ARTS COUNCIL, 1960
The Arts Council of Great Britain, London. *Nigerian Tribal Art.* 1960.

BANKES, 1975
George Bankes. *African Carvings.* Brighton, 1975. Catalogue, Royal Pavilion, Art Gallery and Museums, Brighton.

BARNES AND BEN-AMOS, 1983
Sandra T. Barnes and Paula Ben-Amos. "Benin, Oyo, and Dahomey: Warfare, State Building, and the Sacralization of Iron in West African History." *Expedition: The University Museum Magazine of Archaeology/Anthropology, University of Pennsylvania,* vol. 25, no. 2 (Winter 1983), pp. 5–14.

BASSANI, 1977
Ezio Bassani. "Kongo Nail Fetishes from the Chiloango River Area." *African Arts,* vol. 10, no. 3 (April 1977), pp. 36–40, 88.

BASSANI, 1978
———. "Una bottega di grandi artisti Bambara." *Critica d'arte,* vol. 43 (1978), nos. 157–59, pp. 209–28; nos. 160–62, pp. 181–200.

BASSANI, 1982
———. "Un cimier Bambara." *Bulletin, L'Association des Amis du Musée Barbier-Mueller, Genève,* no. 15 (1982).

BASTIN, 1982
Marie-Louise Bastin. *La sculpture Tshokwe.* English translation by J. B. Donne. Meudon, 1982.

BATKIN, 1979
Jonathan Batkin. "African Art at the Denver Art Museum." *African Arts,* vol. 12, no. 3 (May 1979), pp. 24–30, 94–95.

"BAULE MASK," 1930
"A Baule Mask in the Museum Collections." *The University Museum Bulletin,* vol. 1, no. 2 (February 1930), pp. 4–5.

BIEBUYCK, 1976
Daniel P. Biebuyck. "Sculpture from the Eastern Zaïre Forest Regions: Mbole, Yela, and Pere." *African Arts,* vol. 10, no. 1 (October 1976), pp. 54–61, 99–100.

BOURGEOIS, 1979
Arthur P. Bourgeois. Nkanda *Related Sculpture of the Yaka and Suku of Southwestern Zaire.* Ann Arbor, 1979.

BOURGEOIS, 1985
———. *The Yaka and Suku.* Leiden, 1985.

BROOKLYN MUSEUM, 1954
The Brooklyn Museum, New York. *Masterpieces of African Art.* October 21, 1954–January 2, 1955.

CHAFFIN AND CHAFFIN, 1979
Alain Chaffin and Françoise Chaffin. *L'Art Kota: Les figures de reliquaire.* English translation by Carlos E. Garcia. Meudon, 1979.

CHEVRIER, 1906
M. A. Chevrier. "Note: Relative aux coutumes des adeptes de la société secrète des Scymos. Indigènes fétichistes du littoral de la Guinée." *L'Anthropologie,* vol. 17 (1906), pp. 359–76.

CHRISTENSEN, 1955
Erwin O. Christensen. *Primitive Art.* New York, 1955.

CHRISTIE'S, 1977
Christie, Manson & Woods Ltd., London. *Tribal Art and Ethnography from Asia, the Americas, Africa and Pacific.* Sale, July 13, 1977. Catalogue by William Fagg.

COLE AND ANIAKOR, 1984
Herbert M. Cole and Chike C. Aniakor. *Igbo Arts: Community and Cosmos.* Los Angeles, 1984. Exhibition (traveling), The Frederick S. Wight Art Gallery, University of California, Los Angeles, October 9–November 25, 1984.

CORNET, 1971
Joseph Cornet. *Art of Africa: Treasures from the Congo.* New York, 1971.

CULIN, 1892
Stewart Culin, ed. *Objects Used in Religious Ceremonies and Charms and Implements for Divination.* Philadelphia, 1892. Exhibition, Department of Archaeology and Palaeontology, University of Pennsylvania, Philadelphia, 1892.

DE LA BURDE, 1972
Roger de la Burde. "Ancestral Rams' Heads of the Edo-Speaking Peoples." *African Arts,* vol. 6, no. 1 (Autumn 1972), pp. 28–34, 88.

DREWAL, 1980
Henry John Drewal. *African Artistry: Technique and Aesthetics in Yoruba Sculpture.* Atlanta, 1980. Exhibition, The High Museum of Art, Atlanta, April 17–May 25, 1980.

EINSTEIN, 1915
Carl Einstein. *Negerplastik.* Leipzig, 1915.

ELISOFON, 1958
Eliot Elisofon. *The Sculpture of Africa.* New York, 1958.

EZRA, 1985
Kate Ezra. *African Ivories.* New York, 1985. Exhibition,

The Metropolitan Museum of Art, New York, June 26–
December 30, 1985.

FAGG, 1953
William Fagg. *The Webster Plass Collection of African Art: The Catalogue of a Memorial Exhibition Held in the King Edward VII Galleries of the British Museum.* London, 1953. Exhibition, British Museum, London, 1953.

FAGG, 1961
———. *Nigeria: 2000 Jahre Plastik.* Munich, 1961. Exhibition, Städtische Galerie, Munich, September 29, 1961—January 7, 1962.

FAGG, 1963
———. *Nigerian Images: The Splendor of African Sculpture.* New York, 1963.

FAGG, 1964
———. *Afrika: 100 Stämme—100 Meisterwerke/Africa: 100 Tribes—100 Masterpieces.* Berlin (West), 1964. Exhibition, Hochschule für Bildende Künste, Berlin (West), September 12–October 4, 1964.

FAGG, 1965
———. *Tribes and Forms in African Art.* New York, 1965.

FAGG, 1966
———. *African Tribal Sculptures.* Vol. 1, *The Niger Basin Tribes.* New York, 1966.

FAGG, 1967
———. *The Art of Central Africa: Sculpture and Tribal Masks.* New York, 1967.

FAGG, 1968
———. *African Tribal Images: The Katherine White Reswick Collection.* Cleveland, 1968.

FAGG, 1970
———. *African Sculpture.* Washington, D.C., 1970. Exhibition (traveling), National Gallery of Art, Washington, D.C., January 28–March 1, 1970. Organized by the International Exhibitions Foundation, Washington, D.C.

FAGG AND PEMBERTON, 1982
William Fagg and John Pemberton 3rd. *Yoruba: Sculpture of West Africa.* Ed. Bryce Holcombe. New York, 1982.

FAGG AND PLASS, 1964
William Fagg and Margaret Plass. *African Sculpture: An Anthology.* London, 1964.

FERNANDEZ, 1966
James W. Fernandez. "Principles of Opposition and Vitality in Fang Aesthetics." *The Journal of Aesthetics and Art Criticism,* vol. 25, no. 1 (Fall 1966), pp. 53–64.

FISCHER, 1978
Eberhard Fischer. "Dan Forest Spirits: Masks in Dan Villages." *African Arts,* vol. 11, no. 2 (January 1978), pp. 16–23, 94.

FISCHER AND HIMMELHEBER, 1975
Eberhard Fischer and Hans Himmelheber. *Gold aus Westafrika.* Frankfort on the Main, 1975. Exhibition, Museum für Völkerkunde, Frankfort on the Main, 1975. Organized in association with the Museum Rietberg, Zurich.

FISCHER AND HIMMELHEBER, 1984
———. *The Arts of the Dan in West Africa.* Zurich, 1984. Exhibition, Museum Rietberg, Zurich, 1976.

FISCHER AND HOMBERGER, 1985
Eberhard Fischer and Lorenz Homberger. *Die Kunst der Guro, Elfenbeinküste.* Zurich, 1985. Exhibition, Museum Rietberg, Zurich, May 11–October 13, 1985.

FISCHER AND HOMBERGER, 1986
———. *Masks in Guro Culture, Ivory Coast.* New York, 1986. Exhibition, The Center for African Art, New York, January 8–April 6, 1986.

FLAM, 1971
Jack D. Flam. "The Symbolic Structure of Baluba Caryatid Stools." *African Arts,* vol. 4, no. 2 (Winter 1971), pp. 54–59, 80.

FROBENIUS, 1898
Leo Frobenius. *Die Masken und Geheimbünde afrikas.* Halle, 1898.

GLAZE, 1975
Anita J. Glaze. "Woman Power and Art in a Senufo Village." *African Arts,* vol. 8, no. 3 (Spring 1975), pp. 24–29, 64–68, 90–91.

GOLDWATER, 1960
Robert Goldwater. *Bambara Sculpture from the Western Sudan.* New York, 1960. Exhibition, The Museum of Primitive Art, New York, February 17–May 8, 1960.

GOLDWATER, 1964
———. *Senufo Sculpture from West Africa.* Greenwich, Conn., 1964. Exhibition (traveling), The Museum of Primitive Art, New York, February 20–May 5, 1963.

HALL, 1917
Henry Usher Hall. "Some Gods of the Yoruba." *The Museum Journal* [The University Museum], vol. 8, no. 1 (March 1917), pp. 53–59.

HALL, 1919
———. "Examples of African Art." *The Museum Journal* [The University Museum], vol. 10, no. 3 (September 1919), pp. 77–101.

HALL, 1920
———. "Fetish Figures of Equatorial Africa." *The Museum Journal* [The University Museum], vol. 11, no. 2 (March 1920), pp. 27–55.

HALL, 1922
———. "Great Benin Royal Altar." *The Museum Journal* [The University Museum], vol. 13, no. 2 (June 1922), pp. 105–68.

HALL, 1923, "Notes on Woodcarvings"
———. "Notes on Some Congo and West African Woodcarvings." *The Museum Journal* [The University Museum], vol. 14, no. 2 (June 1923), pp. 101–34.

HALL, 1923, "Woodcarvings"
———. "Congo and West African Woodcarvings." *The Museum Journal* [The University Museum], vol. 14, no. 1 (March 1923), pp. 47–84.

HALL, 1924, "Cups"
———. "African Cups Embodying Human Forms." *The Museum Journal* [The University Museum], vol. 15, no. 3 (September 1924), pp. 190–227.

HALL, 1924, "Fetish"
———. "A Congo Fetish or Divining Image from the Coast Region." *The Museum Journal* [The University Museum], vol. 15, no. 1 (March 1924), pp. 58–69.

HALL, 1926
———. "An Ivory Standing Cup from Benin." *The Museum Journal* [The University Museum], vol. 17, no. 4 (December 1926), pp. 414–32.

HALL, 1927
———. "Two Wooden Statuettes from French West Africa." *The Museum Journal* [The University Museum],

vol. 18, no. 2 (June 1927), pp. 174–87.

HALL, 1931

———. "A Batetela Image." *The University Museum Bulletin,* vol. 2, no. 5 (March 1931), pp. 155–57.

HALL, 1932

———. "The African Collections." *The University Museum Bulletin,* vol. 3, no. 6 (April 1932), pp. 145–71.

HALL, 1937

———. "The African Expedition." *The University Museum Bulletin,* vol. 6, no. 6 (May 1937), pp. 10–13.

HALL, 1938

———. *The Sherbro of Sierra Leone: A Preliminary Report on the Work of The University Museum's Expedition to West Africa, 1937.* Philadelphia, 1938.

HALL CORRESPONDENCE, 1917–23

Henry Usher Hall Correspondence, 1917–23, Folder 1 of 5; Africa, Curatorial, Box 1, Correspondence, UMA.

HALL CORRESPONDENCE, 1924–26

Henry Usher Hall Correspondence, 1924–26, Folder 2 of 5; Africa, Curatorial, Box 1, Correspondence, UMA.

HALL CORRESPONDENCE, 1927–28

Henry Usher Hall Correspondence, 1927–28, Folder 3 of 5; Africa, Curatorial, Box 1, Correspondence, UMA.

HALL CORRESPONDENCE, 1936–40

Henry Usher Hall, Sierra Leone Expedition, Preparation Correspondence and Organization Material, 1936–40; Africa, Expedition Records, Box 10, Hall Research Notes, UMA.

HALL HOUSEHOLD BOOK, 1936–37

Henry Usher Hall Research Notes: Notebook—Sierra Leone—Household Book/Diary, British West Africa; Africa, Expedition Records, Box 10, Hall Research Notes, UMA.

HART, 1984

W. A. Hart. "Research Notes: So-Called Minsereh Figures from Sierra Leone." *African Arts,* vol. 18, no. 1 (November 1984), pp. 84–86, 96.

HENSHAW, 1985

Julia P. Henshaw, ed. *100 Masterworks from the Detroit Institute of Arts.* Detroit, 1985.

HOLAS, 1978

B. Holas. *L'Art sacré Sénoufo: Ses différentes expressions dans la vie sociale.* Abidjan, Ivory Coast, 1978.

HOMMEL, 1974

William L. Hommel. *Art of the Mende.* College Park, Md., 1974. Exhibition (traveling), Art Gallery, Department of Art, University of Maryland, College Park, Md., March 18–April 19, 1974.

HOOPER AND BURLAND, 1954

J. T. Hooper and C. A. Burland. *The Art of Primitive Peoples.* New York, 1954.

HORNE, 1985

Lee Horne, ed. *Introduction to the Collections of The University Museum.* Philadelphia, 1985.

"IVORY COAST DOOR," 1930

"An Ivory Coast Door." *The University Museum Bulletin,* vol. 1, no. 4 (April 1930), pp. 21–23.

JOHNSON CORRESPONDENCE, 1908–23

Amandus Johnson Correspondence, 1908–23, Folder 1 of 2; Africa, Expedition Records, Box 2, Kerr Research Notes and Correspondence to Johnson Correspondence, UMA.

JOHNSON CORRESPONDENCE, 1924–61

Amandus Johnson Correspondence, 1924–61, Folder 2 of 2; Africa, Expedition Records, Box 2, Kerr Research Notes and Correspondence to Johnson Correspondence, UMA.

KECSKÉSI, 1982

Maria Kecskési. *Kunst aus dem alten Afrika.* Innsbruck, 1982. Catalogue, Staatlichen Museum für Völkerkunde, Munich.

KERR FIELD ALBUM, 1893–99

Kerr Field Album, 1893–99; Africa, Expedition Records, Box 1, Kerr Research Notes and Correspondence, UMA.

KOCHNITZKY, 1948

Leon Kochnitzky. *Negro Art in Belgian Congo.* New York, 1948.

KUNSTHALLE BASEL, 1962

Kunsthalle Basel. *Nigeria: 2000 Jahre Plastik.* January 20–February 18, 1962.

LAMP, 1985

Frederick Lamp. "Cosmos, Cosmetics, and the Spirit of Bondo." *African Arts,* vol. 18, no. 3 (May 1985), pp. 28–43, 98–99.

LAMP, 1986

———. "The Art of the Baga: A Preliminary Inquiry." *African Arts,* vol. 19, no. 2 (February 1986), pp. 64–67, 92.

LEHUARD, 1980

Raoul Lehuard. *Fétiches à clous du Bas-Zaire.* Arnouville, 1980.

LEIRIS AND DELANGE, 1968

Michel Leiris and Jacqueline Delange. *African Art.* Trans. Michael Ross. New York, 1968.

LEUZINGER, 1963

Elsy Leuzinger. *Afrikanische Skulpturen/African Sculpture.* Zurich, 1963. Catalogue, Museum Rietberg, Zurich.

LEUZINGER, 1972

———. *The Art of Black Africa.* New York, 1972.

LEUZINGER, 1978

———. *Kunst der Naturvölker.* Frankfort on the Main, 1978.

MADEIRA, 1964

Percy C. Madeira, Jr. *Men in Search of Man: The First Seventy-Five Years of The University Museum of the University of Pennsylvania.* Philadelphia, 1964.

MAESEN, n.d.

Albert Maesen. *Umbangu: Art du Congo au Musée Royal du Congo Belge.* Brussels, n.d. [c. 1960].

MERRIAM, 1978

Alan P. Merriam. "Kifwebe and Other Masked and Unmasked Societies among the Basongye." *Africa-Tervuren,* vol. 24, no. 3 (1978), pp. 57–73; vol. 24, no. 4 (1978), pp. 89–101.

MURDOCK, 1959

George Peter Murdock. *Africa: Its Peoples and Their Culture History.* New York, 1959.

MUSEUM OF FINE ARTS, 1958

Museum of Fine Arts, Boston. *Masterpieces of Primitive Art.* October 16–November 23, 1958.

NICKLIN, 1974

Keith Nicklin. "Nigerian Skin-Covered Masks." *African Arts,* vol. 7, no. 3 (Spring 1974), pp. 8–15, 67–68, 92.

NOOTER, 1984

Mary H. Nooter. "Luba Leadership Arts and the Politics of

Prestige." Master's thesis, Columbia University, 1984.

OLBRECHTS, 1959
Frans M. Olbrechts. *Les arts plastiques du Congo Belge.* Brussels, 1959.

OLDMAN CORRESPONDENCE, 1908–16
Correspondence between W. O. Oldman and G. B. Gordon, 1908–16; Oceania, Curatorial, Box 3, General Correspondence, Research, and Collections to Collectors and Collections, UMA.

OLDMAN CORRESPONDENCE, 1921–22
W. O. Oldman, 1921–22; Director's Office, Gordon, Box 30, Alphabetical Correspondence, O–R, 1921–28, UMA.

OLDMAN CORRESPONDENCE, 1930–39
Correspondence between W. O. Oldman and H. U. Hall, 1930–39; Oceania, Curatorial, Box 3, General Correspondence, Research, and Collections to Collectors and Collections, UMA.

OLDMAN LISTS, 1921–28
W. O. Oldman, Lists of Collections; Director's Office, Gordon, Box 30, Alphabetical Correspondence, O–R, 1921–28, UMA.

OVERSEAS MUSEUM OF ETHNOLOGY, 1972
Overseas Museum of Ethnology, Lisbon. *Peoples and Cultures.* Lisbon, 1972. Exhibition, National Gallery of Modern Art, Lisbon, April–June 1972.

PALAIS DES BEAUX-ARTS, 1966
Palais des Beaux-Arts, Brussels. *Arts d'Afrique, d'Oceanie, d'Amerique: Choix des collections du Musée d'Ethnographie de la Ville d'Anvers.* 1966 (traveling).

PARRINDER, 1967
Geoffrey Parrinder. *African Mythology.* London, 1967.

PERICOT-GARCIA, GALLOWAY, AND LOMMEL, 1967
Luis Pericot-Garcia, John Galloway, and Andreas Lommel. *Prehistoric and Primitive Art.* New York, 1967.

PERROIS, 1972
Louis Perrois. *La statuaire Fan: Gabon.* Paris, 1972.

PERROIS, 1976
———. *Arts du Gabon: Les arts plastiques du bassin de l'Ogooué.* Arts d'Afrique Noire, supplement to vol. 20 (Winter 1976). [Arnouville-Les-Gonesse, 1979.]

PERROIS, 1985
———. *Ancestral Art of Gabon from the Collections of the Barbier-Mueller Museum.* Trans. Francine Farr. Geneva, 1985. Exhibition (traveling), Dallas Museum of Art, January 26–June 15, 1986.

PHILADELPHIA MUSEUM OF ART, 1969
Philadelphia Museum of Art. *Impact Africa: African Art and the West.* January 24–June 30, 1969.

PHILLIPS, 1980
Ruth B. Phillips. "The Iconography of the Mende *Sowei* Mask." *Ethnologische Zeitschrift Zürich* (1980), vol. 1, pp. 113–32.

PIJOÁN, 1931
José Pijoán. *Arte de los pueblos aborígenes.* Summa Artis, Historia General del Arte, vol. 1. Madrid, 1931.

PLASS, 1956
Margaret Plass. *African Tribal Sculpture.* Philadelphia, 1956. Exhibition, The University Museum, University of Pennsylvania, Philadelphia, April–September 1956.

PLASS, 1957
———. "African Negro Sculpture: A Walk through the Gallery." *The University Museum Bulletin,* vol. 21, no. 4 (December 1957), pp. 5–76.

PLASS, 1959, *Image*
———. *The African Image: A New Selection of Tribal Art.* Toledo, 1959. Exhibition, The Toledo Museum of Art, February 1–22, 1959.

PLASS, 1959, *Metals*
———. *Seven Metals of Africa.* Philadelphia, 1959. Exhibition (traveling), The University Museum, University of Pennsylvania, Philadelphia, November 12, 1959–January 15, 1960.

PRESTON, 1985
George Nelson Preston. *Sets, Series & Ensembles in African Art.* New York, 1985. Exhibition, The Center for African Art, New York, July 17–October 27, 1985.

PRICE, 1975
Christine Price. *Made in West Africa.* New York, 1975.

RAINEY, 1947
Froelich G. Rainey. "Masks." *The University Museum Bulletin,* vol. 13, no. 1 (November 1947), pp. 2–29.

ROBBINS, 1966
Warren M. Robbins. *African Art in American Collections/ L'Art africain dans les collections americaines.* French translation by Richard Walters. New York, 1966.

ROTH, 1899
Henry Ling Roth. "Personal Ornaments from Benin." *Bulletin of the Free Museum of Science and Art of the University of Pennsylvania,* vol. 2, no. 1 (January 1899), pp. 28–35.

ROY, 1979
Christopher D. Roy. *Mossi Masks and Crests.* Ann Arbor, 1979. Microfiche.

ROY, 1985
———. *Art and Life in Africa: Selections from the Stanley Collection.* Iowa City, 1985. Exhibition, The University of Iowa Museum of Art, Iowa City, April 5–August 11, 1985.

ROYAL ONTARIO MUSEUM, 1959
The Royal Ontario Museum, Toronto. *Masks: The Many Faces of Man.* February 11–April 5, 1959.

RUBIN, 1984
William Rubin, ed. *"Primitivism" in 20th Century Art: Affinity of the Tribal and the Modern.* 2 vols. New York, 1984. Exhibition (traveling), The Museum of Modern Art, New York, September 27, 1984–January 15, 1985.

SEATTLE ART MUSEUM, 1984
Seattle Art Museum. *Praise Poems: The Katherine White Collection.* March 8–May 27, 1984 (traveling).

SIROTO, 1968
Leon Siroto. "The Face of the Bwiiti." *African Arts/Arts d'Afrique,* vol. 1, no. 3 (Spring 1968), pp. 22–27, 86–89.

SWEENEY, 1935
James Johnson Sweeney, ed. *African Negro Art.* New York, 1935. Exhibition (traveling), The Museum of Modern Art, New York, March 19–May 14, 1935.

THOMPSON AND CORNET, 1981
Robert Farris Thompson and Joseph Cornet. *The Four Moments of the Sun: Kongo Art in Two Worlds.* Washington, D.C., 1981. Exhibition, National Gallery of Art, Washington, D.C., August 30, 1981–January 17, 1982.

TORDAY, 1913
Emil Torday. "The New Congo Collection." *The Museum*

Journal [The University Museum], vol. 4, no. 1 (March 1913), pp. 13–32.

TROWELL AND NEVERMANN, 1968
Margaret Trowell and Hans Nevermann. *African and Oceanic Art.* New York, 1968.

UMA
The University Museum Archives, University of Pennsylvania, Philadelphia.

UMLAUFF CORRESPONDENCE, 1912–14
Correspondence between Dr. George Gordon and J.F.G. Umlauff, 1912–14; Oceania, Curatorial, Box 3, General Correspondence, Research, and Collections to Collectors and Collections, UMA.

UNIVERSITY MUSEUM, 1936
African Art: Catalogue of a Collection of African Art to Be Sold at Auction for the Benefit of a Proposed Expedition to Africa by The University Museum. Sale, The Barclay Hotel, Philadelphia, April 16, 1936.

UNIVERSITY MUSEUM, 1965
The University Museum, University of Pennsylvania, Philadelphia. *Guide to the Collections.* Philadelphia, 1965.

UNIVERSITY MUSEUM, 1974
———. *African Ritual Dolls.* December 1973–February 1974.

URBAIN-FAUBLÉE, 1963
Marcelle Urbain-Faublée. *L'Art malgache.* Paris, 1963.

VANCOUVER ART GALLERY, 1964
Vancouver Art Gallery. *The Nude in Art.* November 3–29, 1964.

VANSINA, 1984
Jan Vansina. *Art History in Africa: An Introduction to Method.* London, 1984.

VOGEL, 1981
Susan Mullin Vogel, ed. *For Spirits and Kings: African Art from the Paul and Ruth Tishman Collection.* New York, 1981. Exhibition, The Metropolitan Museum of Art, New York, June 3–September 6, 1981.

VOGEL, 1986
———. *African Aesthetics: The Carlo Monzino Collec-*

tion. New York, 1986. Exhibition, The Center for African Art, New York, May 7–September 7, 1986.

VOGEL AND N'DIAYE, 1985
Susan Mullin Vogel and Francine N'Diaye. *African Masterpieces from the Musée de l'Homme.* New York, 1985. Exhibition, The Center for African Art, New York, September 17, 1984–January 6, 1985.

VOLAVKOVA, 1972
Zdenka Volavkova. "Nkisi Figures of the Lower Congo." *African Arts,* vol. 5, no. 2 (Winter 1972), pp. 52–59, 84.

WALKER ART CENTER, 1967
Walker Art Center, Minneapolis. *Art of the Congo: Objects from the Collection of the Koninklijk Museum voor Midden-Afrika/Musée Royal de l'Afrique Centrale, Tervuren, Belgium.* November 5–December 31, 1967 (traveling).

WARDWELL, 1966
Allen Wardwell. "Some Notes on a Substyle of the Bambara." *Museum Studies* [The Art Institute of Chicago], vol. 1 (1966), pp. 112–28.

WHITE, n.d.
J. Noble White, "Idol or Dikixi of the Otetela Tribe," n.d., General Information on African Collection—Letters, Object Inventory and Description, Inventory Lists; Africa, Curatorial, Box 3, Collections, UMA.

WIESCHHOFF, 1945
Heinrich A. Wieschhoff. "The African Collections of The University Museum." *The University Museum Bulletin,* vol. 11, nos. 1, 2 (March 1945), pp. 3–73.

WILLETT, 1971
Frank Willett. *African Art: An Introduction.* New York, 1971.

WINGERT, 1948
Paul S. Wingert. *African Negro Sculpture.* New York, 1948. Exhibition, M. H. de Young Memorial Museum, San Francisco, September 24–November 19, 1948.

WINGERT, 1950
———. *The Sculpture of Negro Africa.* New York, 1950.

Index of Peoples